INTERPRETING ART IN MUSEUMS AND GALLERIES

In this pioneering book, Christopher Whitehead provides an overview and critique of art interpretation practices in museums and galleries. Covering the philosophy and sociology of art, traditions in art history and art display, the psychology of the aesthetic experience and ideas about learning and communication, Whitehead advances major theoretical frameworks for understanding interpretation from curators' and visitors' perspectives. Although not a manual, the book is deeply practical. It presents extensively researched European and North American case studies involving interviews with professionals engaged in significant cutting-edge interpretation projects. Finally, it sets out the ethical and political responsibilities of institutions and professionals engaged in art interpretation.

Exploring the theoretical and practical dimensions of art interpretation in accessible language, this book covers:

- the construction of art by museums and galleries, in the form of collections, displays, exhibition and discourse;
- the historical and political dimensions of art interpretation;
- the functioning of narrative, categories and chronologies in art displays;
- practices, discourses and problems surrounding the interpretation of historical and contemporary art;
- visitor experiences and questions of authorship and accessibility;
- the role of exhibition texts, new interpretive technologies and live interpretation in art museum and gallery contexts.

Thoroughly researched with immediately practical applications, *Interpreting Art in Museums and Galleries* will inform the practices of art curators and those studying the subject.

Christopher Whitehead teaches Museum, Gallery and Heritage Studies and runs the Art Museum and Gallery Studies postgraduate programme at the International Centre for Cultural and Heritage Studies, Newcastle University, UK. He has substantial experience of developing interpretive resources in museums and galleries and is the author of numerous books and articles in the field of museum studies.

INTERPRETING ART IN MUSEUMS AND GALLERIES

Christopher Whitehead

Routledge
Taylor & Francis Group

LONDON AND NEW YORK

First published 2012
by Routledge
2 Park Square, Milton Park, Abingdon, Oxon OX14 4RN

Simultaneously published in the USA and Canada
by Routledge
711 Third Avenue, New York, NY 10017

Routledge is an imprint of the Taylor & Francis Group, an informa business

British Library Cataloguing in Publication Data
A catalogue record for this book is available from the British Library

Library of Congress Cataloging in Publication Data
A catalog record for this book has been requested

ISBN: 978-0-415-41920-8 (hbk)
ISBN: 978-0-415-41922-2 (pbk)
ISBN: 978-0-203-14561-6 (ebk)

Typeset in Garamond
by HWA Text and Data Management, London

MIX
Paper from
responsible sources
FSC® C004839
www.fsc.org

Printed and bound in Great Britain by
TJ International Ltd, Padstow, Cornwall

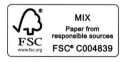

CONTENTS

FIGURES

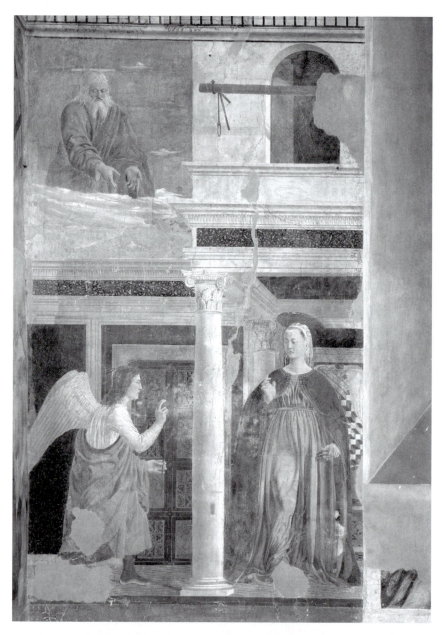

FIGURE 0.1 *Annunciation,* from the *True Cross Cycle* (fresco), San Francesco, Arezzo, Italy, completed 1464 by Piero della Francesca,(c.1415–92). Image courtesy of Bridgeman Art Library.

FIGURE 0.2 *Autumn Rhythm*, Jackson Pollock, 1950. Image courtesy of the Metropolitan Museum of Art and Scala Archives. ©Photo SCALA, Florence.

PREFACE

Looking at art is a true excursion into alien sensibilities …
(Kesner 2006: 10)

Every year I play a game – the 'alien game' – with my postgraduate art curatorship students to evaluate the notion that art 'speaks for itself'. Try it out. Take any work of art and put yourself in the position of someone faced with an entirely alien representation. Imagine that you can strip away almost all but the most basic of your own human cultural baggage. Look at Piero della Francesca's *Annunciation* (Figure 0.1) (please forget for a moment, in the spirit of the game, that it is part of a fresco cycle in a church and is hard to see in isolation except in reproductions). What, in terms of representation alone, does it suggest? That people can be cut off at the waist and can float on clouds? Or, perhaps, as Michael Baxandall (1972: 36) once pointed out, that the column might be an object of devotion? Repeat with a Jackson Pollock painting from the 'Autumn Rhythm' sequence (Figure 0.2), where from a basic cultural perspective we need to know about western understandings of the seasons and the concept of rhythm. Repeat again with the 2000 ink-jet photograph by Tracey Emin, *I've Got It All* (Figure 0.3). What is going on here? Is the female grasping money (assuming we understand it as such) to herself or is it to be supposed that she is issuing it? There are all sorts of cultural data that we need to know in order to interpret this to mean… you decide what! (Are the image's ambiguity and the multiplicity of possible interpretations part of the meaning and intent of the work?) What now of the place of these images within human society? What do they do? What and who are they for? Why do they exist?

Revert to your human self and drop the fantasy. Now ask: why, for whom and how should museums seek to answer these questions?

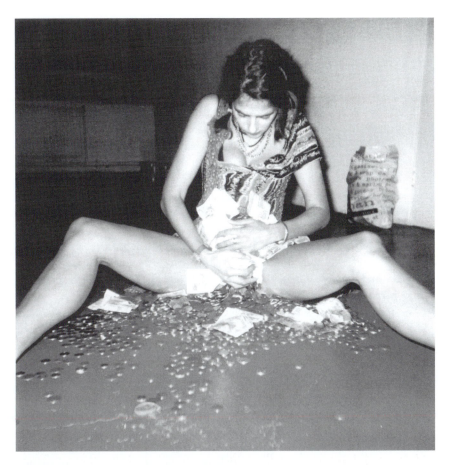

FIGURE 0.3 *I've Got It All*, Tracey Emin, 2000. Image courtesy of the artist.

This book offers a study and a critique of contemporary cultures and practices of art interpretation in museums and galleries. It is not a manual and does not belong to the body of literature interested in providing guidelines for the production of interpretation according to notions of good or even 'best' practice (e.g. Serrell 1996), or to that concerned with the understanding of the grammatical and semantic workings of text writing (e.g. Ravelli 2005). However, my observations, arguments and opinions will, I hope, prompt reflection among those involved in the production of art interpretation, and this reflection alone may form a space of influence of some kind, be it positive or negative.

One of the problems encountered in framing a book like this is the setting of parameters, for in some senses there are no identifiable start- and end-points to interpretation. Interpretation is not just the label on the wall, but everything which precedes, surrounds and follows its production and consumption: it can be every

intellectual and political act governing the ingress of an object into an art museum, into the category of art and into regimes of value and significance; it can extend into the experience of the viewer, not just for the time it takes to read the label, but as a long event for the rest of her life, even if the memory of it appears to fade or lie dormant.

There are also institutional distinctions made which problematise the object of my focus, for example in the ways in which relationships and differences between concepts like 'interpretation' and 'education' (or sometimes 'learning') are embodied through the establishment of different departments and different personnel (sometimes differently trained) to deal with them. Conventionally, curators with their expert knowledge of art and art history have been responsible for the production of interpretation, both through organising displays as discursive projects and, within this, through the development of text interpretation such as labels and panels. Education practice in art museums has developed along a separate trajectory, primarily involving the design and running of events such as practical art workshops and lectures and talks, sometimes involving artists, art historians (including 'docents' in the US) and curators. But such events inevitably involve processes of interpretation, just as 'curatorial' interpretation works as a didactic project.

We could argue for a distinction between, on the one hand, the fixed, static interpretation associated with display, bringing with it a one-way transmission of information from institution to visitor, and, on the other hand, the 'live' interpretation involved in events and the possibility of dialogue and interaction they provide. But this distinction does not account well for practice today, where some institutions have recast their warding staff as interpreters, available for conversations with visitors; where 'multivocal' digital interpretation within displays gives voice to artists and other commentators much as an organised lecture might have done; and where forms of audience participation are explored and encouraged (Simon 2010). It is this collapsing of boundaries between the interpretive work of curators and educators in the art museum which has led to cross-departmental approaches to interpretive planning and even, in a few larger institutions, to the emergence of specialised departments or professional figures responsible for overseeing interpretive practice. This is a recent and not yet fully widespread development, involving a move away from an older model of practice in which curators would develop displays and exhibitions independently from education and learning staff, who would then be expected, after the fact, to design a complementary events programme as an 'extra'.

Control over interpretation planning and production is still (in my experience) closely contested by professionals of different denomination and purview in many institutions, but as I have indicated there is also (at the time of writing) an important shift towards co-ordinated practice in which interpretation and learning are part of a single but multifaceted and multimodal intellectual project of visitor engagement. While I am concerned to recognise this shift and to welcome it, for reasons of space this book will concentrate on 'in-gallery' interpretation (this may include 'live interpretation') rather than organised events such as talks and workshops, although I claim the right to draw upon the latter occasionally where they give special understandings of interpretive planning and processes. I am also concerned with what

Falk and Dierking have termed 'free-choice learning' (2002), and not with the ways in which art museum interpretation might function within school or other curricula. My focus on 'in-gallery' interpretation also removes from view the complex roles played by art museum websites today, or applications for mobile technologies such as smart phones, in forming highly complex interpretive frameworks which enrich and complicate museum communication and, potentially, museum epistemology, as well as allowing for the dimensions of the visitor experience to change radically – consider for example the 'Encyclopaedia Smithsonian: Art and Design', an enormous repository of image galleries, collections databases, blogs, commentaries, games, interactive artistic activities and forums. I do not wish inadvertently to ignore the significance of these areas or to disconnect them disingenuously from other aspects of interpretation. However, my impulse towards presenting an encompassing and holistic view of interpretation must be balanced here against the practical need to write a book of normal size but at the depth which I want to achieve, to be published and read while it is still useful and current. In general, my discussion of new digital technologies and their potential for interpretive practice is not extensive; this pertains to my own lack of expertise in this area, and while I regret this and want to rectify it, it does mean that this book can function as a critique of relatively established practice while leaving open the field for future work on digital interpretation resources (see Parry 2007 and 2009, Tallon and Walker 2007 and Cameron and Kenderdine 2010 for recent work).

So, for my purposes here, 'the production of art interpretation' includes the manipulation of the physical display environment (e.g. exhibition design and lighting) and the development of supporting materials such as text panels, labels, audioguides, interactives, audiovisuals, and so on. These comprise what can be termed *environmental* and *verbal* registers of interpretation, and are presented in a model of the museum visit (see Figure 0.4), which emphasises the relational

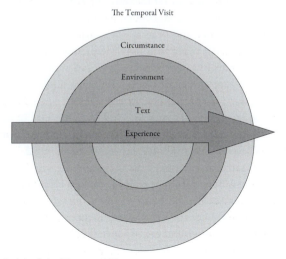

FIGURE 0.4 Model of the Temporal Visit

importance of: (1) the circumstances of a given visit – e.g. visitors' social interaction, affective state, time available, prior knowledge and attitudes, and so on; (2) the visit environment – lighting, graphics, use of space, and so on; (3) textual materials – from labels to digital units; and (4) visitor experience, which is temporal, responsive and cumulative, and traverses the other registers. Text production makes up one of two main curatorial registers of interpretation; another register is constituted by the environmental factors which act within the process of mediating between artwork and visitor. Environmental factors are varied, including for example: the physical readability of labels; the lighting; the colours and textures of walls, ceilings and floors; the ways in which objects are grouped; the presence or absence of museum furniture (cases, seating, barriers, and so on) and its design, and so on. All of these factors and more are controllables, which can be manipulated (however consciously) by museum staff in order to create and convey meanings and messages about individual artworks, groups of artworks, and art itself.

There is a third register, which is not, properly speaking, curatorial. It is based upon the emotional and personal contexts and vicissitudes of the visit. Many factors affect the visitor's interpretations of art and artworks here: is the visit solitary or in company? Was it planned or casual? Who decided that the visit would occur? In what frame of mind or mood was the visitor? What personal and intellectual histories does the visitor have? One could proceed further, considering, for example, what might be the impact upon the visitor's interpretation of the artworks on display of her or his experience of an awkward staircase, of unpleasant lavatory or baby-changing facilities, of a reprimand from a member of the custodial staff, or of a nice cup of tea in the café.

The relationship between these three registers of interpretation – experiential, environmental and textual – to the visit can be modelled as shown in Figure 0.4. The visit traverses all three registers (indeed, visiting is a temporal process). The experiential register is, in my view, by far the most influential, and the textual register the least influential, indeed, factors embedded within the experiential register such as background, cultural capital, the time at one's disposal and so on may actually determine whether any engagement with text interpretation takes place at all, and, when it does, may determine its extent and nature. For example, a lone parent visiting with a toddler may find himself unable to dedicate much time to reading labels, and may find that taking the onus of interpretation on himself is a more fruitful way to engage with art on display together with his child – to the benefit of each, for the parent is able to engage with art and provide intellectual and social stimulation for the child, who is less liable to become bored and difficult to control. Further examples can be considered in relation to cultural capital: individuals may feel unequipped to read and understand text information, especially where its language and/or content require some specialist knowledge, and may therefore not engage with it; conversely, a professional art historian may well feel that engaging with text interpretation will add little or nothing to her understanding of a given work of art.

All three of these registers must be borne in mind when managing and using interpretive technologies. And even though curators only really have significant levels

of control over two of the registers, namely environmental and textual interpretation, an understanding of the great diversity of possibilities in the circumstances and experiences of people's visits is necessary for inclusive interpretation practice, which this book presents as an ideal – albeit one which is never fully attainable – towards which art museum professionals should work.

The presence of interpretive acts in other museum activities, such as collecting, documentation and conservation, will be acknowledged but not explored in full depth for reasons of space. We must also be careful when splitting acts of production and consumption or pitting them against one another. In this sense, my understanding of 'interpretation' enfolds both curators' production, and visitors' consumption, of knowledge. But this dualism can be collapsed in the light of debates about agency and authorship. In the museum context these consider how interpretation can also be seen as a co-construction in which individual visitors are agents, responding unpredictably to curatorial interpretation and developing their own understandings, which may differ from those intended by curators (Hooper-Greenhill 2000: 4).

This book is interested in practice both at art museums which are designated thus in law or statute and with publicly-funded galleries which do not aspire to be museums by dint of having no collection. The nomenclature can be confusing: the National Gallery in London is a museum, for example, while technically speaking BALTIC Centre for Contemporary Art in Gateshead, UK, with no collection and a changing programme of mostly contemporary exhibitions, is not. But the two organisations share a public obligation to display and interpret art, and it can be argued that even a temporary exhibition programme works as a form of collection when surveyed retrospectively from the present, even if the works shown are materially removed or destroyed when exhibitions close. This museal operation is all the more evident when an organisation cares for its own history (as BALTIC does), and archives collected documents and traces of exhibitions past. For this reason – for these similarities – and for the purposes of brevity, I will talk of art museums to include institutions which have not been designated as such in law or by professional accreditation. Sometimes it will be instructive to look at the use and display of art in other types of museums, notably social and civic history museums; there is also a developing tradition of exhibiting contemporary art in science and ethnography museums, amongst others, which can lead to interesting interpretive practice (not least because the interpretive value of the artwork itself comes to the fore as different knowledges are brought to bear upon each other). Some more parameters though. First, I am not concerned here with commercial galleries which have no particular interpretive obligation to any audiences without an immediate stake in the commercial economics of the artworld. Second, my study is not intended to be a comprehensive overview of practice: it is based on experiences and encounters I have had in my travels around Europe and North America. I have not been able to visit and write about every institution with interesting interpretive practice, nor would it have been feasible or ecologically responsible to do so. I have also limited myself primarily to the study of interpretive practice in English, even if this includes non-Anglophone countries like Italy and the

Netherlands where there is a substantial production of interpretive materials in English (although in one instance I have translated some of the interpretation that serves as an example). Third, it is possible to identify things as art in many places, and not just in museums and galleries or in the form of objects and performances designated and designed as 'public art': art can be seen to be at work in the shaping and fashioning of our environment, from parks, gardens and urban spaces to buildings, and perhaps also in many intangible cultural practices (I leave to one side the vexing question of whether animals other than humans produce art). Such things can be interpreted as art too, and this has ramifications for the ways in which historic sites and practices are managed and presented outside the museum and *in situ*. This is too imposing and important a topic to be dealt with here with an already vast terrain to cover, for it deserves more attention than I can give it; but it is important to point to this as a significant epistemological issue to be engaged with, as part of an intellectual project concerned with the understanding of our relations with the world and with ourselves.

Also, although the book is primarily concerned with the production of interpretation (noting the caveat advanced above about the production/consumption dualism), it will involve some limited discussion of the ways in which visitors interpret art. The book's main aims are: to consider the importance and role of art interpretation in museums and galleries from historical, philosophical, sociological and practical viewpoints; and to review practices and problems of interpreting historical and contemporary art, with particular references to very recent interpretive initiatives which involve relations with contemporary issues in scholarship, theory and politics.

This book is premised upon the notion that interpreting art is an important political act. It is not merely the explanation of art. Rather, interpretation is one of the technologies of the construction of art as a category of material culture (that is, where the 'art' takes material form) and experience. This means that we should take art museum and gallery interpretation seriously. In its many forms (institutional, architectural, audiovisual, textual, and so on) it is a means of identifying art and producing and reproducing discourses of art: what counts as art and what does not? Why? What is art for and what is art good for? What art is good, and why, and who says? How can art be subdivided into types, media and genres? How should one engage with art and what should the experience(s) be? How should we know, and know about, art? These are political questions with relations to philosophical, psychological and sociological ones concerning the nature of our relationships with the world, our subjectivities, the nature of affect and the construction of knowledge. My position in this book is in broad alignment with Pierre Bourdieu in critique of transcendental claims for (high) culture, which sees the production and consumption of art not as innocent or pre-political (Bennett *et al.* 2010: 10); I also write as a moderate social constructionist adopting a critical realist approach, which is to claim 'that there is a real world, including the social world, which exists irrespective of whether or how well we know it', and recognises that 'natural and social worlds differ in that the latter but not the former depends on human action for its existence and is "socially constructed"' (Fairclough 2010: 4). There is a question about whether

art belongs only in the social world or whether it also has an existence in the natural world – a question of interest to philosophers, evolutionary biologists and all those who claim that art can be produced and consumed irrespective of political relations, and may indeed involve intrinsic benefits (sometimes expressed as 'art for art's sake'). I will not attempt to answer this question, but I am most of all concerned to emphasise the importance of social processes, including museum action, in the construction of art and the fact that what counts as art may be incomprehensible to many visitors if it is not interpreted carefully and generously.

Museum discourses of art are also inextricable from the politics of government. Public institutions in particular do not form some kind of an aesthetic space outside the relationships between polity and people. Recognition of the fallacy of the neutrality of gallery space is a commonplace now: the gallery is not, and never was, a value-free location like a transparent architectural frame for transcendent objects, and to go there is not to leap into some alternative pre-political reality of aesthetic contemplation and reverie, some place of 'refuge' from the world (contra Cuno 2003: 73). Public art museums and galleries are involved in the regulation of social and intellectual life, in the construction of culture and the iterative, continuous development of values, ideals and identities. In some ways, this was well known during the early growth of public art museums in nineteenth-century Europe, where managed exposure to high culture served (at least in the minds of policy makers) to engender the 'moral improvement' of citizens and new electorates. It is no less obvious now, when art interpretation is still enfolded in debates about inclusion and exclusion, access and elitism. This is because of the high cultural status of art, a result of centuries of discursive work, which means that knowledge of art is (still) a mark of social distinction, and ignorance of art can incur in people a sense of cultural inadequacy and even social anxiety.

Andrew McClellan has suggested that the politics of the museum have changed, such that museums can no longer be seen as the 'engines of bourgeois assimilation' which they were in the nineteenth century (2008: 7), for today 'wealth matters more than breeding, taste or education, [while] conspicuous consumption – of property, designer couture, or sports franchises – carries more weight than patronage of arts and museums' (2008: 8). In this sense the elitism of the art museum could be seen to matter less, and indeed such elitism has been somewhat celebrated by critics like James Cuno, who doubts that museums should seek to be accessible to everyone and should serve their primary audience – really a middle-class one (Cuno in McClellan 2003: 36–7). Should we then cease to harbour the utopian expectation that everyone should be able to access, and benefit from, art and art interpretation in the art museum? This is a question which concerns personal political and moral convictions. My own view is that there is no good reason to perpetuate publicly-funded structures of exclusion, irrespective of who visits; nor is there any reason to force people into the museum. But it is only by making the museum an inclusionary space and an inclusionary concept that visiting patterns will change, and these are long and slow processes which are a long way from full realisation. An inequality does not cease to matter simply because it is ignored for the moment by some of those on either side of it.

The cultural status of art is also a source of tension, for it is often at odds with people's understandings of value and worth. This explains some of the defensive indignation and ridicule which some contemporary art prompts, sentiments encouraged by professional communities in the media interested in stoking latent popular fears of undisciplined intellectual anarchism. The oft-heard derisive evaluative statement 'a three-year-old could do that' is an expression of non-identification with an ethic of production not governed by conventional notions of skill, hard work and (sometimes) morality, and identifies a fault line between people's personal values and social discourse about the transcendent worth of art. It is an expression of cultural non-belonging and exclusion, whether voluntary or not. It represents unfamiliarity with institutional codes.

It should be evident by now that a key position of this book – an ethical position no less – is that public art museums and galleries should provide the intellectual and metacognitive means for wider audiences to understand such codes or, to put it another way, to read the cultural map delineated in and through gallery space. This may seem an obvious and uncontroversial position to take, some decades after the advent of the 'new museology', in an age where 'access' is a widespread concern (but is it really?) and when visitor numbers are, for many institutions, key performance indicators which influence funding received. However, in my experience of working in and around, and visiting, art museums and galleries I have come to the view that accessibility is an ideal which, while it may inspire laudable discrete initiatives (especially those developed by education, learning and outreach teams), only rarely influences core interpretive practices in such a way as to prompt fundamental rethinkings bearing on the epistemology and cognition of art. It is important to address this because, as I have stated above, art interpretation *matters*. Its importance relative to newsworthy inequalities and violences of life today may be minor, but it is nevertheless an epistemological practice with an unavoidable bearing on social organisation, on the production of value, on questions of identity, equality, belonging and inclusion and, in the best of worlds, on the politics of pleasure.

This book is organised roughly in two unequal parts. Part I, comprising three chapters, forms a kind of philosophical and theoretical framing for the rest of the book, touching on areas of interest and practice which will be picked up again later on. It looks broadly at questions of art and interpretation and seeks to present an overview of the ways in which art museums and galleries function interpretively. They do this by identifying art and types of art, narrating stories of art and evaluating art in different ways ranging through institutional practices from accession to display (we will see in Chapter 6 that even staffing arrangements are constructive of specific interpretations of art). In the course of these three chapters some of the concerns which will be addressed in greater depth later on will be mapped out – concerns, for example, about authority, the specific cultures of interpretation which pertain to and construct different types of art (like historical and contemporary) and about the status of meaning. The dominant theoretical framework developed in Part I is that of the map, and in understanding the art museum as map we observe its operation as a technology for surveying, delineating, grouping, including and excluding (bounding

one thing from another) and naming. This exploration shows us how museum interpretation works cartographically, pulling objects into specific territories, be they geographical, chronological or epistemological, or indeed (inevitably) all three. In Part II, Chapter 4 looks at practices of interpreting historical figurative art and Chapter 5 looks at cultures of interpreting twentieth-century and contemporary art, which I maintain are qualitatively different from those relating to historical art because of matters of art practice and discourse (but at the same time the legitimacy of this difference is something to challenge). The same chapter looks at the interpretation of 'decorative art'.

In Chapters 4 and 5 a further theoretical framework is overlaid on the idea of the museum as map explored in Part I, and this is the idea of the interpretive frame. Here, specific forms of attention are directed towards artworks, each with their own types of explanatory power. They invite specific responses and throw open specific vistas, foreclosing others. The final chapter reviews the main principles of interpretation set out in this book, and points to areas of particular concern in the present and near future, concluding with some reflections of the place of interpretive practice in these times of dramatic and unsettling political and economic change. But before that, Chapters 6 and 7 focus on case studies of institutional practice, and here we will explore the different framings of art which take place and the cultures of practice which relate to this. In these cultures of practice questions of audience experience tend to be of foremost importance, and I have chosen up-to-the-minute examples in order to exemplify interpretive work in the present. I have also chosen case studies which, in my opinion, represent interesting and in different ways laudable examples of practice, each one demonstrating a different kind of commitment to inclusion. Within the context of these case studies I have spoken to a number of staff members, who represent their own perspectives and, broadly speaking, the policies and *ethea* of the institutions for which they each work. This is valuable qualitative data which allows us to anatomise processes and practices of interpretation, but it should of course be treated with the care due when dealing with the words of people who are conscious of representing their institutions as employees. My analysis of interpretive practice is therefore not of the 'fly on the wall' variety, for it is based on my own analysis of displays complemented by an open engagement with staff, who are understandably interested in representing their institutions in a positive light. In reality, my interviewees and respondents have been remarkably frank, and in any case I have sought to maintain an analytical perspective which sets practice (even good practice) in critical contexts.

While the force of local concerns and regulations means (to my mind) that no example can ever encapsulate a universal model of perfect practice, I hope that the case studies I have chosen will offer a snapshot of thoughtful interpretive work today and a panoply of suggestions for those of us engaged in thinking about and developing interpretive resources and structures in art museum and gallery contexts. The risk of moving from the abstraction of principles to the concrete specificity of practice is that this book and the ideas it represents and showcases will soon appear to be dated. For me, this risk is more than counterbalanced by the need to think

through contemporary practice and to ground analysis in this, to overcome to some degree the regrettable divisions which exist between cultures of museum theory and museum practice (when, of course, practice is always inevitably theoretical) and to recognise (albeit critically) the qualities of work done and the intellectual and political commitment of those who do it.

With this in mind I need to acknowledge the help and support of a number of individuals who have helped me in my research. These include Judy Koke at the Art Gallery of Ontario, Barbara Martin and Ben Weiss at the Museum of Fine Arts, Boston, Alistair Robinson at the Northern Gallery of Contemporary Art in Sunderland, UK and Linda Bulman, Peter Jackson, Hazel Lynn and Emma Thomas at BALTIC Centre for Contemporary Art in Gateshead, UK. I also need to thank colleagues at the International Centre for Cultural and Heritage Studies at Newcastle University, notably Rhiannon Mason, Andrew Newman, Helen Graham and Anna Goulding, who have worked with me on interpretive projects of one kind or another that have shaped my thinking, Myra Giesen, Jean Price and Alex Elwick, who kindly allowed me to share a snippet of data derived from his doctoral research in Chapter 7. I am also grateful to several annual cohorts of Newcastle University students on the postgraduate Art Museum and Gallery Studies MA programme which I run, and to the postgraduate research students from all sorts of disciplines on the Qualitative Methods module to which I contribute, who every year provide me with an opportunity for intelligent and often surprising discussion about interpreting art. I hope that these students, and others on comparable programmes elsewhere in the world, will form a core readership for this book and that at the very least it will provoke within them a critical and responsible approach to questions of interpretation within their own careers. I must also gratefully acknowledge the grant provided through Newcastle University's Humanities and Social Sciences Faculty Research Fund, which allowed me to conduct fieldwork in Boston, Toronto, Sheffield and London.

It should be noted that some of the material found in Chapters 2 and 3 is drawn – in much modified and expanded form – from an earlier essay 'Towards Some Cartographic Understandings of Art Museum Interpretation', which was my contribution to *Fear of the Unknown* edited by Juliette Fritsch, a pioneering contribution to the surprisingly small body of studies of art museum and gallery interpretation. This book, too, is intended to respond to the need for more studies in this area, not only because of its social and political importance, as argued above, but also because it is a cardinal activity of so many professionals and a key area of training for students interested in gaining access to art museum work. For these reasons I have attempted to write for a broad audience with various levels of prior knowledge, although I am sure that I cannot hope that my writing is as clear, refined and accessible as I believe art museum texts should be.

PART I
Introductory mappings

1

WHAT IS ART INTERPRETATION?
WHY INTERPRET ART?

What is art interpretation and why interpret art? The first three chapters work together to address these questions and introduce some of the principal issues in art interpretation today. Chapter 1 examines: the interpretation of material or intangible culture *as* art, examined from a philosophical and sociological perspective and in relation to the politics of personhood. Chapter 2 goes on to examine: the cultural terrain into which art is mapped and the museum's role in the discursive construction of art; and the regimes of apprehension into which art objects are disciplined through museum acts like display. Chapter 3 explores some of the intellectual consequences of the ways in which museums 'map' art, bringing into focus issues around the materialities and chronologies of art, questions of interpretive authority, inclusion and exclusion – for example in relation to trends in multivocality and the presentation of contemporary art; and finally, we explore the value to people of engaging with museum interpretation. These three short introductory chapters, making up Part I of this book, act as a broad theoretical, philosophical and historical frame for subsequent chapters, which will involve greater focus on examples of practice.

Interpreting things as art

Any talk of art interpretation is necessarily complex, for art itself is complex and practically impossible to define in itself. We may have personal convictions, more or less articulated, about what makes something art and what precludes something else from entrance into that category, but as we will see, such convictions do not readily stand up to scrutiny other than as expressions of personal identity. For many people today the ability to value something as a 'work' of art lies in the perception that certain criteria have been met in the production of that work. Commonly, these might include: the application of sophisticated technical craft skills (like drawing); close observation and possibly mimetic translation of external reality, as in a realistic portrait or landscape image; the expenditure of considerable effort; if not on the work

itself then on the build up of skills and creative abilities that led to the work's genesis; and maybe even the selection of appropriate 'subject matter'. The subjectivity and culture-specific nature of these example criteria is immediately apparent: what counts as craft skill, and what qualifies it as sophisticated? What counts as external reality and realism? What is creativity and what is appropriate subject matter?

What is also apparent is the discrepancy between such criteria and the possible manifestations of art available to the historian's gaze. Few people would expect to be able to wander into an interior and encounter a scene exactly resembling the one in Francis Bacon's 1963 oil painting *Study for Portrait on Folding Bed* (Figure 1.1), which, while it counts as a figurative painting – a translation of external reality (i.e the real, physical existence of humans and folding beds), is not intended in a thorough sense to be a *visually* realistic representation of a man on a bed as we would apprehend such a scene ordinarily through sight. Whistler's 1875 *Nocturne in Black and Gold, the*

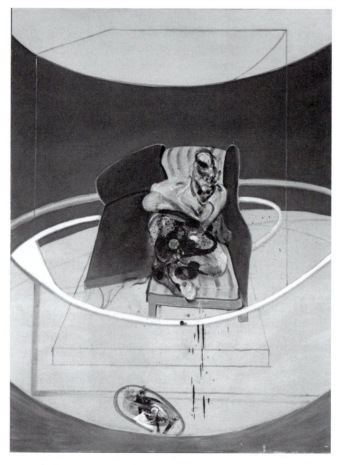

FIGURE 1.1 *Study for Portrait on Folding Bed,* Francis Bacon, 1963; image supplied by Tate Enterprises Ltd; © The Estate of Francis Bacon. All rights reserved. DACS 2011.

Falling Rocket (Figure 1.2) *is* arguably accurately realistic, but prompted an intense debate about the nature of art in the libel case brought by Whistler against the critic John Ruskin, who had criticised the artist for asking 200 guineas for 'flinging a pot of paint in the public's face' (Merrill 1992). The subtext of the criticism was that the artist had applied neither effort nor skill in his painting (necessary conditions of art for Ruskin), which Whistler later stated had taken him only two days to complete. What then of entirely abstract works, like Mondrian's later paintings, or of 'readymades' like Marcel Duchamp's 1917 *Fountain* (comprising an ordinary manufactured urinal), or conceptual works like Martin Creed's *Work No. 227: The Lights Going On and Off* of 2001 (which, in material terms, consists only of exactly what the subtitle states)? What of objects from historic non-western cultures which can be seen to involve creativity, craft skill dedication and so on, but where the originating culture had or has no concept of art and no word for it (Maquet 1986: 9)?

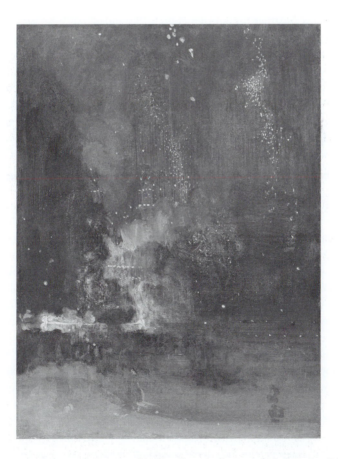

FIGURE 1.2 *Nocturne in Black and Gold, the Falling Rocket*, c.1875 (oil on panel) by James Abbott McNeill Whistler (1834–1903). Detroit Institute of Arts, USA, gift of Dexter M. Ferry Jr. Image courtesy of the Detroit Institute of Art and the Bridgeman Art Library.

One could search for some principle which unites everything that has been claimed to be art, an underlying human creative impulse, for example. But quickly it becomes evident that creativity itself is a historically contingent concept. It was not always much in demand, for example, in what we now call the early Renaissance, where the practical usability and conventionality of an image – say an altarpiece of the kind we now revere in museums – might have been much more important than any creative innovation brought to it by an artist. This is evident in some contracts for commissioned works, where creative aspects are subordinate to concerns surrounding the preciousness of materials, the elaborate frames and the proportion of work to be undertaken by the master as opposed to his apprentices (Baxandall 1972: 3–14; Welch 1997: 103–30). Indeed, Baxandall draws to our attention one commission in which questions of innovation and originality are entirely subordinated: here the Florentine artist Neri di Bicci undertook, in 1454, 'to colour and finish an altarpiece in S. Trinità' after the same fashion as one he had completed a year earlier for another church (Baxandall 1972: 8), and Baxandall's thesis is that our post-Romantic attitude to art, and to value in art, involving particular beliefs about the importance of creativity and the specialness of the artist as creator able to produce objects of transcendental significance, is fundamentally different from that of other historical cultures. This theme is taken up by Larry Shiner in *The Invention of Art* (2001) which argues comprehensively that the category of fine art is a modern invention. It also accounts for the ways in which, to use André Malraux's 1967 distinction, some objects – even non-western ones not produced as 'art' – *become* works of art by *metamorphosis* (i.e. they are taken up into the category of art through processes like their acquisition, classification and display in museums) while other objects are works of art by *destination*, in that their production took place in relation to modern discourses of art, with a view to display in a gallery setting to invite a certain type of regard (see also Maquet 1986: 18).

It is arguably the case that so far all attempts to fashion a timeless and universal definition of art in the analytic philosophical tradition have failed. In this tradition a number of competing definitions of art exist, each one confounded either by the identification of objects as art which do not fit their criteria, or by the identification of objects which, while they fit their criteria, are nevertheless not considered as art for other reasons. (For useful introductions to this see Carroll 1999, Freeland 2002, Warburton 2002 and Davies 2006.) So far, it has not proven possible to identify a condition of art which is both necessary *and* sufficient, and this makes analytic philosophy, at least for now, a tool of limited use in comprehending art definitively. What it is useful for is the comprehension of people's personal understandings of art, as the following account may show.

Some years ago, alongside other researchers, I conducted a focus group with adults who had just taken part in an artistic workshop in which they had produced their own artworks based on those they had seen in a high-profile group exhibition at BALTIC Centre for Contemporary Art in Gateshead, UK, which will be one of the case studies examined in Chapter 7. One adult – not a habitual visitor – made

the following comments, disparaging works by artists including Antony Gormley, Damien Hirst, Carl Andre and Tracey Emin:

> I think it's … I've never been in the BALTIC until today, and quite frankly … I would never come over the door, because I've heard so many adverse comments from people, half a dozen balls in a row, you know. To me, that isn't art, just balls in row, or stones or something like that or rocks. I like to come and see a painting or something …which does represent something, but I can't see anything in half a dozen balls. Cows wrapped in formaldehyde, a pile of bricks on the floor, an unmade bed, to me that isn't art …

The respondent, clearly familiar with the art she so disliked (none of which, incidentally, was in the exhibition she had just visited), was then asked why this was *not* 'art' in her view.

> Personally I like to see a painting, something which represents something, you can look and [say] 'oh well that represents a …', that the very paintings, the water colours [by artist Silke Otto-Knapp] … looked a bit like Monet's [paintings] … You know something's gone … something's gone into that, rather than just …

This participant was then challenged by another respondent who referred to Tonico Lemos Auad's *Fleeting Luck* (2005) (comprising sculpted animal forms – one a headless rabbit – made out of carpet fluff which appear to emerge from the surface of the carpet) (Figure 1.3):

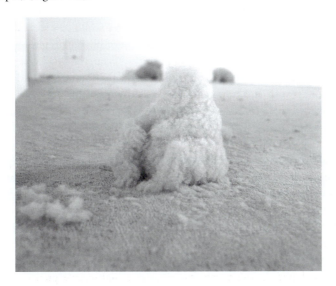

FIGURE 1.3 *Fleeting Luck*, Tonico Lemos Auad, 2005. Photographer Lisa Byrne; image courtesy of the artist and photographer. Copyright Tonico Lemos Auad and Lisa Byrne.

> I know what you're saying there ... but since I tried to have a go at the cotton wool, you know to make something like the carpet fluff, and seeing how difficult it is, you know it's really difficult, and it must have taken hours and hours of work to get that carpet fluff to look like a creature dead on the carpet there.

The first participant responded:

> Well I didn't like it, because if there'd been a head there, if there'd been a head there, it wouldn't have been so bad.

And the second:

> It was quite chilling, but I appreciated the expertise and all the time that they had used, and I think it's good craftsmanship.

In analytic philosophical terms the definition of art constructed by the first participant in the exchange can be formulated as follows:

> X is art if and only if 1) it is representational, 2) it requires craft skill and 3) it excludes subject matter seen to be uncomfortable.

Notably, this artwork responded in various ways to the first participant's criteria for evaluation: as stated by the second, it was representational and required hard work and high levels of technical craft skill on the part of the artist. However, the apparently subversive element of the artwork (the headlessness of the rabbit) nevertheless meant that the participant remained unable to decode the image, for example by accepting that the work was 'quite chilling' and, as the second participant almost did, identifying value therein (a full account of this data is given in Goulding *et al.* 2012).

This episode gets us nowhere near a universal definition of art, but it does show how definitions work and how personalised and contestable they can be. In fact, it is possible to argue on the basis of personal accounts of this kind that subjective definitions of art are closely tied to people's sense of personal identity in relation to profound questions of morality (what can be appropriately represented) and work ethics (how much work, and what kind of work, must go into an art object before it can be designated and respected as such). This is another indication of what is at stake from the point of view of social politics and the politics of personhood in the practice of interpreting art – especially contemporary art, as in this example, which brings particular problems and complexities to which this book will return. This example also exemplifies the continued currency of Romantic notions of art, as explained by Danielle Rice:

> in my experience, most novice visitors to art museums, subscribe to what may be characterized as an aestheticist position on art. They are still heavily

invested in the Romantic theory that the arts relate more to the emotions than to the intellect and therefore visitors assume that the arts constitute a universal language equally accessible to all.

(Rice and Yenawine 2002: 289)

And Philip Yenawine:

I have … heard pretty serious grousing from visitors when they come upon art that they do not understand. If they lack the option of going into galleries full of older art, both modern and contemporary art can produce a great deal of angst, if not negativity. It's not surprising: much of the art since the last half of the 19th Century has in fact been made for people with a serious commitment to art. Artists have assumed certain kinds of experience, expectations, and openness. Great numbers of people who come to museums today have no such accumulated knowledge. And it is small wonder that they are confused and often hostile when confronted with, for example, an all black canvas. But the question remains: what to do for these visitors? (ibid.)

So if art cannot be defined as a constant quantity with essential or universal criteria how can it be identified? A Neo-Wittgensteinian approach to the understanding of art stresses that there is no single criterion or property that renders something 'art', and that instead we should see art as a developing field of material or an 'open concept', in which 'family resemblances' between objects qualify them for inclusion within the category of art even where art practice itself changes in nature over time. Implicit here is the idea that few works are so innovative that they bear no resemblance to other objects already broadly accepted by many as art, and it is when that resemblance is most strained (like Duchamp's *Fountain*) that serious philosophical debate is most likely to be triggered. This is an approach which can accommodate the changing character of art, encompassing a renaissance altarpiece, an abstract painting and a conceptual installation. Ultimately, however, this approach too is flawed, for it opens the field of art too broadly to all comers. As Carroll points out (1999: 223), the case of Duchamp is one of the more illustrative: *In Advance of a Broken Arm*, a work composed of a 'readymade' – a snow-shovel – might allow for the possibility that any other snow-shovel, and indeed shovels or implements with handles of any kind, might be considered works of art.

One of the most significant attempts to break out of such philosophical binds lies in the articulation of 'institutional' theories of art, which seek to identify and define works of art not as essential quantities but as objects (in the broadest sense) which become art through the social processes involved in the practices, institutionalisation and discourses of art. In this view, there is nothing that can be identified within the object in any inherent or fundamental sense that makes it art, but its functioning within an artworld makes it such. For the art critic and theorist Arthur Danto, to 'see something as art requires something the eye cannot descry – an atmosphere of artistic theory, a knowledge of the history of art: an artworld.'

Here something is an artwork only where an art historical context is absolutely required for it to be interpreted as such (Danto 1981; Carroll 1999). This allows for a time-sensitive approach, so that what counts as art in 1964 (Warhol's *Brillo Boxes* for example, which are to all appearances indiscernible from those used as packing containers for retail) would not have counted as such a century earlier, for the art historical context at the time would not have admitted this (consider the litigation over Whistler's 1875 *Nocturne* mentioned earlier).[1] This relates also to historicist theories of art, where something becomes art if it stands in an appropriate relation to its historical predecessors, for example by dint of stylistic similarity and by inviting the same kind of regard which has become conventional for art (Davies 2006: 39–41).

George Dickie's institutional theory of art (1974; 1984) has greater prominence. In the first iteration of this he asserted that a 'work of art in the classificatory sense is (1) an artifact (2) a set of the aspects of which has had conferred upon it the status of candidate for appreciation by some person or persons acting on behalf of a certain social institution (the artworld)' (Dickie 1974: 34). Dickie later modified this assertion in response to critiques, proposing, in a purposefully circular set of definitions, that:

- A work of art is an artifact of a kind created to be presented to an artworld public.
- An artist is a person who participates with understanding in the making of a work of art.
- A public is a set of persons the members of which are prepared in some degree to understand an object which is presented to them.
- The artworld is the totality of all artworld systems.
- An artworld system is a framework for the presentation of a work of art by an artist to an artworld public.

(1984: 80–2)

Such understandings bear relation to Pierre Bourdieu's sociological approach to art as a category which is upheld as a means of social distinction. Here, some but not all members of society (a key point is that not everything is equally possible for everybody, as there are structural inequalities within society) can accrue and inherit cultural capital. This is knowledge of, and familiarity with, art and artworld codes, and social competence in circumstances in which art is at play (such as a gallery visit). In turn, one's cultural and indeed social and symbolic capital determine the extent of one's agency and power in the field of art, which is not reducible to a community but involves the relational positioning of numerous 'players', including institutions, and is overlapped by other fields such as media, education and commerce, and subsumed by the field of power (see Bourdieu 1993; Swartz 1998; Grenfell and Hardy 2007; and Whitehead 2009). To succeed in the field of art, for example in successfully consecrating something as art, with all of the benefits of symbolic and economic capital that this can bring with it, the field itself and the rules of the game must

be understood, relevant playing skills developed and one's field position must be such that it allows for effective action, much as in football (Thomson 2008: 68). In this way, not all actors have the same or similar power to achieve objectives like transforming a found object into art. I cannot pick up a random object like a pen from my desk, call it art or construe it as such and expect it to be displayed in an art museum and to be widely understood as art, because my field position is not one which would allow me to do this. Bourdieu talks more specifically about the social production of art in this passage:

> The subject of the production of the artwork – of its value but also of its meaning – is not the producer who actually creates the object in its materiality, but rather the entire set of agents engaged in the field. Among these are the producers of works, classified as artists … critics … collectors, middlemen, curators etc.; in short, all those who have ties with art, who live for art and, to varying degrees, from it, and who confront each other in struggles where the imposition of not only a world view but also a vision of the art world is at stake, and who, through these struggles, participate in the production of value of the artist and of art.
>
> (Bourdieu 1993: 261)

In Dickie's model, someone recognised by the artworld as an artist produces an object intended to be presented as art to an artworld public, which is evaluated, commoditised and presented as art through its placement in an artworld system, which is a framework for the presentation of work by an artist to an artworld public (for example by dint of its sale at auction or its display in a museum or commercial gallery). The circularity of this interlocking system of definitions and validations has been much remarked (it is, for Dickie, an instructive circularity), as has the fact that it does not account well for very earliest works of art, those of some millennia ago, where no clear 'artworld' resembling that of the present can be said to have existed (Davies 2006: 39; see Yanal 1998 for further critiques).

The purpose of dwelling on these theories and approaches is not to debunk art as some kind of philosophical fallacy, but to question and problematise its nature (something which art museums do very little) and to prompt questions about the importance of interpretation in identifying and regarding something *as* art. In one view of Dickie's institutional theory we could think quite literally about art museums themselves as institutions – a key part of the larger institution of the artworld and undoubtedly a frame of presentation for art. In this view, art museum professionals make political choices about what counts as art when they choose what to collect and/or display in museums, and in what historical relations they choose to narrativise works there. It is in these acts of interpretation involving differentiation, evaluation and narrative, I will argue later, that the artwork is 'produced'.

This is at the heart of debates about the politics of the art museum, for if the museum is engaged in the social production of works of art and indeed the social

construction of art as a concept (even a developing concept), then it is also engaged in all of the divisionary politics associated with art as a set of elite practices and discourses. Bourdieu and Darbel (1997: 112) went so far as to assert that 'in the tiniest details of their morphology and their organisation, museums betray their true function, which is to reinforce for some the feeling of belonging and for others the feeling of exclusion'. While this assertion may be too strong and accusatory for some, it is safe to say that art museums have tended to shy away from recognition of their involvement in the social politics of division except in the temporary form of exhibits or performances by artists interested in institutional critique (for example Andrea Fraser) – which is arguably an easier and more merciful way to assuage an institutional political conscience and consciousness than that offered by the prospect of a thorough rethinking of the epistemology of curatorial practice (McClellan 2008: 152; Whitehead 2009: 24). At all other times the dominant, if unspoken, discourse of the art museum is that art exists in and of itself, and that human beings are innately equipped to have fulfilling experiences in front of it which would not be possible otherwise (for biological theories of artistic practice and experience see Davies 2006: 1–4). In this view, the art museum can assume the role of facilitator of encounters – a role of noble servitude. As hinted at in the preface, I am not going to argue for or against the notion that art has a biological basis in human behaviour (for I think we cannot know), but I will suggest it is irresponsible to ignore the role of art museum interpretation in the active construction of art.

A more productive, but perhaps also more onerous, way of thinking about this from an art museum viewpoint is to wonder what is not art. Within analytic philosophy, definitions of art are sometimes critiqued as being too broad and inclusive, and opening up the category to 'non-art' or, sometimes, 'everyday' objects. From the point of view of the expressive potentials of museums, which I will discuss below, I struggle with this kind of critique and with the categorisation it involves, and for me it is hard to think of anything human-made which could absolutely not be interpreted as art. James Elkins has roundly stated that 'most images are not art', including medieval paintings made in the absence of humanist ideas of artistic value (which relates to Danto's idea, for there is an absence of an 'atmosphere of artistic theory' here) and images principally intended to convey information, such as 'graphs, charts, maps, geometric configurations, notations, plans, official documents, some money, bonds, seals and stamps, astronomical and astrological charts, technical and engineering drawings, scientific images of all sorts …' (1995: 553). In a similar way one could assert that many 3-D objects are not art by dint of their being designed for absolute functionality – an ironing board, an arrowhead or an AK-47 'Kalashnikov' rifle, for example. But equally it is possible to perceive all such images and objects with an aestheticising gaze or to redeploy them aesthetically (something that has certainly happened to the AK-47, for example in the flag of Mozambique), so that at the very least they can be pulled into aesthetic territory and perceived as art in acts of consumption. And in the conveying of information or the fulfilment of functional promise, the makers of images and objects inevitably make choices and decisions

which we might perceive to be similar to those trenchantly associated with the discourses of the production of art.

In this view, identifying things as art becomes a matter of contextualisation and interpretation, and this is a cardinal role of the art museum, which places things within the particular epistemological terrain of art according to their relation with discourse, be it visual or linguistic or both. So, if something is presented in relation with elements of discourse which have a rooted association with art, such as decoration, aesthetic effect, creative intention, and so on, then they are mapped as art within the cultural cartography of the museum. This is not the same as saying that they become art in any essential or universally agreed way. Consider the aestheticising display of popstar Kylie Minogue's famous hotpants at the Victoria and Albert Museum (V&A), a world-renowned art museum. Does the mere fact of the display of the hotpants make them art? Not necessarily, as we can understand in relation to Norman Fairclough's distinction between *construal* and *construction*:

> The world is discursively construed (or represented) in many and various ways, but which construals come to have socially constructive effects depends upon a range of conditions which include for instance power relations but also properties of whatever parts of the world are being construed. We cannot transform the world in any old way we happen to construe it; the world is such that some transformations are possible and others are not.
>
> (2010: 4–5)

In other words, the consecration of an object as art – a kind of apex of canonisation, as will be exemplified with reference to a sculpture by Michelangelo in Chapter 2 – is not achieved in one stroke by one institutional action but by what Bourdieu (1993: 81) calls the 'vast operation of *social alchemy* jointly conducted' by agents of all kinds acting over time, where arbitrary relations (between objects and categories for example, and so between a celebrity's piece of clothing and 'art') are transformed into legitimate ones (Bourdieu 1977: 195). The V&A's interest in fashion and performance and its siting of this interest alongside consecrated art is part of this long process of social alchemy, working as a developing claim for the conferral of distinguished status on objects which align problematically with accepted discourse. I have called these 'discrepant boundary objects' elsewhere in that they come to be used to explore discrepancies in knowledge and knowledge relations (Whitehead 2009: 97). Notably, a V&A curator still had to defend the exhibition and the cultural significance of its contents in the face of criticism (Fox 2007) that they were 'not worthy of the museum' (Bakewell 2007), while the museum's director, Mark Jones, was at pains *not* to construe the contents of the exhibition as art, going so far as to state that the V&A 'is not an art gallery' but rather a 'museum of contemporary and historic design' of all kinds, including that associated with celebrity culture (Teeman 2007). All of this suggests that we cannot indeed 'transform the world in any old way we happen to construe it', at least not in one fell swoop.

Fruition

If it is so difficult to identify any timeless properties of art and to define it as an entity, is it possible to characterise generally what it is that we 'get out of' engaging with art? Can we define 'fruition' in the art museum? Such questions, surely, must be at the heart of another: why do we visit art museums? Ladislav Kesner has reviewed many theoretical understandings of fruition in his study of 'cultural competence', which, in the art museum context, is 'to be able to exercise the perceptual activities that artworks require in order for a museum visit to register as a form of satisfying experience' (Kesner 2006: 2). But how does this act of requiring take place and what is the agency (if any) of the artwork in this? Kesner problematises this by pointing out that regimes of fruition have changed drastically over time (we *look* at things differently from previous generations), and continue to change now as generations who have grown up with digital media pay attention to things in ways which are ontologically and neurologically different from previous generations. There is, he goes on, 'nothing like a perfect, or canonical, viewing that works of art require; no pristine state of an ideal aesthetic vision to which people should aspire, and no ideal format of the object experience' (ibid.: 5). Nevertheless, a widespread assumption that we can benefit in some way or ways from prolonged acts of looking at and engaging with art underpins most interpretive practice in art museums, and this fuels attempts to design spaces and to produce and dose interpretation resources such as to increase visitors' 'dwell time' in front of objects, so that visitors slow down and pay more attention to them in order to derive such benefits (see for example Bitgood 2003). We will look again at these assumptions in practice in Chapters 6 and 7, and once more in a parting discussion in Chapter 8, but for now let us consider some ideas of fruition.

Discourses of aesthetic experience and fruition arguably inform the production of art museum interpretation, and it is instructive in this sense to examine the aesthetic experiences of curators, as Csikszentmihalyi and Robinson have done (1990), for these may form a kind of target for the visitor embedded within interpretive resources. Csikszentmihalyi and Robinson identify the aesthetic experience in terms of dimensions which are *perceptual* (being drawn to the visual characteristics of an artwork), *emotional* (having positive and/or negative emotional responses, which may also have a physical dimension, to artworks), *intellectual* (e.g. understanding the 'meaning' of a work and 'cracking the code') and *communicative* (engaging in 'intrapsychic' interaction with the artist) (1990: 27–71). The authors also plot the philosopher Monroe Beardsley's review of criteria for the aesthetic experience (Beardsley 1982: 288–9) against Csikszentmihalyi's own criteria for the well-known conceptualisation within positive psychology of 'flow experience' (1990: 8), a heightened state of consciousness and absorption which is intrinsically rewarding (Figure 1.4). In this view, the aesthetic experience is merely the 'flow experience' by another name.

Indeed in one sense the identification of the aesthetic experience with a flow experience may help us to understand breakdowns in the interpretation interface

Criteria for the aesthetic experience*	Criteria for the flow experience
Object focus: The person invests attention in a visual stimulus	Merging of action and awareness: Attention fixed on activity
Felt freedom: Release from concerns about past and future	Limitation of stimulus field: No awareness of past and future
Detached affect: Experience not taken literally, so that the aesthetic presentation of a disaster might move the viewer to reflection but not to panic	Loss of ego: Loss of self-consciousness and transcendence of ego boundaries
Active discovery: Active exercise of powers to meet environmental challenges	Control of actions: Skills adequate to overcome challenges
Wholeness: A sense of personal integration, leading to a sense of self-acceptance and self-expansion	Clear goals, clear feedback
	Autotelic nature: Does not need external rewards, intrinsically satisfying

* The first criterion is essential, and an aesthetic experience comprises this is addition to any three of the other criteria.

FIGURE 1.1 Beardsley's criteria for the aesthetic experience mapped against Csikszentmihalyi's criteria for flow experience

within the art museum. Csikszentmihalyi represents flow in an equal balance between the difficulty of the challenge and the skills which one brings to that challenge (Figure 1.5); if the balance is incorrect then anxiety or boredom can ensue (2008: 74). This might also work as a representation of the relationship between the visitor and the interpretation materials within a display. If the visitor is not familiar with the concepts and terminology of art history and the labels are full of cultural assumptions and technical language she may experience anxiety about her competence to meet the challenge; if, on the other hand, the interpretation materials are too rudimentary for her then she may experience boredom. The problem that we will continue to encounter, of course, is that visitors come equipped with diverse types and levels of interpretive skills, meaning that the curatorial task of pitching to visitors' needs is not straightforward. As Ingrid Schaffner suggests, any label you write 'should appeal to someone who knows more, less and as much as you do' (2006: 165).

One problem with Csikszentmihalyi and Robinson's experiment with curators, suggestive though it is, is that it ignores the importance of sociological factors such as social status, education and, in Bourdieu's terms, cultural capital and habitus – one's acquired (and not innate) ways of being in, and seeing, the world, comprising

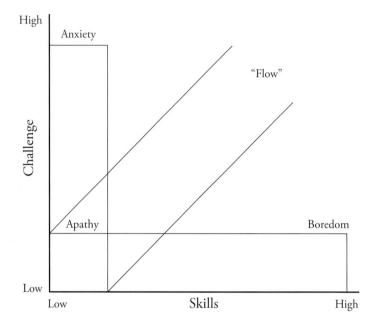

FIGURE 1.5 Csikszentmihalyi's flow experience, 2008; reproduction rights courtesy of the author and Random House Group.

dispositions, sensibilities and taste. By looking at the aesthetic experiences of highly educated north-American art curators it is not possible to generalise about universal responses to artworks. But the notion that there is a universal aesthetic experience which has physical and spiritual dimensions is a popular one that relates both to Romantic and modernist discourses of art. This is at play when we hear people talking of the experience of a heightened sense of spirituality, or physical reactions to artworks: commonly, the hairs on the back of one's neck standing on end, goosebumps, or even 'like being hit in the stomach' (in Csikszentmihalyi and Robinson 1990: 35). As hinted, there are accounts of the importance of art and aesthetic behaviour within the field of evolutionary biology, and accordingly the existence of an aesthetic experience could be seen to biological and pre-social, to be innate rather than learnt and to be a product of nature rather than nurture. But as Hooper-Greenhill comments, the 'gut response to colour, the physical response to mass, the engagement with art that is both embodied and cerebral, remains mysterious' (2000: 4).

Alternatively, from sociological and historical perspectives the aesthetic experience might be seen as a means of contributing to the construction of canons and discourses of taste, as a personal and social expression of distinction and as learned behaviour (albeit possibly naturalised and unconsciously performed) involved in identity construction processes and rituals of group belonging. From a Bourdieuean perspective, such behaviour will carry more or less social weight according to one's position within the field of art, according to one's power therein and the corollary reach of one's expression.

Some have attempted to formulate the aesthetic experience as a pre-social one, such as Ludovico Solima, who suggests that 'fruition' is a happy medium between an intellectual dimension and an aesthetic one (2000: 18). But such formulations are blighted by the indeterminacy of what really constitutes the 'aesthetic' and how, if at all, it can be distinguished from the 'intellectual'. Nevertheless, without seeking to provide an essentialist definition of a general aesthetic experience, it is possible to speculate about some of the ways in which we might benefit from engaging with art. Such speculations (for they can be no more than this) do no harm to biological accounts of innate capacity or to sociological accounts based on the hunger for distinction. The following notions of fruition are, in fact, gleaned from other writers and from many years of quizzing both participants in relevant research projects and students about what they get out of visiting art museums. They cannot, of course, be presented as comprehensive!

Art provides opportunities for a number of things. For those who engage with it in social contexts, it can provide content for discussion, a basis for social interaction and a way of understanding one's identity and that of one's companions. This social interaction may take literal form in the gallery or indeed after the visit. Or, in line with ideas associated with the relational aesthetics articulated by Nicolas Bourriaud and others in relation to 'interactive' art in the 1990s (Bourriaud 1997; Bishop 2004), a particular social dynamic may be engendered in and generated by the artwork, for, 'rather than a one-to-one relationship between work of art and viewer [as in the modernist critic Clement Greenberg's ideal], relational art sets up situations in which viewers are not just addressed as a collective, social entity, but are actually given the wherewithal to create a community…' (Bishop 2004: 54). But as Claire Bishop asks, questioning the democracy of such dynamics, 'if relational art produces human relations, then the next logical question to ask is what types of relations are being produced, for whom, and why?' (ibid.: 65)

More straightforwardly than this it can be asserted that within the interlocking contexts of personal identity and group belonging, art can provide material against which one can frame self-expression, making it a significant psychological resource (Waterman 1992). For some groups, including families, it may provide opportunities for tuition and learning and the exercise of social relations built on this dynamic. For those who count themselves as artists it provides a resource for influence, be that influence positive or negative. It may act similarly for anyone engaged in creative processes of various kinds, the principle being that the course of one's creativity may, consciously or unconsciously, be influenced in some way by someone else's creative expression (although as indicated, 'creativity' itself can be endlessly problematised). In a related theorisation, which takes fruition beyond the mere encounter between visitor and object, John Falk proposes a model in which 'each museum visit experience is the synthesis of the individual's identity-related needs and interests and the view of the individual and society of how the museum can satisfy those needs and interests' (Falk 2009: 36). He then proposes a typology of 'identity-related museum motivations' which invoke specific notions of fruition (or 'satisfaction' as Falk puts it). Museums are, in this view, 'settings that allow the visitor to play the role' or

roles of an explorer, a facilitator, an experience seeker, a professional/hobbyist or a 'recharger', roles corresponding respectively to the following motivations:

1 the need to satisfy personal curiosity and interest in an intellectually challenging environment;
2 the wish to engage in a meaningful social experience with someone whom you care about in an educationally supportive environment;
3 the aspiration to be exposed to the things and ideas that exemplify what is best and intellectually most important within a culture or community;
4 the desire to further specific intellectual needs in a setting with a subject specific matter focus; and/or
5 the yearning to physically, emotionally, and intellectually recharge in a beautiful and refreshing environment.

(Falk 2009: 63–4)

We will encounter this typology again in Chapter 6 in relation to its use in interpretive planning, but for now it can be noted that in theory all of these motivations may find a response in the art museum, which it might be argued has been particularly associated with the notion of 'recharging', as a place of escape from concern and as a place of aesthetic refuge. There is a history and discourse of this form of fruition (see Whitehead 2005: 6), but, as Bourdieu has taught us, it should be understood as a complex social behaviour inextricable from the cultural positions of visitors as complicit (whether consciously or not) within systems of social and political regulation which involve epistemological values. At heart, this form of fruition involves ideas that exposure to (good) art might have magically restorative or pseudo-medical properties.

Art also forms a resource for learning to decode visual expressions, to learn about histories, cultures and narratives of various kinds (from the mythical to the pictorial and spatial), and sometimes to encounter and respond to statements embodying political critique. Within such contexts, art can be consciously and unconsciously mobilised within auto-didactic processes, and it could be that in an individual's learning process there comes a point when accumulating knowledge of art and art history becomes its own reward, when the epistemological system of classifying, locating and comprehending art, and working to this system, becomes an object of love. In Michael Baxandall's view (to which we will return in Chapter 3), artworks involve specific demands on a viewer's discriminative skills, and the exercise of such skills and the experience of meeting the demands of an artwork are inherently rewarding. Meanwhile, to visit an art museum – at least for a sighted person – is to engage in a formal practice of sustained and concentrated *looking*, or perhaps rather for some bind of *looking and thinking* for which there are few other accepted opportunities and invitations in modern life, and which may be beneficial in ways which we have yet to imagine (for a review of the history of this idea see Kesner 2006: 6–9). The possibility of marvelling at artists' expressive skills, much as we might marvel at the speed of a famous sprinter, is also attractive in allowing us to

contemplate the extremes of human abilities. It is possible that such experiences function as welcome distractions from the day-to-day in the lives of many.

Some theorists have attempted to codify such different forms of fruition in relation to different stages of competence. One such framework is Abigail Housen's Visual Thinking Strategy (VTS), which has been influential in framing interpretive practice in various museums, notably in North America, amongst them the Museum of Fine Arts in Boston which will be examined in depth in Chapter 6. VTS is a framework of some three decades' standing predicated on a theory of aesthetic development describing 'the viewer's experience of the visual world, and specifically of visual art' (VTS 2010). Underpinned by longitudinal qualitative research, it identifies five stages of understandings, as follows:

Stage 1 – *Accountive*
Accountive viewers are storytellers. Using their senses, memories, and personal associations, they make concrete observations about a work of art that are woven into a narrative. Here, judgments are based on what is known and what is liked. Emotions color viewers' comments, as they seem to enter the work of art and become part of its unfolding narrative.

Stage 2 – *Constructive*
Constructive viewers set about building a framework for looking at works of art, using the most logical and accessible tools: their own perceptions, their knowledge of the natural world, and the values of their social, moral and conventional world. If the work does not look the way it is supposed to, if craft, skill, technique, hard work, utility, and function are not evident, or if the subject seems inappropriate, then these viewers judge the work to be weird, lacking, or of no value. Their sense of what is realistic is the standard often applied to determine value. As emotions begin to go underground, these viewers begin to distance themselves from the work of art.

Stage 3 – *Classifying*
Classifying viewers adopt the analytical and critical stance of the art historian. They want to identify the work as to place, school, style, time and provenance. They decode the work using their library of facts and figures which they are ready and eager to expand. This viewer believes that properly categorized, the work of art's meaning and message can be explained and rationalized.

Stage 4 – *Interpretive*
Interpretive viewers seek a personal encounter with a work of art. Exploring the work, letting its meaning slowly unfold, they appreciate subtleties of line and shape and color. Now critical skills are put in the service of feelings and intuitions as these viewers let underlying meanings of the work what it symbolizes emerge. Each new encounter with a work of art presents a chance for new comparisons, insights, and experiences. Knowing that the work of

art's identity and value are subject to reinterpretation, these viewers see their own processes subject to chance and change.

Stage 5 – *Re-Creative*
Re-creative viewers, having a long history of viewing and reflecting about works of art, now willingly suspend disbelief. A familiar painting is like an old friend who is known intimately, yet full of surprise, deserving attention on a daily level but also existing on an elevated plane. As in all important friendships, time is a key ingredient, allowing Stage 5 viewers to know the ecology of a work – its time, its history, its questions, its travels, its intricacies. Drawing on their own history with one work in particular, and with viewing in general, these viewers combine personal contemplation with views that broadly encompass universal concerns. Here, memory infuses the landscape of the painting, intricately combining the personal and the universal.

(VTS 2010)

These are developmental stages but they involve theories of fruition (and, notably in the instance of Stage 2, non-fruition). They are, of course, just models of complex experiences and cognitive processes (even if they are evidence-based), and here we might mention others such as the museum experience typologies developed at the Smithsonian by Zahava Doering and others (Doering 1999; Pekarik *et al.* 1999; see Kesner 2006: 4), or the Generic Learning Outcomes which were much used in the UK during the later 2000s to frame evaluations of people's experiences of museums, and in particular to provide qualitative and quantitative evidence of the transformational effect on individuals of interacting with museums (MLA 2008; Hooper-Greenhill 2007). Such frameworks are not without their critics (see for example Ritchhart's discussion of VTS and McManus' (2009) discussion of the GLOs), and one issue that we must attend to in talking of fruition is the problematic nature of measuring it with only people's verbal responses to go on. Nevertheless, they are often mobilised at the interstices of education and interpretation practice in museums, and we will see in Part II how they can influence interpretive planning.

Lastly, art provides content for vicarious experience, giving literal insights into the thought processes, perceptions, framings, opinions and expressions of others. This may provide a sense of recognition of similarity or homology between our lived experience and our perception of another's: identification, in other words. Such identification may involve vicarious insight through others' expressions which a viewer may comprehend as relevant or valuable, even where they seem a bit alien. This dynamic tension between self and other (identification and alterity) can form the basis of a 'connective' experience. Sometimes this might simply allow for a viewer's sense of a shared 'worldview' between herself and the artist in question, or even that the viewer comes to share the artist's worldview through the experience of the artwork, possibly even in the romantic sense articulated in 1945 by John Maynard Keynes, in which the artist – a special individual within society whose expressive

liberties are to be protected – 'leads the rest of us into fresh pastures and teaches us to love and enjoy what we often begin by rejecting' (Upchurch 2004).

Such an experience can function on different levels, from appreciating the way in which an artist frames and represents a landscape to sympathy for a political critique embodied within an artwork. In other cases such identification may bolster a sense of a common, universal basis to the human condition and the possibility of a generalised aesthetic experience. In other words, it can support a specific romantic discourse which endures: if it is possible to 'connect' aesthetically with an artist – possibly even a long-dead one from a remote time and place, what Csikszentmihalyi and Robinson might call 'intrapsychic' dialogue – then surely there must be a universal basis to, and a shared character of, aesthetic experience. This is one of the factors leading to tension when there is no such recognition – when what is institutionally held up as art fails to induce in an individual the kind of response described. Carter and Geczy describe this as a failure of complicity between the requirements of the artwork and the discriminations of the viewer:

> Works of Art manifest a particular combination of forms of visuality that we might term 'to-be-looked-at-ness'. The viewer, on the other hand, activates a particular mode of sight that we might term 'looking-at-ness'. We also suspect that both instances rest upon a set of highly coded activities that require a high degree of 'complicity' before any substantial interface can take place.
>
> (Carter and Geczy 2006: 152)

Here, the viewer may feel (precisely because the discourse is so strong), either personally incompetent, or that the art is bad: somewhere in the interface, there is a failing. This is where political matters return strongly to the fore and we feel what is at stake in the politics of art interpretation, of art museum discourse and of the ways in which institutionally-framed encounters with art engineer relationships of authority between museums and people.

So far, we have surveyed a variety of problems concerning the identification of things as art. We have observed the difficulties of robustly and surely identifying a discrete 'out-there' category of material and experience which is undeniably art, and I have argued that there are analogous problems in trying to establish what is not art. We have seen that definitions of art can be highly personal, and can guide behaviour and form important elements within someone's personal identity and sense of belonging. This chapter has examined just some of the problems of just some of the theoretical approaches to art and has recognised the importance of an understanding of the identification of art (which may be synonymous with its construal and sometimes, but not always, with its construction) as a social activity, working through time, power relations and institutions. The art museum, it emerges, is a key agent in determining what can count as art. In my discussion of the importance of the art museum in the identification of objects as art I am not seeking to evade the tautological bind of institutional theory. And this understanding – which is basically to say that, 'in the museum, art *can be* whatever *can be* interpreted as such (but not

everyone will agree)' – does not necessarily account for those moving experiences of affective transport, visceral effect or epiphany (and as to whether such responses are 'real' or 'learnt', or whether such a dualism obtains, can we know, and does it always matter?). But I am interested in identifying the precise nature of the interpretive agency permitted by the museum as a technology, and it is to this that we will turn in the next chapter.

2

THE CULTURAL CARTOGRAPHY OF THE MUSEUM

Museums, metaphorically and literally speaking, are not 'mirrors' and their representations are not mere 'reflections'. To produce a display in an art museum is not to hold a mirror to society, to reflect the state of contemporary art or whatever else. Likewise, the museum is no simple container in which to represent truth. In fact, there are practical and discursive relations of mutual construction, although not straightforward ones, between artistic practice, art history and museums, as explored by authors like Donald Preziosi (2003) and Hans Belting. The latter, for example, characterises the construction of 'modernist art' as:

> best described as avant-garde art reflecting the idea of linear progress, conquest, and novelty, thus testifying against its own culture as a dead and unwelcome past. Avant-garde, which as we should note, was originally a military term, made it possible to measure progress and innovation within the art context. Therefore, art history became necessary, which, in turn, needed art museums to display art history's materials and results.
>
> (Belting 2003: 21)

Rather than acting as a mirror, the museum's spatial nature, and the discursive media which can be adopted within it, structure specific kinds of articulations between objects and between knowledges. These articulations work through the actions of differentiation, narration and evaluation, all of which are themselves fundamentally interconnected (Whitehead 2009: 40), as we will see. This chapter will explore these actions and their interconnection, understood as part of the cultural cartography of the museum in which knowledges and objects (which are themselves mutually constitutive) are mapped. We will look at the consequences of this mapping for the stories of art told in the museum and for museum audiences – those imagined in the process of production and those real ones composed of visiting individuals. It has been argued that belonging to a culture 'provides us with access to ... shared frameworks

or 'maps' of meaning which we use to place and understand things, to 'make sense of the world', to formulate ideas and to communicate or exchange ideas and meanings about it' (Du Gay *et al.* 1997: 10). One of the key institutions in the creation of such shared maps is the museum, and this chapter builds on a growing body of thought concerned with the ways in which museums operate cartographically (Hooper-Greenhill 2000: 16–18; Duclos 2004; Whitehead 2009 and 2010). Both map and museum are involved, as Hooper-Greenhill observes, in selecting 'from the totality of the world those aspects that can serve to depict it through ordering, classifying and constructing pictures of "reality"', and both are technologies of authority:

> Maps are official, legitimating documents. They, like modernist museums, have the authority of the official, the authenticated. They, like museums, are not neutral, may be inaccurate, may bear little relationship to territory – the concrete that they supposedly accurately reflect. Maps and museums both bring the world into an apparent single, rational framework, with unified, ordered, and assigned relationships between nature, the arts, and cultures. Museums, like maps, construct relationships, propose hierarchies, define territories, and present a view. Through those things that are made visible and those things that are left invisible, views and values are created. These values relate to spaces, objects and identities.
>
> (2000: 18)

As noted elsewhere, however, the map is not simply a metaphor (Hooper-Greenhill, ibid.; Whitehead 2010), for the museum itself can be understood as a map (it is not 'like' a map), albeit one with different expressive potentials from those of the conventional map on a plane surface, notably the augmented scope for narrativisation. In the nineteenth century the travels of curators were a means of drawing together objects and delineating representations of the world, so that museum practice itself was concerned with travelling, surveying and encompassing territories, and this was refracted in visitor itineraries, as Rebecca Duclos notes, 'assemblages of items map out what we might call landscapes of desire – real or imagined destinations to which we can travel using objects as our symbolic guides' (Duclos 2004: 87). But the territories and geographies of the museum need not only be indexed to places with longitude and latitude; they can also be epistemological, functioning as a spatial means of separating bodies of objects and knowledge. It is to the act of differentiation implicit in this that we will turn first.

Differentiation

Differentiation is implicit in the ways in which classificatory structures are developed and embodied. It involves the identification of discrete, but not fixed or stable, categories like archaeology, ethnography, art, social history and so on, followed by sub-categories; so art subsumes 'design', 'decorative art', 'craft', 'fine art' and so on, and these subdivisions can appear, disappear and mutate over time both in relation to

discourse and as part of it. Such categories form disciplinary regimes of apprehension (including sensory apprehension), interpretation and understanding for the objects used to embody them. Political-epistemological choices are made in this context, for the same problems of definition which we encountered earlier also beset the formation of such categories, and the logics of what can be included and excluded become naturalised until they are forced into crisis by problematic boundary work. Boundary work is 'the development of arguments, practices and strategies to justify particular divisions of knowledge and the strategies used to construct, maintain and push boundaries' (Whitehead 2009) or the 'set of differentiating activities that attribute selected characteristics to particular branches of knowledge on the basis of differing methods, values, stocks of knowledge, and styles of organization' (Thompson Klein 1993: 185). The establishment and upholding of canons is one form of boundary work, for they 'create order by giving authority to certain texts, figures, ideas, problems, discursive strategies and historical narratives'. As Eilean Hooper-Greenhill describes, even the conservation and reproduction of canons in boundary maintenance is divisive, for 'some are enabled to speak and are empowered but others are silenced and marginalised' (2000: 21), recalling (but also recasting) Foucault's aphorism that 'knowledge is not made for understanding; it is made for cutting' (Foucault 1984: 88). Another form of problematic boundary work is encountered in mobilisations of objects which somehow subvert the naturalised criteria for acceptance into a given category, as with the objects associated with Kylie Minogue exhibited at the V&A, or in the vexed question of whether the work of flower arranger Constance Spry could count as 'design' by virtue of its exhibition at the Design Museum in London in 2004.

In an earlier book, *Museums and the Construction of Disciplines* (2009), I tried to account for this theoretically and in reference to historical episodes, showing how 'boundary objects' like the Parthenon marbles were, in the early nineteenth century, mobilised by different communities in appeals to different knowledges. In this way, objects like the marbles can be pulled across category boundaries to constitute 'art' or 'archaeology' (and possibly other categories too – why not ethnography, social history or geology?), according to different parties' political interests in making knowledge through embodied representations of the world. The issue of which (disciplinary) kind of museum collects or displays a given object and how it is positioned relative to other objects therein is constitutive of difference.

With disciplinary positioning comes entry into an epistemological regime – a prescribed way of knowing which informs display practices and forms of consumption – which is in dynamic relations with the development of discourse about categories of culture like art. When an object is shown focally, in dramatic lighting conditions (perhaps spotlit), in relative isolation and within a carefully designed architectural framework judged to complement the object's visual characteristics, then it is effectively being distinguished and classified as art, for these conditions of display are nothing less than codes. To borrow from reception theory, such a display also works as a 'response-inviting structure' (Iser 1978) and its characteristics act as prompts to the visitor who (it is imagined) has the cultural capital both to comprehend at a

glance its signification and to behave appropriately (the adoption of a specific kind of aesthetic gaze, circumspection in one's movements and quiet in one's speech) as a response. Things 'become art in a space where powerful ideas about art focus on them' (O'Doherty 1999: 14). The production and consumption of displays like this are structured by, but also structuring of, discourses about the specialness of art objects, their significance as opportunities for aesthetic experience, their claim to focal dominance (our undivided attention may be required) and so on. As Victoria Newhouse (2005) has shown using the example of a touring exhibition, the same objects can be shown in relation to different disciplinary regimes (or, to put it another way, with different response-inviting structures), namely those of art and archaeology, leading to entirely different epistemologies of display and entirely different ways of *knowing* something.

Narration

Narration works through representations of the relations between objects. In display, for example, objects, or suites of objects, are placed in sequence. The sequence may be explicitly chronological, to tell a literal story which unfolds in historical time (for example, the abandonment of gold backgrounds and the development of figurative ones in fifteenth-century Italian painting). Otherwise, it may form an intellectual sequence which does not index a historical chronology, but nevertheless involves a here-and-now chronology of perception and cognition, by virtue of the order in which the visitor's temporal encounter with objects is organised spatially. In this sense a narrative can emerge from the 'moments' of a topic, where a story is cumulatively constructed through the opening of new dimensions and the gradual layering of strata of interpretation. This is done through the physical and thematic grouping of objects and, very often, the written interpretation which explains such groupings. Groupings of and relations between objects work to construct objects of higher order, for example the period room is both assemblage of objects and object in itself, both in its physicality and as an object of knowledge concerning domesticity and material culture.

Evaluation

Within both differentiation and narration acts of evaluation are implicit, when the significance and merit of an object is determined relationally to others. The value of an object can be signalled in numerous ways: in display, through the character of its display, through its use within museum marketing and publicity, and even through its place in order of priority for rescue in a disaster plan.

In relation to display we can consider this in relation to the place of a specific object – Michelangelo's *'Rondanini' Pietà* within the display of the Museum of Ancient Art within the Castello Sforzesco complex in Milan, Italy (Figure 2.1). This is a significant object in accounts of art history, as Michelangelo's last work and one of his most expressive, with its elongated limbs and drastic departure from realism which, in one possible interpretation, points forward hundreds of years to the development of

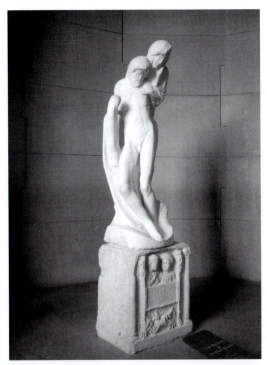

FIGURE 2.1 '*Rondanini' Pietà*, Michelangelo, Museum of Ancient Art, Castello Sforzesco, Milan, Italy; author's own photograph.

abstract form in modernity. The physical display, irrespective of the copious written interpretation, is carefully orchestrated to present this work as being of the highest order of consecration. In the museum context, consecration is the situational process in which high value is conferred upon an object through the combined interpretive acts of producers past and present, ranging from art historians who have upheld a tradition of writing and talking about the paramount importance of Michelangelo in and to the history of art, to the curators involved in the presentation of Michelangelo's work today, as well as a host of additional actors, including the producers of postage stamps, postcards and other reproductions, and travel agents who suggest to potential tourists that Italy is a good place to visit because (amongst other reasons) it contains works by Michelangelo. For Bourdieu, consecration confers 'on the objects, persons and situations it touches, a sort of ontological promotion akin to a transubstantiation' (Bourdieu 1984: 6). In the Castello Sforzesco the *'Rondanini' Pietà* is consecrated through its culminative place within the sequence of objects, its relative isolation, the furniture and scenography involved in its presentation and its situation within the spatial context of the individual room in which it is located.

The sculpture can be found at the end of a one-way circuit of fifteen rooms,[1] working chronologically from fourth-century early Christian objects, pre-designated as 'ancient art' by virtue of the museum's name, to sixteenth-century sculpture. Already with this placement the special significance of the *Pietà* is signalled, for it

operates as the most advanced expression of artistic endeavour within the historical narrative, closing the display as the culmination of over a millennium of development. Its relation to other displayed objects is dialectical, and while it is the final moment of a connective narrative it is also separated and isolated from other objects. This is achieved by means of an uncompromising cement screen – a literal 'response-inviting structure', which places the visitor in prescribed and limited viewing positions, controlling the field of vision and the textures, tone and colour against which the sculpture can be seen and hiding from view any other objects as well as the mediaeval architecture of the castle interior. Visitors move from a general scopic regime of surveying many objects together or consecutively to another of viewing a single object exclusively, where the invitation is to focus and contemplate. Behind the cement screen is a wooden one, corralling visitors into place, limiting the distance from which the sculpture can be seen and creating a theatrical space of encounter between artwork and audience. On the wooden screen itself is a bust of Michelangelo, working as a connection between the sculpture and the long-dead man, emphasising authorship and personality and cementing the relationship between artworks and the special individuals who make them. Upon entering and exiting the museum complex the visitor may notice that the *Pietà* is reproduced on the banners hung from the heights of the building's exterior, advertising both the museums within the castle and their contents and indelibly affirming the ultra-significance of the sculpture as a metonym for consecrated culture.

This extreme form of evaluation, in which an object is so strongly consecrated, necessarily does its work on relatively few objects within given museums (as I write I am reminded of my encounter with Picasso's 1937 *Guernica* at the Museo Nacional Centro de Arte Reina Sofía in Madrid, Spain, at either side of which, during my visit, stood a uniformed guard clutching a sub-machine gun). But all other objects are evaluated, too, by virtue of their relational positioning within a kind of matrix of cultural significance and, certainly in the case of art, monetary worth. The *'Rondanini' Pietà* provides an example of the interrelationship between the interpretative acts of differentiation, narration and evaluation: it is distinguished as special by the conditions of its display, which at the same time present it at the head of a narrative of artistic development and at the centre of a matrix of cultural value and significance.

One way to think analytically about such acts of interpretation – to understand, in other words, the potential of such acts for theorising about the world, or about subdivisions of it which we identify, like art – is to consider their cartographic operation, as introduced at the outset of this chapter. In this critical context the museum operates as a vast, three-dimensional map of knowledge relations, where objects are literally mapped in epistemological space. Such mappings can be double- or triple-coded too, in the spatial indexing of the geographical places and times of cultural production (as in a display of 'Dutch Golden Age painting', for example). If anything the museum is far more complex than any map on a plane surface: it has a capacity for (multiple) narratives in creating sequential orders of encounter and demanding a transitory, mobile and perambulatory gaze over fragmented relations and connections, even where some of these connections are incidental, or

the consequence of 'folds' in the museum's history such that the museum becomes 'a scrumpled geography' (Hetherington 1997: 214).

While the museum map is different from the plane-surface map in some respects, in others it is the same. The museum's representation is spatial, and indexes an out-there reality made of boundaries, divisions, territories and landmarks. It has a particular claim to accuracy and its use of 'real' objects organised by unknown authors bolsters this authority, but in effect the map is always contestable in the relations in which it places things: critically, other cultural mappings are possible – Michelangelo's 'Rondanini' Pietà could well be displayed very differently, and might be made to stand within and for quite different knowledge relations. But, like any map, the cartography of museum action has an effect on the things mapped in political terms, for it both interprets them and determines the interpretation to which they can be subjected.

This tension between the museum's questionable and contestable mapping of culture (many stories are possible but few can be told) and its authorless authority and appeal to accuracy is one which bears on questions of the status of truth in late modern society. It is a tension forever at work in art museum interpretation practices, but one which is rarely acknowledged, much less used strategically. In the next section we will consider some of the conventional cultural mappings of the art museum with a view to providing (cartographic) grounds for their contestation.

Boundaries: inclusions, exclusions

What is mapped as art? Or: what constitutes the territory of art? One of the first things to say about museum representations of art is that they have been limited in scope. Partly, this is a consequence of practical and physical questions. The landscape gardens of eighteenth-century Britain may be studied within the disciplinary confines of art history, but they are hard to place as physical objects in the museum building, at least where the museum is itself confined in a single building (other models which permit a focus on distributed objects of large scale, like the ecomuseum, have not been mobilised in relation to art). But there are also less pragmatic reasons for the relatively narrow scope of art museums, which relate to the development of artworld politics over the centuries, and particularly around the genesis of public art museums in the eighteenth and nineteenth centuries. The social politics of professional art practice and the workings of academies of art (like the Royal Academy in England, founded in 1768) produced specific hierarchies of value which were reproduced in museums, in part because the two institutions shared communities of practice and personnel. Such hierarchies were, I would argue, contingent on questions of economics and group and personal interests, and do not represent other purely 'artistic' real-world phenomena, if such things can be said to exist at all – indeed the process of evaluation and hierarchisation is inevitably social in its rationale, enactment and significance.

Here, painting and sculpture jostled for position as being of highest value in terms of moral and artistic worth, while sub-genres within painting were situated hierarchically in relation to their perceived value, with history painting at the top and

still life at the bottom (Carter and Geczy 2006: 86). Other forms such as engraving and the catch-all of 'decorative arts' (sometimes 'applied' or 'industrial' arts) were subordinated, creating what the archaeologist and material culture theorist Charles Thomas Newton called in 1853 an 'invidious line of demarcation' (in Whitehead 2009: 113). This line of demarcation still exists in the separation of bodies of material culture over different museums, or different departments within museums, and different categories. We continue to police the boundaries of art closely, guarding entrance to an only-gradually-expanding category of fine art, which no longer contains just painting and sculpture but also drawing, conceptual, video, digital, sound and installation art, but not yet quite comic book illustration, television programmes and advertisements, while objects like an Olivetti typewriter, a Robin Day 'Polyprop' chair, an early Apple Macintosh or a contemporary ceramic piece are mapped in nearby territories of 'design' and 'craft'. It is as though where it is perceived that an artwork is (even putatively) *for* something other than its own contemplation then it is not fine art (an idea with Kantian overtones). But this is to place fine art in a transcendent sphere, outside the politics of the everyday, and to ignore the clear functions which artworks have throughout history been made to fill, from liturgical objects to emblems of social distinction. This act of mapping art away from questions of function, use and the everyday is, I will argue, a key element within the exclusionary politics of art museum interpretation.

It is important here to point to innovative boundary work on the part of museums who have sought, albeit often in a short-lived way, to recognise the fact that art figures in our lives in many ways which are not represented in museums. The V&A's 'Days of Record' in the early 2000s sought to 'document contemporary fashion, style and identity, including applied and decorative arts in relation to the body' by photographing visitors who engaged in artistic practices relating to hairstyling, tattooing, carnival costume and Goth subculture (V&A). From its early inception, the Museum of Modern Art in New York has collected films, later including music videos. Tate has exercised interest in 'folk' and 'outsider' art and I have already mentioned the Constance Spry exhibition at the Design Museum – a significant piece of expansive boundary work within the disciplinary space of 'design'. But this last exhibition demonstrates what is at stake, for in the media ruckus that ensued, the complaints by influential trustees with interests in the market for objects of 'design', the museum was pushed into crisis. Again, as Fairclough (2010: 5) notes, we cannot transform the world in any old way we happen to construe it, for 'the world is such that some transformations are possible and others are not', and transformations may be limited by powerful actors with a stake in outcomes.

Interpretive narratives

What kinds of narratives have been characteristic in art museum displays historically, and what is their legacy? Let us consider just a few cardinal examples here, without pretensions to comprehensiveness (for fuller accounts see Bazin 1967; Carrier 2006; McClellan 2008, and Klonk 2009).

FIGURE 2.2 The Picture Gallery, Paxton House; image courtesy of Paxton House and Hudson's Heritage Group. Copyright Hudson's Heritage Group.

The public art museum emerged from the domestic collection in the late eighteenth and early nineteenth centuries with some evident continuities. In domestic displays (see Figure 2.2) visual narratives predominated in the creation of intricate formal connections between works based on scale, colour and composition, such that particular ahistorical affinities were identified between artworks whose display worked as an ensemble – an aesthetic object in itself where the close scrutiny of individual works was often not a priority, and could be disabled by the high placement of small paintings, or the display in niches of in-the-round sculptures. Such displays were for social elites and contained no educational agenda other than to impress upon the viewer the wealth and taste of the collector and owner.

That this model of display was unsuitable for the wider purposes of a public art museum in some instances only became clear after a lapse of some time. The National Gallery in London was founded in 1824, and in its first decades it was run by aristocratic trustees under whose management the domestic display model was simply reproduced. More didactic organisations of artworks in geographical and chronological groupings, i.e. according to their places and times of origin, became current in public art museums largely in response to political exigencies. The Louvre, inaugurated in 1793, displayed paintings with labels informing visitors of who had owned them prior to the French Revolution, while the 'chronological sequence of pictures culminating in the French school affirmed the principle of progress on which

the Revolution was founded and made clear that the future of art belonged to France' (McClellan 2008: 19–21; see also McClellan 1999). Back in London it was the need to educate and mollify a new electorate, amongst other factors, which led to the adoption of a didactic system intended to represent the development of art over time and in specific places (hence the mobilisation of topographical concepts such as 'Italian School' and chronological ones relating to periodisation). This system, based on the narrative of progress and decline (for art, in the British view, did not always improve over time but worked in cycles of quality) embodied a learnable structure and, in the form of catalogues, visitors were provided with the resources to develop metacognitively – to learn not just about the history of art but rather to learn how to learn about the history of art – through the explanation of terms and concepts. The 1847 *Descriptive and Historical Catalogue of the Pictures of the National Gallery: with Biographical Notice of the Painters* was explicitly designed for use within the gallery itself and was intended 'not merely as a book of reference for visitors in the gallery, but also as a guide to the history of painting' (Whitehead 2005: 24). By the late 1850s there was government interest in the provision of labels for artworks 'including their Date, their Subject, the Name, with the Date of Birth of the Artist, and the School to which he belonged' (Whitehead 2005: 152).

Around the same time but further to the west of London was the new South Kensington Museum, opened in 1857 after earlier incarnations. Here interpretation worked slightly differently, but was still hinged to a political agenda: this time the drive to improve local manufacture by presenting examples of 'ornamental art' to artisans, manufacturers and consumers. There were, in some instances, photographic labels showing the original physical context of an object of which a cast had been made for the museum (Michelangelo's *David* for example), an early acknowledgement of the importance of the prior contexts of artworks for an understanding of them.

Skipping across the Atlantic and forward by some decades, Alfred H. Barr articulated similar developmental schemes in relation to his pioneering work as first Director of the Museum of Modern Art in New York. His famous diagram representing the 'development of abstract art' (Figure 2.3), reproduced on the dust jacket of his 1936 book *Cubism and Abstract Art*, shows a vertical and teleological view of art history governed by causation (such as influence) and a principle of development. This was a view worked out in narratives presented in and through the display spaces of the museum, for example in the exhibition of the same year, *Fantastic Art, Dada, Surrealism*; Barr noted that the museum was a 'laboratory' (Wolf 2006) – a recognition of the theorising potential of museum acts like collecting and display as a means to advance hypotheses about history. Displays at the museum emphasised the significance of the isolated aesthetic encounter between artwork and spectator, with close attention to the formal nature of display whose intellectual and philosophical foundations are not substantially different from those which we saw earlier in the display of Michelangelo's *'Rondanini' Pietà* in the Castello Sforzesco.

This primacy of the visual and the privileging of a refined, sometimes spiritual aesthetic experience in which all that interferes in the encounter between artwork

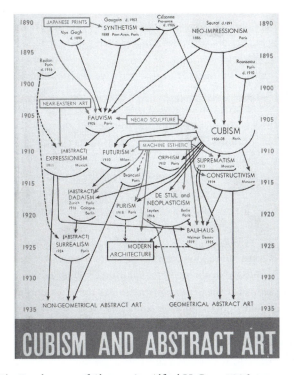

FIGURE 2.3 *The Development of Abstract Art*, Alfred H. Barr, 1936; image courtesy of the Museum of Modern Art and Scala Archives. ©Photo SCALA, Florence.

and visitor is excised came to characterise the development of the 'white cube' model, which is both celebrated and reviled in equal measure. While the term has been primarily applied to the understanding of display spaces for contemporary art, the aesthetic principles which underlie it are also obtained in other display spaces. In London's National Gallery the opulent Victorian decorations were boarded over in the 1950s and 1960s, while in the Uffizi in Florence the rooms opened in 1956 house displays of medieval religious painting in crisp white environments different from those in which the works would have been situated in their first 'life' within a church setting.

The clinical, white, uncluttered spaces of display unencumbered by all but the most minimal of texts ('tombstone' texts if any, detailing only the artist's name, the title, date and media or materials of the work), the isolation in space of art objects inviting our silent contemplation … all of these elements might be seen to efface and neutralise the gallery and to maximise the intensity of focus on what ostensibly matters: the work of art. But inevitably the physical organisation of the gallery itself constructs knowledge and is interpretive, mapping art away from everyday spaces and concerns – away from place and time – as if in an alternative dimension of pure aestheticism and pure visuality. Thus, the transcendental qualities of art are constructed discursively and the object is the portal to our contact with art as a

metaphysical encounter: as O'Doherty puts it, in his influential text *Beyond the White Cube*, which unpicks the discursive working of such gallery spaces:

> The ideal gallery subtracts from the artwork all cues that interfere with the fact that it is 'art.' The work is isolated from everything that would detract from its own evaluation of itself. This gives the space a presence possessed by other spaces where conventions are preserved through the repetition of a closed system of values. Some of the sanctity of the church, the formality of the courtroom, the mystique of the experimental laboratory joins with chic design to produce a unique chamber of esthetics.
>
> (O'Doherty 1999: 14)

He explains:

> A gallery is constructed along laws as rigorous as those for building a medieval church. The outside world must not come in, so windows are usually sealed off. Walls are painted white. The ceiling becomes the source of light. The wooden floor is polished so that you click along clinically, or carpeted so that you pad soundlessly, resting the feet while the eyes have the wall. The art is free, as the saying used to go, 'to take on its own life.'
>
> (ibid.: 15)

This is not an egalitarian aesthetic. Weibel points out that the 'myth of neutrality of gallery or museum space' explained by O'Doherty:

> constitutes a synonym for a North American and European art that conceals all social, gender, religious, ethnical differences in the name of aesthetic autonomy and a universal language of forms, thus suppressing the social, national, ethnic, religious, and gender conditions of the origin of art … In the twentieth century, the aesthetic, neutral space of the white cell became a symbol for the decoupling of what is cognitive and social from what is aesthetic, and also for exclusion.
>
> (Weibel 2007: 139–40)

As art contributes to the production of certain kinds of spaces for art, so such spaces contribute to the production of art. The cultures of display embodied in the white cube soon became inextricably embedded in cultures of production and consumption of contemporary art. In some instances this meant the production of art from within the discourse of the white cube – art intended to be displayed and regarded within this architectural and visual regime: a regime which suppresses history and time and place and denies artworks 'the right to participate in the construction of reality' (ibid.: 140), for they participate instead in the construction and reproduction of a mythic space of aesthetic reverie. In other instances artists opposed such mythology and 'made the formal, social, and ideological conditions for

the production, distribution, presentation, and reception of art, the actual topics of their art (ibid.) such that "context" becomes "content"' (O'Doherty 1999: 65–86). We will return to the white cube in Chapter 5.

These are just a few moments in the history of display and interpretation which can be scrutinised, and I cannot expect them to stand metonymically for more history than they can bear. But they do serve to illustrate a distributed but generally obtaining tendency, which is the perpetuation of discourses of art and art history focused on *objects* as a way of articulating stories of cultures of stylistic development; it obscures, as we will see in the next chapter, other histories.

3

MATTERS OF INTERPRETATION

MATERIALITY, AUTHORITY, CHRONOLOGY

This chapter concludes Part I of this book. Here, we persevere with our cartographical 'reading' of the art museum. We will consider some of the most drastic institutional mappings, notably those related to the understanding of art as a narrative of materialities rather than of no-longer tangible events (or products and processes, to put it another way) and those involved in the drawing of boundaries between historical and contemporary art. Within this, questions of authorship, authority and reception emerge which will form cross-cutting themes in this chapter. We begin by thinking about the significance of materiality for museum knowledges of art.

Art as product and process

A principal characteristic of art museum cartography is the focus of interpretation on works of art as objects which embody the history of art, a product-based approach where objects are understood as outcomes of the creative act – as products. This tends to hide from view the role of process within the production of such objects and the role of such objects in artistic and other social processes. The issue is a historiographical one about how to map art contextually. It bears on the relative merit of questions about the transcendent, transhistorical status of art or the place of art as representation of and element within specific cultural and historical moments and processes.

The sorts of questions and issues which are incorporated into a product-based approach are: who the artist is; what the visible characteristics of the work are in terms of technique and style; how they are different from those of the works of predecessors and other artists generally, or indeed from those manifest in other parts of the same artist's '*oeuvre*'; how important this object is; and how important the artist is. More recently, there has been a trend to interpret artworks (particularly historical ones) in relation to their own physicality by way of sharing discoveries made in the process of conservation and restoration activities. Here, insights about materials used and the working practice of artists can be revealed. These are all ways of mapping works within

context. Notably, some of the product-based questions which (in my experience) most commonly occur to visitors are not often answered in art museums. For example, I recently visited an art museum with a large collection of medieval and renaissance paintings in the company of a friend with no background in art history. I was surprised to see that one of the things that most frustrated her about the interpretation was that it did not help her to account for the fact that some pictures looked so different from others. In fact, the paintings she had identified as different from one another were egg-tempera paintings and oil paintings respectively, but she lacked the knowledge that these media impose different techniques and treatment, or that over time a green flesh tone becomes visible in tempera painting (very confusing at face value!), and the museum interpretation resources were not forthcoming in this regard.

Process-based approaches ask different questions, literally about the processes in which art is embedded: why was this object made; for whom; how was it paid for and by whom; what contract existed; what contingent historical circumstances existed; how was it displayed and viewed; how does all of this relate to what it represents; how does it relate to societal concerns? In short, art objects can be mapped in relation to different cultural concerns in museum interpretation, and indeed the two axes of product-based and process-based interpretation can intersect most suggestively: an obvious example might be the cultural significance of the use of ultramarine pigment in fifteenth-century Italian paintings, which, because of its cost, was often used to colour the most important parts of a pictorial composition and acted as an interpretive prompt to viewers who would be culturally primed to understand the relationship between colour, material, value and meaning (Baxandall 1972: 11). Meanwhile, contemporary perfomative artworks have the capacity to collapse the dualism of product and process, and indeed in some ways engineering this capacity works as a critique of art history.

But it is my contention that, on the whole, product-based interpretation has predominated in museums, which is both understandable and regrettable. It is understandable because museums are in possession of products in the form of artworks, and it is easiest to interpret them in relation to cultural aspects which, in the tradition of the universal survey museum (Duncan and Wallach 1980), can be objectively and visually identified *in situ*, rather than in relation to abstract connections with apparently absent cultures like patronage or worship. It is regrettable not because product-based interpretation is inherently evil (it is not), but because it can help to remove art from some of the social realities from which it emerges, and which might form (for some) readier means of comprehension than the nuances of technical and stylistic distinction and the subjectivities of value and worth. *Process*-based interpretation might function, in other words, to 'ground' art, removing it from the transcendental sphere which arguably works to exclude those visitors who have not internalised the kind of map of objective, stylistic, technical and educational relations which has structured most art historical study in the modern period and today. Bourdieu and Darbel noted that in museums 'the world of art opposes itself to the world of everyday life' (1969: 112); I suggest that process-based interpretation might overcome this obstacle to access.

Aperture

Alongside this the *aperture* of the museum text must be considered. Closed interpretation presents itself as informative rather than as explicitly interpretive. Even when there are statements of opinion – perhaps relating to subjective quantities such as style, stylistic observations – they are presented as fact or as definitive. There may be a preponderance of facts, a prescribed gaze (literal directions as to what the visitor should look at and in what order) and prescribed understandings. In qualitative research conducted at the V&A by Paulette McManus, interpretation resources which shared some of these characteristics were deemed by some visitors to be impersonal in tone and written by 'academics' unconcerned by the ease or difficulty with which their 'messages' would be received (McManus 2005: 10 and 29). In more open interpretation there may be a sense of a multiplicity of possible histories, narratives and experiential outcomes, a recognition of uncertainties and of the things that we do not actually know. There may be obvious historical uncertainties pertaining to the date of production of an object, or its historical meaning, but there are also theoretical and philosophical ones, foremost amongst which are: what is art, what can be art, what thinking processes guide us in making such decisions and how do those processes change? This recognition of uncertainty – like a cartographic recognition of unknowns – allows for the ability to open debate and dialogue with visitors, but it also cedes some of the grounds for the museum's claim to authority.

One way of 'opening' museum interpretation is the posing of questions (see Rand 1990; Litwak 1996; Hirschi and Screven 1988, and Bitgood 2003). This can be exemplified in the following example at Kelvingrove Art Gallery in Glasgow pertaining to Anne Redpath's oil painting *Pinks*:

> This painting has very vibrant colours. Anne Redpath was interested in the effects colours have on mood when they are placed beside each other. How do these colours make you feel?

This involves anticipating questions which visitors may ask themselves or each other, or which they may care to answer (it is in fact set up as a game for adults with children). It is a strategy which risks alienating and patronising those visitors who wish to ask and find answers to quite different questions. A more dialogic approach may be to invite visitors themselves to pose questions and to find some way, within the lifespan of an exhibition and/or through web resources, to answer those questions. This was exemplified at the Cantor Arts Centre at Stanford University in the experimental exhibition *Question* in which questions were elicited from visitors. Questions such as 'What is artistic quality?', 'Where is the meaning in the work?', and 'Who decides what is art, and who is an artist?' prompted staff to respond, developing displays and interactives which allowed visitors to explore the dimensions of the issues at play (Fohrman 2007). This involved recognition of some of the uncertainties and philosophical complexities of art museum work, as well as opening

out many of the processes involved in negotiating such complexities on a day-to-day basis and demystifying the art museum as a place of work and knowledge production.

Other open forms may present multiple views involving the juxtaposition of different interpretations of single objects. A pioneering experiment in interpretation in this context was the digital interface at the V&A's Photography Gallery[1] originally developed in 1998, which presented multiple perspectives on a single object, for example the 1992 dye destruction print *Invocation* by Adam Fuss, which is interpreted in diverse ways respectively by Vanessa Lowndes and Mary Connerly, two visually impaired visitors, the photographer Susan Derges and a Year 7 pupil at Shacklewell Primary School in Hackney, London. What this does is apparently to submerge the authority of the museum in a panoply of voices and to demonstrate thus that there are multiple possible understandings, each with their own legitimacy. This recognition of outsider expertise is taken further in an audioguide recording at Tate Modern in relation to Asger Jorn's 1956–7 oil painting *Letter to My Son* which, we are told, 'recalls the children's drawings that Jorn admired during his CoBrA period' (Tate website). The digital audioguide proceeds by invoking the opinions in this regard of some 'experts', who turn out to be not art curators but mothers of young children.

Such practices are indicative of a new tendency for the museum to direct a challenge to its own interpretive authority, but they can also be seen as the somewhat undesirable demotion of received knowledge, disavowing the interpretive benefits of centuries of specialist expertise belonging to curators and connoisseurs past. This demotion, it has been argued, privileges a pseudo-constructivist project to democratise the interpretation of culture within the context of the postmodern commonplace which is the denial of empirical truths. Here, all personal interpretations are seen as equally valid, a regime characterised by Cheryl Meszaros as 'the reign of "whatever"', which 'refers to the idea that individual interpretation should dominate all others'. This was, according to Meszaros' historical account, partly a consequence of a turn to the 'reader':

> This turn was precipitated by one of the gnawing polemics of structuralism: if the real interpretation of a text lay buried in the text itself, then how could people who share the same language and decoding systems produce different interpretations of the same thing? The answer came in the form of reader-response theory, audience studies, communities of practice, identity politics, and the host of 'isms' that fall within the rubric of post-structuralism. All of these agreed that meaning was dependent on the reader/viewer; it was indeterminate. This turn towards the audience was both produced and fostered by growth in consumer capitalism, which is built on individual choice, and on a political milieu that supports ideologies of individualism (from both the left and the right). All of these factors deposited final interpretive authority squarely and firmly in the hands of the individual. What do you think? Which do you like? How does this relate to you? Which would you buy?
>
> (Meszaros 2007: 17)

The actual redistribution of authority here is, however, far from straightforward, as the museum is inevitably the collector, steward and marshal of new interpretive voices.

In my view, received knowledge *should* be a part of museum interpretation, but it should not be reproduced uncritically, nor should it form the only voice in the museum's address. This is simply because the production of knowledge and the boundary work it entails are inevitably involved in the politics of power relations. For example, the genealogical representation of art history in nineteenth-century museums wherein trajectories of tuition and stylistic influence were demonstrated through chronological displays does not represent some kind of transcendent 'best way' of organising knowledge which museum professionals happened to discover. Rather, and as I have argued elsewhere, it formed an epistemological apparatus which both structured and was structured by discourses of class relations (including the pastoral/patriarchal duty of elites with respect to the working classes), moral improvement, didacticism and responsible enfranchised citizenship (Whitehead 2005). Too often the metacognitive rules of engagement rooted in such received knowledge, or, to put it in another way, the intellectual codes, are simply not explained. This works to naturalise them and leaves many visitors in a position in which they are never given ready means to learn how to learn in the art museum, much less to be alive to the multiple stories of art which are *not* being told in any given interpretation (see also Hooper-Greenhill 2000: 137). In any intellectually responsible interpretive project, the historical cultures in which received knowledge was produced need to be considered and the inevitable partiality of the cultural map it delineates needs to be borne in mind. From this reflexive and historical consideration we may scrutinise and remake received knowledge iteratively, seeking always to think through the political ramifications of such a remaking for curatorial practice, and the potentially exclusionary consequences for visitors.

One of the ways in which the invocation of received knowledge has worked most violently is the continued reluctance of many curators to produce written interpretation of contemporary art. As Robert Storr (one of the curators in question) puts it, the 'primary means for explaining an artist's work is to let it explain itself' (2006: 23). This, arguably, could be seen to form another aspect of Meszaros' 'reign of "whatever"' rooted in the assumptions of structuralism and then post-structuralism (notably the drift away from the primacy of the author first, and second from the primacy of the text, and ultimately towards the primacy of the 'reader') (Meszaros 2007: 17). It bolsters a position where neither artists nor curators are expected to impose specific interpretations of given works of art, thereby infinitely multiplying the possible meanings of, and aggrandising, such works by means of a limitless and reverential silence (a term with cartographical resonance, as we will discover later). Artists may now operate in a culture in which they do not have to expect their works to be subject to the indignity of written explanation within the gallery, while curators do not have to run the risk of offending artists, belittling their works or demonstrating their own intellectual limits by producing such explanation. Here, it is received knowledge that such freedom and ambiguity is the dominant interpretive key, and a continuous process of social inclusion (for some) and exclusion (for others)

is the inevitable result. This preserves and protects the elite social and economic order of contemporary art (an act which pays artworld dividends), while simultaneously causing feelings of cultural dispossession and self-doubt among the uninstructed, for many of whom a necessary resolution is the expression of anger at the expenditure of public money to pay for cultures of contemporary art and/or the defensive ridicule of such cultures.

As I will argue more fully in the next section of this chapter, contemporary art is not easier to understand because it is produced in our time, and yet the conventions of museum practice often dictate that historical art should be interpreted while contemporary art (however defined) should not, irrespective of the obvious truism that in one sense all art was contemporary once (in another, as we shall see in the section below, the term 'contemporary art' today involves a discursive specificity that itself forces difference). Many visitors are not possessed of the kind of internalised map of relations which might make sense of contemporary art, and the museum itself typically maps it in a space far removed from everyday life. Without access to such cultural capital, visitors' interpretations of artworks may be at best unique and highly personal, but certainly uninformed; at worst they will simply be unsatisfying, confusing and possibly disenfranchising. If it is widespread access that we wish to promote through displays of contemporary art (and admittedly for many artworld professionals this is not an objective at all) then it is time to start interpreting using more than just the architecture of the gallery and the orchestration of artworks in space. The polyvocal interpretation characteristic of recent museum experiments may have a part to play here, but so too should simple intellectual courage on the part of curators.

What is historical art? Is contemporary art different?

Chapter 1 discussed the many problems of defining art. *Historical* art is no less treacherous epistemological territory. It is, of course, immediately evocative of its apparent other: contemporary art. The dividing line between these is not universally clear and varies markedly in different critical and institutional contexts, and within this confusion the term 'modern art' is also at work, further complicating matters, for different chronological definitions of 'modern' abound. In some cases institutional practice is governed by chronological markers of one kind or another. Alfred H. Barr famously likened the Museum of Modern Art in New York to a torpedo, moving through time into the future, comprising, as Terry Smith explains, 'the works of the early moderns from Goya to the impressionists and Homer, Eakins, and Ryder in the body, with the avant-garde French and recent American, Mexican, School of Paris, and "rest of Europe" at its large nose' (Smith 2009: 30), a statement which set a precedent for a policy of deaccessioning artworks in order to remain modern, sometimes transferring works to the Metropolitan Museum of Art. By 1953 this idea of the 'transitionary' museum had failed and MoMA ceased to pass works on to the Metropolitan, deaccessioning only in order to raise funds for new acquisitions (Smith ibid.), but this still shows how one institution sought to traverse the divide

between historical and contemporary and how institutional collecting policy is historiographical in nature. Consider also the messy cartography implicit in the following subdivisions of material culture amongst just some of the national museums in London, in which convenience is fashioned out of chaotic historic relationships between institutions; in the Tate Modern website's 'about' information, time and place are mapped across different museums:

> Created in the year 2000 from a disused power station in the heart of London, Tate Modern displays the national collection of international modern art. This is defined as art since 1900. International painting pre-1900 is found at the National Gallery, and sculpture at the Victoria & Albert Museum. Tate Modern includes modern British art where it contributes to the story of modern art, so major modern British artists may be found at both Tate Modern and Tate Britain.
>
> (Tate Modern 2010)

Meanwhile, a brief web search using the search term 'What is contemporary art?' produces many conflicting definitions, commonly including: art produced after World War II; art from the 1950s onwards; the art of the second half of the twentieth century; the art of the late twentieth and early twenty-first centuries; art of the present and of the relatively recent past; 'art from the 1960s and 1970s up until this very minute'; and 'art produced in our time'. Other common descriptors include: avant-garde art; the notion of contemporary art as something specifically produced in a globalised context for a global art market, intended for display in modernist settings such as the white cube gallery; and art with a greater preoccupation with social concerns and a greater social conscience (in general) than hitherto. Terry Smith, in his book *What is Contemporary Art?*, works against a discourse of opposition to definitions: 'No idea about contemporary art', he notes, 'is more pervasive than the idea that one can – even *should* – have no idea about it' (Smith 2009: 1). He shows how contemporary art is itself produced as different narratives in different museum representations (for example at MoMA) but also stakes a claim for contemporary art's inherent distinctness ('contemporary' is not, in his view, a neutral substitute for 'modern') through the identification of current artistic preoccupations with contemporaneity itself:

> Provocative testers, doubt-filled gestures, equivocal objects, tentative projections, diffident propositions, or hopeful anticipations: these are the most common forms of art today. What makes these concerns distinct from the contemporary preoccupations of previous art is that they are addressed – explicitly, though more often implicitly – not only by each work of art to itself and to its contemporaries but also, and definitively, as an interrogation into the ontology of the present, one that asks: What is it to exist in the conditions of contemporaneity?
>
> (Smith 2009: 2)

But not all of these varying and sometimes contrasting criteria coalesce in every artwork which is dubbed as contemporary and are not all uniformly required for something to be classified as such. And of course, in determining what is contemporary, we determine what is not.

Earlier I suggested that all art was contemporary once, and by the same token it is arguable that all artworks which exist in the present are already 'historical', for they also have an existence in the past, however short that existence is in relative terms. But it is perhaps more helpful to talk about such categories not strictly in relation to time and chronology, but rather in relation to discourse, which is to say that historical and contemporary art are spoken of differently, that in this speech act the difference is constructed, and to observe that in some contexts the classifications of 'historical' and 'contemporary' involve different types of regard (with certain ideas of use and fruition in mind). More crucially, artworks may be created as it were *within* the discourse of contemporary art, specifically to invite certain types of regard, recalling Malraux's proposition that some objects are works of art by *destination*, or Baxandall's idea that artworks may be produced by their makers with a certain kind of 'exhibitiability' in mind (Baxandall 1991). They are thus built into knowledges wherein they are made to dictate the terms of one's engagement with them. They may embody ideal notions of subjectivity which encourage experiences of works as liminal and constructively ambiguous, as touched upon in Chapter 2. They are rarely presented within art historical narratives except those which they themselves bespeak (for much contemporary art is concerned with the history of art) or in relation to wider historical socio-cultural conditions (even of the immediate present) except those which they themselves bespeak in acts of social critique. Is this because they are too recent in their genesis to allow for such contextual narrativisation? Or is it based on an implicit expectation that any sentient and worldly viewer will be capable of constructing such contextual narratives for herself?

Because this difference bears upon production and on forms of interpretation it is helpful to discuss the respective interpretation of historical and contemporary art separately. But in other ways it is not helpful, precisely because it perpetuates a cartographical distinction, mapping them separately and suggesting that the same forms of regard, narrativisation and evaluation are not equally possible or at the very least not equally instructive for each, and that the same forms of contextualisation are not required. Can we not ask the same questions and hazard similar types of explanation and understanding for historical and contemporary works? There are two ways of looking at this issue, which relates to a longstanding debate in aesthetics and reception studies 'as to the degree which an Art object determines the interpretations that are made of it', against the claim that 'every encounter between the object and its spectator is a unique one, capable of generating completely fresh interpretations' (Carter and Geczy 2006: 30). First, we might argue that contemporary art is coded differently, involving specific interpretive cues which arise from its own discourse and the cultures of its own production and intended reception: a contemporary artist knows that she can rely on audiences having the cultural capital (as Bourdieu would put it) or the equipment (as Michael Baxandall would) to make sense of culture-specific interpretive

cues in her work, for example by understanding its ambiguity constructively as a cue to make personal meanings. In this argument, contemporary art *is* fundamentally different and needs to be – *has* to be – interpreted differently. Otherwise, we might argue that notwithstanding such fundamental difference it might be fruitful, heuristic and constructive to ask similar questions about works of art of all ages and from all sorts of cultures, and that doing so may help us to identify and understand such differences, and also to understand when and where differences do not obtain.

It may be argued that the shift to the contemporary occurs in interpretation when there is no implied quality of cultural difference, as if the historical culture of production and consumption of an artwork is somehow fundamentally identified as our own. This is, indeed, one possible justification for the relative absence of textual interpretation of contemporary art, for it might be assumed that we as an audience have a natural mastery of all of the cultural references necessary to understand it because it is of our own time. In this view, we have the 'period eye' as Michael Baxandall (1972) theorised it in relation to practices of viewing in fifteenth-century Italy. Today, the argument might run, a period eye enables us immediately to comprehend signs embedded within contemporary artworks without the need for help. In these passages, which I want to quote at length because they can illustrate an important principle about interpretation and distinctions between historical and contemporary, Baxandall charts the limits of universal experience of art, in an account which begins with the biological before moving towards culture, or more precisely, cultures:

> An object reflects a pattern of light on to the eye. The light enters the eye through the pupil, is gathered by the lens, and thrown on the screen at the back of the eye, the retina. On the retina is a network of nerve fibres which pass the light through a system of cells to several millions of receptors, the cones. The cones are sensitive both to light and to colour, and they respond by carrying information about light and colour to the brain.

> It is at this point that human equipment for visual perception ceases to be uniform, from one man to the next. The brain must interpret the raw data about light and colour that it receives from the cones and it does this with innate skills and those developed out of experience.
>
> (1972: 29)

He goes on to exemplify this, bringing out the relationship between production and reception – the embedding into an artwork of an invitation to engage in certain types of regard, or as Wolfgang Iser would put it, a 'response-inviting structure' (1978: 34). A picture, Baxandall notes, 'is sensitive to the kinds of interpretive skill – patterns, categories, inferences, analogies – the mind brings to it':

> A man's capacity to distinguish a certain kind of form or relationship of forms will have consequences for the attention with which he addresses a picture. For instance, if he is skilled in noting proportional relationships, or he is

practiced in reducing complex forms to compounds of simple forms, or if he has a rich set of categories for different kinds of red and brown, these skills may well lead him to order his experience of Piero della Francesca's *Annunciation* [Figure 0.1] differently from people without these skills, and much more sharply than people whose experience has not given them many skills relevant to the picture. For it is clear that some perceptual skills are more relevant to any one picture than to others: a virtuosity in classifying the ductus of flexing lines – a skill many Germans, for instance, possessed in [the fifteenth century] – or a functional knowledge of the surface musculature of the human body would not find much scope on the *Annunciation*.

(1972: 34)

Baxandall's account can easily be extended to help us to think about the relationship between production and reception of objects designed as contemporary art, which is to say, objects produced from within the discourse of contemporary art. Such artworks, simply put, appeal to notionally shared interpretive skills which may concern visual characteristics such as form, colour and composition but which more often than not concern concepts and their relations to other cultural data, including the place of an artwork within or in relation to artistic traditions – our ability to make connections between things. We (or more precisely, some of us) are able to 'read' Tracey Emin's *I've Got It All* (Figure 0.3) in relation to things which are ostensibly absent from the image – perhaps in relation to consumer cultures, cultures and histories of the representation of women, contemporary notions of possession, happiness and success, perhaps to Emin's own well-known biography and also to the cultures of interpretation and meaning making associated with contemporary art, in which meanings can legitimately be personal, multiple and indeterminate. For Baxandall this is tantamount to an account of taste, which is, in this context, 'the conformity between discriminations demanded by a painting [or, in my extension of this argument, a contemporary artwork] and skills of discrimination possessed by the beholder' (1972: 34). This in turn becomes an account of fruition, not dissimilar to Csikszentmihalyi's balance between challenge and skills:

We enjoy the exercise of skill, and we particularly enjoy the playful exercise of skills which we use in normal everyday life very earnestly. If a painting gives us opportunity for exercising a valued skill and rewards our virtuosity with a sense of worthwhile insights about that painting's organization, we tend to enjoy it: it is to our taste.

(ibid.)

If, as L.P. Hartley said in 1953, 'the past is a foreign country' where things are done differently by others, then the contemporary is our country in which actions and things are ours to understand.

But here we must take caution. It is not difficult to unpick the assumptions in such discourses, to observe that with regard to the provision and character of interpretation

it is cultural difference that matters and not necessarily chronological difference; and that a contemporary artwork can be just as alien to a modern-day visitor as an Italian renaissance painting of the annunciation or a Congolese nkisi object might be; and that, because of the diversity of human experiences, the types and levels of prior knowledge that visitors bring to them must differ infinitely. Baxandall too recognises this as a problem, for it is an assumption that all contemporary people (and peoples) bring the same 'equipment' to the experience of viewing 'complex visual stimulations' like pictures or artworks of other kind (1972: 38). This is untenable, and requires a qualification bringing us back into the terrain of institutional theories of art, for in fact 'one is not talking about all … people, but about those whose response to works of art [is] important to the artist – the patronizing classes, one might say' (ibid.). This means that any implicit appeal to a universally shared period eye, or a common stock of interiorised interpretive repertoires, ultimately works rather disingenuously to exclude many visitors, bringing us back once more to the political significance of art interpretation and to the potential violence it can do.

The point of this discussion is to explore the ways in which discourse and interpretation work together (for they involve each other but they are not the same thing) to generate differences between historical and contemporary. On the one hand, production itself is involved in interpretation in prefiguring the interpretive cues to which an artwork is subject. There is a need to be sensitive to this in providing interpretive materials for the art museum, but it should not be taken to mean that strictly different interpretive regimes always have to prevail, or that we cannot benefit from interpreting historical and contemporary artworks using similar frames and practices. On the other hand, differences between historical and contemporary are reproduced in museum interpretation itself, as a consequence of contrasting assumptions about the information which viewers and visitors require in order to make sense of works of art: here, historical work is seen to be at such a cultural remove from contemporary cultures of discrimination and evaluation that explanation is required. Interpretation in this context is an exercise in both emphasising and overcoming otherness between people past and present. This does not mean that contemporary art is by definition *never* subject to explanatory interpretation (we will see in later chapters that it sometimes is), but this is still only a burgeoning practice, certainly less well developed than it is in the context of art understood to be historical, and arguably has different textual characteristics; but more of this later. For now, we can suggest that what constitutes historical art and what constitutes contemporary art is not a matter of chronology but literally a matter of interpretation which is to suggest both that interpretive cues are built into it and that it is built into specific cultures of interpretation upon which it depends for its status.

Map users

This conclusion – not just to this chapter, but to Part I of this book – will focus on visitors, imagined and real. Some years ago I undertook a subjective exercise at the Metropolitan Museum of Art in New York. What I did was try to travel through the

museum, over the space of a whole day, and to try to receive the overall message, to understand as far as I could, bearing in mind the subjectivities of my own selfhood, the general cultural map of which I could form a mental impression as a visitor subject to communication within the museum. I ignored the obvious problem with this approach – that the museum's messages are crafted by many authors and may be discrepant; rather, I tried to look at everything and read as much as I possibly could and make sense of it as a whole. While moving through time and space in the museum, or indexical time and space, I saw ancient non-western countries and material cultures introduced in some detail. Social and religious contexts were explained very clearly, as was the significance of chronology and geography. There was a lot of written text and a lot of graphic explanatory material too. I felt that I was being given the resources necessary to understand these (to me) relatively unfamiliar cultures of artistic production. As I proceeded, the post-medieval European past was less well introduced and there was less information about context. Interpretation thinned even more as I moved through time and into the modern West, into the nineteenth and early twentieth century (e.g. Impressionism) and when I reached the contemporary art galleries I found 'tombstone' labels only, providing the usual recipe of artist, title, date and media. But as a highly educated westerner of European descent, the map was clear enough to me.

Brian Harley (2002) talks of *silences* in maps, or what maps do not say. When understanding museums as maps of culture, a silence can occur because something is purposefully excluded or because it is assumed that something is obvious. In the latter case an implicit assumption about the visitor, and about visitor demographics and visitors' stocks of cultural capital, is made. There is an imagined visitor, 'the moving, seeing, reading, learning, intellectualising, behaving and feeling element in curators' visions of display spaces', a visitor whose imagined social milieu and cultural capital inform the curatorial stories told through display and how they are told (Whitehead 2009: 32) – a concept not unrelated to O'Doherty's idea of the 'spectator' (1999: 35–64). At the Metropolitan Museum of Art it appeared to me that an imagined visitor – of European descent and/or educated in the western history of ideas – was bespoken through the cartography of the museum and invoked in the balance of provision of explanatory interpretation. Whether such visitors predominate or not, I would argue that we have an ethical responsibility to serve the interpretive requirements of more diverse audiences.

This is an example of the way in which the imagined visitor informs interpretation and how no-doubt unintended, exclusionary messages can prevail through interpretative practices. But I want to finish with an account of the inclusionary power of interpretation, and here it is worth returning to that most difficult terrain on the map: contemporary art. The following stories come from some qualitative longitudinal work with people who were not familiar with contemporary art who had attended a programme of artists' talks at BALTIC Centre for Contemporary Art in Gateshead, UK (see Goulding *et al.* 2012 for a full account). The following quotations need little comment, but they show the benefits of interpretation (in this case artist-led) and the ways in which received information and individual interpretive agency

can blend to good personal effect. Incidentally, and countering the 'whatever' regime of interpretation, they also show the continued importance for visitors of artists' statements about the personal intentions behind their works.

One of the works in question was a single-screen video *Lights Go On: The Song of the Night Club Attendant* by Paul Rooney, in which a cloakroom attendant's description of her job is set to music and sung by a lead female voice backed by two other voices over static video shots of a nightclub on a Sunday morning. 'When I saw it', said one respondent, 'sort of cold, I thought I can't actually find a word to describe it but', she whispered, '*"crap"* will do.' However, she went on:

> Having then ... listened to the talk and the artist and seen it more, I actually got an awful lot more from it, from having had the opportunity to hear him speak. And I actually then went back and looked at it and thought, 'Yes, I wouldn't say this is over-the-top-fantastic-this-is-marvellous, but I did find, that having discovered more about it and more about the artist, then I could appreciate what it was, where he was coming from and what it was.

Another respondent noted:

> What I've done, is a lot of my friends and acquaintances and family members I've brought back to the exhibition. I've sort of been delighted to be able to, because of my experiences, explain to them what it is about, so it's percolated down. I met the artists and things like that so I can actually go to the exhibitions, and I felt sort of like proud, although 'proud' is not the right word. I can't really find the right word.

The last two chapters have proceeded from the premises developed in Chapter 1 to argue that art museums are constructive of objects rather than reflective of them. They function discursively in ways which are specific to the spatial and epistemological nature of the museum institution, working through actions like the differentiation and evaluation of objects (both physical ones and objects of knowledge of other kind) and the creation of narratives around and through objects. This was exemplified by a brief analysis of the display of Michelangelo's '*Rondanini' Pietà*. Such actions can be accounted for in relation to practices of cultural cartography, in which the museum can be viewed as an extremely complex map – much more complex than a map on a plane surface as we might normally think of, not least in its greater capacity for narrative. The mapping process is constitutive of the history of art in elaborating object and knowledge relations, establishing (and sometimes challenging, moving and policing) boundaries and mobilising chronologies to create different regimes of interpretation. Chapter 2 surveyed a few historical instances of such cartography, from the domestic collection through to the 'white cube', emphasising their legacy in relation to cardinal stories of art told by the art museum to this day – stories of artworks rather than artworlds, stories of products rather than processes. Such questions also bring us to consider issues of authorship, certainty and expertise, and

to pick again at the politics of interpretive cultures which work, intentionally or not, to exclude audiences. Chapter 3 has concluded with some people's accounts of what specific instances of art museum interpretation have meant to them personally. These accounts show what interpretation can do: it can unlock understandings and it can stimulate social interactions. Art museums, as discussed, engage in the cartographical activity of arranging material in physical, interpretive and epistemological space. This brings with it the elective responsibility to produce a map which can be understood by the many rather than only by the few, and which provides users with opportunities to develop metacognitively in order to make sense of the map, appreciate its emphases and recognise its silences, to grasp its internal structures and rules, and ultimately to be personally empowered to encompass and traverse new geographies of knowledge.

The remainder of this book will survey these geographies and offer suggestions as to how they might be reshaped and expanded. We will begin in the next chapter by thinking about the interpretation of historical, primarily pictorial art in museums.

PART II
Interpretive practice today

4

INTERPRETIVE FRAMES

HISTORICAL FIGURATIVE ART

Part I of this book provided theoretical, philosophical and ethical premises for the study of art museum interpretation and sought to characterise some of the major dimensions of institutional practices of art interpretation. Part II of this book aims to exemplify practice today, while enriching the theoretical framework constructed so far. In an initial pairing of chapters we will consider, through modern-day examples (modern-day, that is, at the time of writing), some of the conventional 'framings' of art which are realised through interpretation, and through which specific knowledges are enabled while others are disabled. In subsequent chapters we will engage more thoroughly with case studies of what I perceive to be cutting-edge practice, focusing on the presentation of historical and contemporary art in a number of institutions where innovative interpretive work has taken place very recently.

One important premise for this chapter, and indeed for Part II of this book, is that there are myriad interpretive 'frames' which can provide different but always partial understandings about art, and that their use in art museums is part of the production of knowledge about art and art history. As discussed by Snow *et al.* (1986) in their discussion of Erving Goffman's conceptualisation (1974: 21), frames render events or occurrences meaningful, and 'function to organize experience and guide action, whether individual or collective'; they are 'schemata of interpretation' that enable individuals 'to locate, perceive, identify and label' occurrences within their life space and the world at large (Snow *et al.* 1986: 464). As these spatial, somewhat cartographic terms might suggest, frames bear relation to the conceptualisation of the museum as a vast multidimensional map discussed in Part I. Like bounded spaces within the map, each with their own rules for representation, individual framings of objects (for example through wall or audio texts) form the means of navigation through culture. The map and the frame might seem to offer two different suggestions as to how to understand museum interpretation, but I want to present them as made from the same fabric. In my thinking, the frame acts as the constructive explanation

of the museum's cartography and the epistemological territories into which objects are pulled, much as early modern maps provided explanatory legends framed within continents, countries and seas to guide the viewer's interpretation and contribute to the construction of the world represented. Two other helpful definitions of frames follow:

> Frames are principles of selection, emphasis and presentation composed of little tacit theories about what exists, what happens, and what matters.
>
> (Gitlin 1980: 6)

And:

> To frame is to *select some aspects of a perceived reality and make them more salient in a communicating text, in such a way as to promote a particular problem definition, causal interpretation, moral evaluation, and/or treatment recommendation* for the item described. Typically frames diagnose, evaluate and prescribe.
>
> (Entman 1993: 52, original emphases)

In this sense, as Robert M. Entman explains, analysis of frames 'illuminates the precise way in which influence over a human consciousness is exerted by the transfer (or communication) of information from one location – such as a speech, utterance, news report, or novel – to that consciousness' (ibid.: 51–2). Frames have been used as a conceptual apparatus to understand the political 'worldviews' held by different groups (e.g. Snow *et al.*) or media representations: Entman exemplifies this with the 'cold war' frame that dominated US foreign affairs news until the early 1990s, which 'highlighted certain foreign events – say civil wars – as problems, identified their source (communist rebels), offered moral judgments (atheistic aggression), and commended particular solutions (US support for the other side)' (ibid.). In this book I want to adopt the concept of framing to help develop understandings of the quite different politics of art interpretation as a form of selective and ideologically informed representation or viewfinding wherein certain perspectives are enabled and others disabled. In this way we can consider how framing works within the production of art museum interpretation like wall texts, or even the way in which lighting can work selectively to focus attention on specific areas of an object while placing others in shadow. But it is also possible to understand the framing process from the perspective of the visitor. John Falk (2009) notes that a 'visitor's own prior knowledge and interests provide a frame of reference for them to make sense of what the museum contains', relating to what it is that the visitor will want to engage with (this corresponds to the first register of interpretation on the model shown in Figure 0.4), for 'decision-making in a novel setting [is] driven by prior interests', and the 'need to feel secure in an environment drives all of us to see that which is familiar; moderate novelty is quite stimulating while excessive novelty is quite disturbing'.

In this context, one practical question becomes, 'What interpretive frames exist to help to provide rewarding experiences for visitors with different levels of prior

knowledge and how, if at all, can they be reconciled?' This question recalls our use of Csikszentmihalyi's theory of a 'flow experience' in Chapter 2, and bears also upon issues relating to disciplinarity, visitor learning and presentation.

Art history as practised in the museum has tended historically to privilege certain interpretive frames – as discussed in Chapter 2, one of these is what could be termed the 'evolutionary' frame, where the primary object of analysis might be the style adopted by an artist in producing an artwork (for example pictorial style) and how this relates to those adopted by the same artist at other times in his or her life and to those adopted by his or her predecessors, contemporaries and successors. Something similar to this was described by Bourdieu in relation to the aesthetic disposition 'which tends to bracket off the nature and function of the object represented and to exclude any "naïve" reaction – horror at the horrible, desire for the desirable, pious reverence for the sacred – along with all purely ethical responses in order to concentrate solely upon the mode of representation, the style, perceived and appreciated by comparison with other styles' (Bourdieu 1984: 54). This frame creates a very specific and systematic regime of understanding which promotes knowledge about stylistic influences, relationships of stylistic similarity and difference, and individual artists' divergence from diachronic trajectories of style observable over generations of artists and successive 'movements'. We will look at examples of this in contemporary practice later on, and we will also encounter other interpretive frames whose use is entrenched in art museum practice. Alternative interpretive frames can be found in different disciplinary formations: those such as the New Art History and Visual Culture Studies which have arisen in part through a disciplinary crisis in art history (much celebrated and enjoyed in some quarters) which is perceived to have occurred primarily in the 1980s and 1990s; and those like history, anthropology, archaeology and sociology which concern themselves in different ways with visual and material objects. Can such a panoply of ways of knowing be fostered in interpretation?

An important problem here is the way in which we understand visitor behaviour and visitor requirements, and our assumptions about what and how much visitors should read and do within the gallery. This often conditions the amount, depth and type of text interpretation provided, while limiting the number of interpretive frames at play. Over the remaining chapters we will look at some different approaches to these interwoven questions of epistemology and presentation and ultimately I will suggest a rethinking of these configurations of practice. In this context, this chapter will point towards the final chapter of this book, which will be partially taken up with the question of what we expect from visitors, alongside an exploration of the significance of digital interpretive technologies capable of presenting multiple interpretive texts. These allow for the presentation of different ways of knowing, without the need to overwhelm display space with metres and metres of text panels resembling nothing less than the many pages of a book, enlarged, printed and made to cover valuable wall space.

This chapter will now begin to move downwards in focus, to examine specific examples of practice – located in specific institutions and networks of institutions

related to one another by dint of their conceptual and/or physical vicinity – which both exemplify the dimensions of the interpretation of historical art and discourses of art and art history. I want to begin by looking at the interpretation of a pair of single artworks in turn – Rubens' *The Miracles of St Ignatius of Loyola* and Tintoretto's *The Bathing* of *Susannah*, both in the Kunsthistorisches Museum in Vienna.

One painting, many possible stories

Rubens' *Miracles of St Ignatius of Loyola* (Figure 4.1) is a monumental painting designed for a large church setting. In the Kunsthistorisches Museum in Vienna it is the focus of a number of interpretive views, forming what I shall call a *complex interpretation programme*, in the sense that it involves an attempt, however imperfect, to create a conceptual whole made up of complicated and related parts or, much like a building, a superstructure made of component structures. The painting is hung alongside a much smaller preparatory oil sketch, which has status both as artwork in its own right and as supporting interpretation to the larger finished painting. There is an identification (or 'tombstone') label for the larger painting as follows:

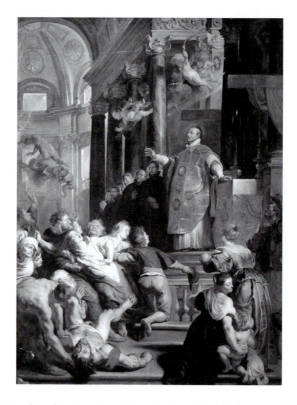

FIGURE 4.1 *Miracles of St Ignatius of Loyola*, Peter Paul Rubens, c. 1617/18; image courtesy of the Kunsthistorisches Museum, Vienna.

Peter Paul Rubens,
The Miracles of St Ignatius of Loyola
c. 1617/18
Canvas
H 535 cm, W 395 cm
GG Inv. No. 517

There is also a text label, as follows:

> Until 1776 this altarpiece decorated alternately with 'The Miracles of St Francis
> Xavier' the high altar in the Jesuit Church of Antwerp, which was built between
> 1615 and 1621 and whose complete interior was designed by Rubens. He used
> the wide expanse of the church to represent singular events from the life of the
> founder of the Society of Jesus. These partly refer to particular incidents and
> partly belong to the 'repertoire' of a prospective saint.

Rubens' *Miracles of St Francis Xavier*, to which the above label refers, is on display
on the opposite wall in the same room. The display and label thus place *The Miracles
of St Ignatius* in relation to a series of external physical objects: the preparatory
study, the alternative painting and the interior of the church referred to. Finally, the
painting is the subject of a much more expansive audiotrack, transcribed as follows
with vocally-emphasised terms evidenced with italics:

> This, and the painting on the opposite wall, are both altarpieces, which Rubens
> created for the Jesuit church in Antwerp. The Jesuit order commissioned
> Rubens to paint scenes from the life [sic] of their most famous members: the
> founder of the order, Ignatius of Loyola, and Francis Xavier, who worked as a
> missionary in Asia. The two paintings were intended to be displayed alternately
> on the high altar of the church. Here, we see St Ignatius standing in the upper
> right before the altar during an exorcism. In the foreground, the possessed
> writhe, while the devil flees the church, below to the left.

> The *painting* is divided into three areas: on the *lowest* level, we see the common
> folk, while the heroic figure of the saint, dominates the *centre*. A strictly ordered
> row of other Jesuits, witness the miracle worked by the founder of their order.
> The *uppermost* area, is the heavenly sphere, where angels flock into the church.

> Rubens' precise arrangement of the composition met one of the artistic
> requirements of the Counter Reformation, which held that paintings should
> be *easy to interpret* for the pious viewer. Like many of his *other* paintings,
> Rubens created this work together with members of his large atelier. The *plan*
> for the picture, was a sketch in oil, made by the master himself. We can *see* this
> sketch to the right. When we *compare* the sketch with the completed altarpiece,
> we *notice* that in the finished work, Rubens tightened up, and more sharply

defined, the composition. The figures have greater individuality of *character*, and their *gestures* are more pronounced. This made the painting's message *yet clearer*, for worshippers in the church, for the altarpiece would have been viewed from a greater distance, than here in the museum.

A series of textual relations are thus established between the painting and different objects – some physical, and displayed within the same room and available to a single or perambulatory gaze, some intangible, such as the story represented within the painting, the real and imagined vicissitudes of St Ignatius' life and the cultures of their representation. Also, relations are drawn out to the nature of artistic professional practice (Rubens' commission to shape the interior of the church holistically) and, more through implication than explicit explanation, to the importance of religious imagery to groups like the Jesuits. Many complicated and interlocking stories are told through this complex interpretive programme. But many other stories are not told, and indeed the interpretation materials function as implicit directions to the visitor about how to apprehend the artwork (particularly through the imperative nature of the emphases in the audio track), potentially foreclosing other understandings. We can visualise this in another way through modelling some of the questions which the interpretation might prompt, but which are not answered. Figure 4.2 does this solely in relation to the audiotrack. It is a breakdown of this text, which appears in the centre boxes. In the boxes to the left are statements about precisely what information is being given in the text; to the right are examples of some of the many obviously occurring questions that are not addressed. These questions are in addition to simpler ones which I have not listed, such as: what is an altarpiece? Who were/are the Jesuits? What was/is the Counter Reformation? What is an '*atelier*'? etc. Furthermore, I have not included the raft of possible questions concerning the painting's subsequent 'lives' following its removal from the Jesuit church in Antwerp, relating, for example, to the vicissitudes of its removal, of its arrival in Vienna, its acquisition, and so on. Nor have I included other likely questions, like: why are some of the people shown in the church possessed by the devil?

Some of the answers to questions in the right-hand boxes, it may be argued, can be deduced through study of the painting itself and common sense, 'Why is this compositional hierarchy in place?' for example. Since the subject matter is religious and there are often, in religions, spiritual hierarchies, it might reasonably be assumed (although we will challenge this below) that one such hierarchy is reflected by locating 'common folk' at the bottom, priests further up, surmounted by a saint and then finally angels (who, in the painting, are actually cherubim). Other questions, however, cannot be answered through deductive processes like this, such as those in the lowest box on the right-hand side.

Within the text itself, as stated previously, the words that were given special emphasis by the speakers are italicised. This line of analysis needs to be qualified, for while I do not wish to assume that the emphases originated with the curators themselves, it can nevertheless be stated that the speaker interpreted a curatorial text in a manner which has been allowed by the institution. It is interesting to note

FIGURE 4.2 Interrogation of the audiotrack for Peter Paul Rubens' *Miracles of St Ignatius of Loyola*, Kunsthistorisches Museum, Vienna.

which words seem to be key terms, and which do not. In the first paragraph the emphases are on what the painting is (an altarpiece), how it relates to another work, where key protagonists – St Ignatius, the possessed and the devil – are located (using compositional terms such as 'foreground') and what they are doing (exorcising, writing and fleeing respectively). Terms such as 'Counter Reformation', which refer to broader contexts beyond the painting itself, are not emphasised. The second paragraph's emphases relate to the need to break down very clearly the (alleged) tripartite organisation of the composition – 'lowest', 'centre' and 'uppermost' are signposts for this. The last paragraph emphasises one of the main (alleged) keys to the understanding of the work – that it is, and was designed to be, 'easy to interpret' because of Counter Reformation requirements (although, as can be seen, how and why such requirements came about is not addressed). Listeners also learn, through

the emphases, that Rubens was prolific. The emphases then involve listeners in the implicitly-suggested activity of cross-referencing between the sketch and the finished painting by signalling the key actions required ('see', 'compare', 'notice'). Finally, readers are given two important differences to note – the 'character' of individuals and their 'gestures': both link back to the 'Counter-Reformation requirements' introduced earlier, for through them the painting is made 'yet clearer'.

Of course, the painting could be interpreted differently, as the questions on the right-hand side suggest. There could have been extensive explanation of the religious and socio-historical context of the Counter Reformation, the economics and logistics of making commissions (on the part of patrons) and working to them (on the part of artists and 'ateliers'), the role of the Jesuits in Antwerp and generally, Rubens' religious affiliations, other representations of St Ignatius and the nature of Jesuit iconography, compositional and other precedents, and so on. Even within the narrow field of compositional analysis, things could have gone differently. The tripartite, vertical compositional hierarchy is emphasised in the interpretation, but it might be just as easy to think in terms of the ways in which relations between foreground, middle ground and background are constructed, or of other things such as the dynamic diagonals and triangle shapes created by the massing of figures, the way the figures of the calm, standing, controlled St Ignatius and the supine, wild possessed man can be seen to refract one another, and so on. The audiotrack also arguably distorts the evidence in order to support the interpretation of a tripartite, vertical hierarchy (parallel to an implied *spiritual* hierarchy). Notice the last sentence of the first paragraph, which suggests that St Ignatius is standing in the 'upper right' whilst the devil flees 'below to the left'. On looking even perfunctorily at the painting it can be seen that St Ignatius and the devil are actually shown at the same height within the composition, and this weakens the authority of the audiotrack interpretation. None of this is intended to suggest that the audiotrack interpretation of the composition is wholly 'wrong' and that the alternative that I have sketched out is wholly 'right'. The point is, precisely, that they are both interpretations, and as such are as easy to contest as they are to affirm.

Also notable within this complex interpretation programme is its culmination in the explanation of strictly pictorial and stylistic data about the artwork, most particularly in the final comparison with the oil sketch, relative to which the larger painting's composition is 'tightened' and 'more sharply defined', with more individual figures whose gestures are more pronounced. This explanation is made in relation to artistic practice and to the representational culture of the Counter Reformation, and is sophisticated in this sense. However, it also points to a particularly common frame of reference, which is the preoccupation with the pictorial. This is at work in the next example from the same museum.

Narrative and the pictorial frame

The audiotext for Tintoretto's *Susannah and the Elders* (Figure 4.3) is the only interpretation provided in English (there is an extended wall label in German which I

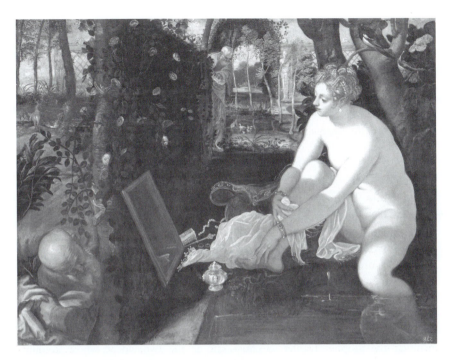

FIGURE 4.3 *Susannah and the Elders*, Tintoretto, 1560-62; image courtesy of the Kunsthistorisches Museum, Vienna.

will not analyse). As before, the following transcript evidences the vocally-emphasised terms with italics:

> The *Old Testament* relates how Susannah was *surprised* by two men while *bathing* in her own *garden*. After she rejected their advances, the two accused her falsely to her *husband*. Only *narrowly* did she escape the penalty of *death*, for *infidelity*.

> Susannah bathing is a *frequent* motif in painting, for it permits artists to paint the female nude, on the pretext of telling a *biblical story*.

> Tintoretto skilfully draws us into the event. Our attention is first *captured* by Susannah's *bright, shimmering body*. The painter then directs our view to the left foreground, where we discover one of the *two intruders*. Tintoretto paints his starkly foreshortened body almost like a *red-coloured bundle*, ignoring the rules of anatomy. From here, our eye follows the *rose hedge* diagonally into the background, where we find the second man.

> Tintoretto creates a sense of *tension* by manipulating opposites: Susannah's light skin *contrasts* with the dark garden; her beauty and youth, with the *old*

men; the extreme closeness to the viewer of Susannah and the voyeur in the foreground, with a view extending far into the background. In the upper left-hand corner, we can even see a silhouette of *Venice* in the *distance*. These *contrasts* were not *ends in themselves*. Instead, they were intended to echo the *tension* between Susannah's sense of safety in her own garden, and the *actual* approaching *danger*. Tintoretto unites all of these contrasts by suffusing the scene with a *golden*, green light.

Like the audiotrack for Rubens' *Miracles of St Ignatius*, there are many other stories that could be told here and there are provocative socio-historical aspects which are treated lightly. The most immediate of these is the matter of women being put to death for alleged adultery (which is, of course, an ever-present horror at the time of writing) and, in relation to this, the sexual politics of gender relations both within the biblical story and in Tintoretto's time. There is, it may be noted, an allusion to the need for a narrative justification for paintings of female nudes. This points towards, but does not explain, a complex context of interrelated cultures of sexuality, gender, representation and viewing. But these aspects are not so much suppressed as they are belittled, as prefatory material for the real business of formal analysis. The biblical story too is given short shrift – we do not learn about God's intervention through inspiring the prophet Daniel to cross-examine the two elders, whose accounts conflicted with one another; nor do we learn that ultimately *they* were put to death for bearing false witness.

Instead, we are led on a careful pictorial journey over the surface of the canvas. By being told what we (all) first notice we are effectively told what to notice first, and how to navigate the composition with our gaze. The use of the possessive adjective 'our' is highly significant in its assumption that we all look at visual phenomena in the same way and in the same order. But this assumption is also an invitation, and really a veiled order. A precise itinerary of travel is suggested within the prescribed gaze: it begins with Susannah's body; it then moves down to the lower left to encounter the first of the two elders (here we learn that Tintoretto has 'ignored' anatomy, building a view of the artist as one who purposefully flouted rules rather than as one deficient in skill – an important and reassuring point of discourse); finally, it uses the rose hedge to move towards the second elder and the background. This scopic itinerary is, for better or for worse, a strong imposition, a closed reading of the formal character of the painting. It cannot be assumed that it is the only way, or even the most common way, to experience the painting. We might just as easily suggest that the viewer's eye should proceed from Susannah to the elder in the background, before moving to see the second elder in the foreground. Or we might question the idea proposed in the text that the process of looking is always so rigidly linear.

Finally, the formal analysis is concluded through the use of the notion of opposites within the painting: light and dark; beauty/youth and age; closeness and distance. This is presented as an index of Tintoretto's creative intention to represent tension – another closed interpretation, for there is no documentary proof of this – but it is tension within unity, because of the most emphatically stressed culmination

of the audiotrack in drawing attention to the 'golden green light' which suffuses the scene. Why should these contrasts be 'united'? What, in this context, does 'united' signify? If such contrasts are united, then is it the golden green light that makes them so? Perhaps it is as much the interpretation which is made to cohere through this explanatory device as the painting itself. The audiotrack attempts to account for pictorial characteristics in relation to highly selective aspects of narrative, highlighting Tintoretto's ingeniousness and sensitivity to the text of the Bible story. This perpetuates discourse about the prowess of artists and the paramount importance of the pictorial as the culmination of the imagined visitor's process of understanding. Other interpretive dimensions, as discussed, are foreclosed.

Again, my point here is not to present such an interpretation as 'wrong', but rather to suggest that it is singular and exclusive of many others. I have also used this example to illustrate something of the politics of 'framing' artworks, for what I have tried to argue here is that there are clearly 'little tacit theories about what exists, what happens, and what matters' and that assumptions about 'our' common ways of seeing in some way form imperatives. This has also exemplified one of the more common frames of interpretation to be found in relation to the presentation of historic art in museums: that of pictorial and formal understanding. This can be seen yet more clearly in our next examples, in which we can contrast the framing of very similar objects across different institutions in the service and construction of different kinds of knowledge.

Frames of representation: Netherlandish painting in Amsterdam

This section looks at different practices of interpretation across a variety of institutional sites in Amsterdam which focus in different ways on and through Netherlandish painting. The institutions are the Rijksmuseum, Holland's premier museum of historical art, the Amsterdams Historisch Museum, whose focus is the history of the city of Amsterdam and the Tropenmuseum, one of the world's leading ethnographic museums with substantial collections from Southeast Asia, Oceania, Western Asia and North Africa, Africa, Latin America, some derived from the Dutch colonial presence. In addition to these sites are others which I shall not explore, which focus primarily on the work of specific individual artists: the Van Gogh Museum and Rembrandthuis – Rembrandt's house on Jodenbreestraat. Together these museums make up a kind of interpretive network, a range of overlapping cartographies each mobilising different frames and creating different kinds of focus, often on very similar bodies of material culture.

The Rijksmuseum

Here we can continue with our attention to the pictorial/formal frame, considering also how it can intersect with another form of framing in relation to technical matters. Let us begin with the following painting (Figure 4.4) and its label.

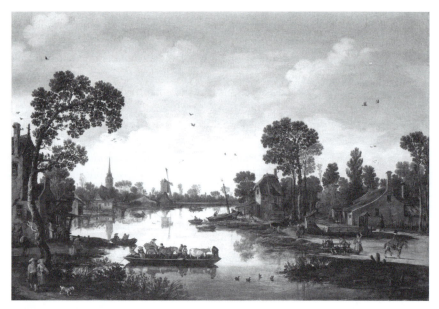

FIGURE 4.4 *The Cattle Ferry*, Esias van de Velde, 1622; image and reproduction rights courtesy of the Rijksmuseum, Amsterdam.

The cattle ferry
Esias van de Velde
Oil on panel, 1622

Around 1600, Dutch artists began to discover the beauty of their own country. This original river view is the first Dutch landscape executed in such a large format. The river leads the eye of the viewer towards the horizon, in the centre of the composition. A windmill and a church tower are silhouetted against the overcast sky.

Here again we see a closed reading of the painting mostly in terms of its formal arrangement, together with clear directions to an imagined visitor about how to look and what to notice. There is an unusually forced reading here as, upon a cursory examination it can be noticed (although perhaps not in the black-and-white reproduction provided here in this book) that in the painting the windmill and church tower are clearly not silhouetted against the sky in the strict sense, for architectonic details and fenestration are carefully picked out on their walls. Aside from this, the explanation of the painting's reason for being – that around 1600 'Dutch artists began to discover the beauty of their own country' – is a statement which is intriguing in its silences. I shall not quibble with the unequivocal implication that the Netherlandish landscape is or was beautiful, but we might question how and why it was seen to be such by artists and, more significantly, by the patrons who acquired such works. And what happened 'around 1600' to bring about this realisation? The statement

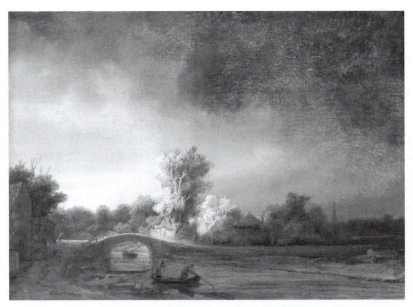

FIGURE 4.5 *The Stone Bridge*, Rembrandt Harmensz van Rijn, c. 1638; image and reproduction rights courtesy of the Rijksmuseum, Amsterdam.

effectively eliminates these considerations pertaining to market and taste and, indeed, historical relationships between people and place in favour of a view of artists as masters of their own interests and creative preoccupations, solely responsible for the development of taste, contributing to a longstanding discourse which concerns the total creative agency of the artist. In this context the formal arrangement of the Rijksmuseum labels are interesting too, with the artists' name being given the largest font size of any of the information given.

Let us look at another example (Figure 4.5), with a new, technical emphasis:

The stone bridge
Rembrandt Harmensz van Rijn
Oil on panel, *c.* 1638

Storm clouds gather above a river. A bright flash illuminates the tall trees and the bridge. A striking feature is the sharp contrast between light and dark, which Rembrandt has accentuated by using a thin layer of paint for the darker sections. In the lighter portions, the paint is applied thickly.

Here we see a text focusing on meteorological details as the primary means of understanding representation and the relativity of the values of light and dark as the primary organising force of the composition. This is explained through reference to the artist's technique, fuelling a discourse pertaining to the artist's skill in mimesis, his mastery of materials and the sense of his touch. The text offers a connective experience

as we are invited to identify with Rembrandt's creative choice and to trace with our eyes the stroke of his brush, perhaps to imagine making such brushstrokes ourselves. This is a biographical framing in a literal sense, for in the textual reconstruction of the making of the painting the body of the artist is indexed. Although at first reading this text seems to be merely descriptive, in fact description itself is always inflected by and bound up in discourse, in this case regarding the technical supremacy of the artist and the possibility of some form of communion through creativity between him and the viewer. These labels concentrate on transhistorical aspects, for the circumstances of the paintings' production, representation and first consumption are only barely grounded in time and place, if at all. Broader interpretive schemes characterise the framing of another Netherlandish 'Golden Age' genre: group portraits of (usually) male companies.

One good example of this from the Rijksmuseum is another painting by Rembrandt: *The Syndics of the Amsterdam Drapers' Guild* of 1662 (Figure 4.6), which, like the Rubens painting discussed above, is the subject of a complex interpretive programme. It has a wall label, an audiotrack and a laminated information board bearing a reproduction of the painting on which key areas are circled and interpreted according to various themes. Here is the wall label:

The syndics of the Amsterdam drapers' guild
Rembrandt Harmensz van Rijn
Oil on canvas, 1662

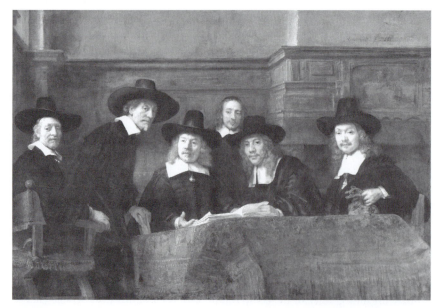

FIGURE 4.6 *The Syndics of the Amsterdam Drapers' Guild*, Rembrandt Harmensz van Rijn, 1662; image and reproduction rights courtesy of the Rijksmuseum, Amsterdam.

The sampling officials, or syndics, monitored the quality of dyed cloth. Rembrandt painted them in action, as if they are looking up from their work. One man is about to sit down or stand up, so that not all of the sitters' heads are at the same level. That clever device, the deft brushstrokes and the subtle lighting make this one of the liveliest of all seventeenth-century group portraits. The work was originally intended for the Staalhof but was transferred to Amsterdam City Hall in 1771.

The audiotrack, which I have transcribed without emphases, is as follows:

This is Rembrandt's last great group portrait. He was 56 when he painted it in 1662 on commission from the Amsterdam Guild of Drapers. The work portrays the five syndics for that year, together with their servant. The syndics' task was to check the quality of dyed cloth from samples. In the portrait it seems as though the syndics have just been disturbed in the course of their work.

This type of portrait has to respect certain clearly defined conventions. There was a set format, and the canvas was destined to hang fairly high on a wall. This immediately explains the striking perspective and why we are viewing the table from below.

This was not the only requirement. The syndics had to be portrayed seated, while their servant, the man without the hat, was supposed to stand. But what do we see here? The second man from the right is either about to sit down or stand up. This device enabled Rembrandt to avoid painting a stiff portrait of five men in a row wearing hats.

Don't forget to look at the right hand of the third man from the left. Willem van Doeyenburg rests the back of his hand on the table with the palm open and thumb pointing up: a gesture which seems to say 'we are open and fair in assessing the cloths'.

Elsewhere in this gallery you can see the man who produced this impressive masterpiece: Rembrandt, in his mid-50s. At the age of 55 the artist portrayed himself as the Apostle Paul.

These two interpretive resources – the wall label and the audiotrack – focus on the pictorial innovations introduced by Rembrandt (i.e. the inclusion of action and movement), and this discourse of the artist's mastery (the painting is indeed called a 'masterpiece', a term whose original connotations are arguably not popularly known), and the overriding importance of the artist within the history of art and as a means of understanding the painting, is entrenched in the final paragraph of the audiotrack which refers the visitor to one of Rembrandt's self-portraits. By such means the visitor

can confront the 'master', in pursuit of the kind of connective experience described earlier. The dynamics of the commission – why the painting exists and what the syndics were trying to achieve by commissioning it – are only hinted at in the passages concerning the painting's original circumstances of display and the conventions of the genre. Such matters are given greater attention in the information board. Here, new information is given in response to questions – the imagined questions of a notional visitor. The questions are:

- How much did Rembrandt receive for the portrait?
- What makes this portrait so unique?
- Why was the portrait commissioned?
- Was this an important commission for Rembrandt?
- Did the subjects have to sit still while Rembrandt painted?
- Where was the painting displayed?
- Was this a difficult assignment?
- Sampling officials, what did they do?

Here then, we see a fuller account of the circumstances of the painting's production, for example the process of sitting, and the revelation that x-rays show that Rembrandt had difficulty deciding on the right play of hands in the painting – proof that this was indeed 'a difficult assignment'. We also learn of the painting's economic importance for Rembrandt and something of the painting's reason for being:

> It was a commemorative painting. Sampling officials were appointed for one year. Each year, on Good Friday, a new board took office. Occasionally an outgoing board would commission a group portrait for display in the building. Apart from this painting, Staalhof boasted another five group portraits.

This sort of historical contextualisation is helpful, but once again the social, economic and symbolic importance of such representations is left to the visitor to infer. This socio-economic frame is only weakly established.

On the reverse of the information board is a series of commentaries on specific areas of the painting. Many of these work through a technical/stylistic interpretive frame:

> The glove is decorated with a wide embroidered band. Rembrandt did little more than suggest a pattern. In fact the glove is rendered with rough strokes of paint, and even scratched over the surface to achieve the desired effect.

Others concern the sitters, bringing in some historical contextual data:

> Long hair and long, floppy collars were in vogue in 1662. The youngest of the samplers is dressed more fashionably than his older colleagues.

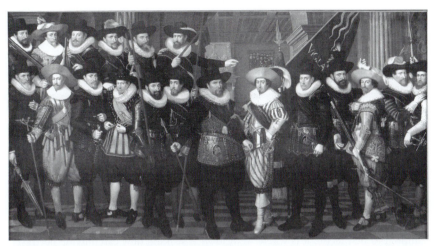

FIGURE 4.7 *Civic Guardsmen from the Company of Captain Jacob Pieterszn Hooghkamer and Lieutenant Pieter Jacobszn van Rijn,* Jacob Lyon, 1628; image and reproduction rights courtesy of the Amsterdams Historisch Museum.

What we see in this complex interpretive programme is a multiplication of interpretive frames, including the biographical frame, the technical-stylistic frame and the socio-economic frame. In some ways the inclusion of the latter corresponds to scholarly tendencies over the last decades in which the position of works of art as both records of and objects within social worlds has been identified as a particular focus of study. However, I have argued that this is the most weakly developed of the interpretive frames, still subservient to more conventional understandings of the painting as masterpiece and demonstration of the artist's creativity, ability to innovate, ingenuity and mastery, what might otherwise (in other discourse) be termed his 'genius'. While the information board generously anticipates the imagined visitor's questions, there are many other depths of enquiry which it does not plumb.

We see a different approach to similar paintings in the separate disciplinary regime of the Amsterdams Historisch Museum. Let us consider the following wall label for a large painting of a military company (Figure 4.7):

Civic guardsmen from the company of Captain Jacob Pieterszn Hooghkamer and Lieutenant Pieter Jacobszn van Rijn
Jacob Lyon (1686/7–1648/51), 1628
From the Crossbow Civic Guard House

The men of captain Jacob Hooghkamer and lieutenant Pieter van Rijn are pictured in the hall of the Voetboogdoelen, the Crossbow Civic Guard House. In the background hangs a civic guard piece by Dirck Barentszn (on view in the museum).

The virtually unknown Jacob Lyon painted the guardsmen full-length. It is striking how carefully he portrayed their clothing and weapons. Slightly off-centre we see the elegant standard bearer with the captain and lieutenant on either side. On his banner is the motto 'VIGILIA' (be vigilant).

Both Jacob Pieterszn Hooghkamer (1578–1641), seen here at the left with a pikestaff, and Pieter Jacobszn van Rijn (1579–1639), on the right holding a partisan, traded in woven silk. In 1638 Hooghkamer went bankrupt. He lost his position as a member of the city council and had to relinquish his post as captain of the civic guard. To save him from dire poverty he was given the job of porter at the Crossbow Civic Guard House.

In this text only perfunctory attention is paid to the aesthetic aspects of the painting; to be precise, it is where we read 'It is striking how carefully he portrayed their clothing and weapons'. Elsewhere, compositional elements are mentioned but only really as a key to help the viewer identify some of the significant individuals represented. These individuals are presented in much more detail than is the artist (although we are told that little is known of him), and their lives and work are the focus here. Again, there is a conspicuous absence of information concerning why such paintings were commissioned, and why they were important within society; what role, in other words, did they play in reflecting and constructing social orders? This silence is partly filled by a more general wall text, as follows:

Civic guard paintings

Civic guard paintings depict bonding among the urban male elite. Generally those portrayed in the same painting lived in the same district and their company was responsible for preserving law and order in that area.

During the middle ages, civic guard companies helped defend the city. After the sixteenth century, they became archery clubs for reservists. For most of the members, the post of officer was not just part of their civic duty; it also meant social advancement. Each company had a captain and lieutenant in charge. They are shown clasping ornamental arms – pikes and partisans – while sergeants and standard-bearers are recognisable from their halberds and standards. Every civic guardsman had to pay for his own portrait. In civic guard paintings one therefore only gets to see part of a company. [There follow line drawings of a pike, a partisan and a halberd.]

Here we see some contextual information which explains the importance of such paintings from the point of view of the sitters, while also accounting for the cultural and social importance of the companies. The text is much less concerned with pictorial traditions, with artistic practices or even with the social history of art production (for example the issue of artists' livelihoods). The frame here – the tacit theorising

FIGURE 4.8 *Three Wardens of the Surgeons Guild*, Cornelius Troost, 1731; image and reproduction rights courtesy of the Amsterdams Historisch Museum.

about what matters and what does not – forces a focus *through* the painting on to the histories it illustrates. Notably, a continued omission is the action of the painting in and on society. This historical-documentary frame is further exemplified in the following wall label (Figure 4.8):

> *Three wardens of the surgeons' guild, 1731*
> Cornelius Troost (1697–1750)
>
> These three gentlemen were wardens of the surgeons' guild in 1730–1. With bright colours and telling brushstrokes, Cornelius Troost has caught them for perpetuity as though they had just interrupted a meeting to pose for him.
>
> The coats of arms on the wall are keys to their identity. Isaack Hartman (1686–1744), Elias Huijzer (1688–1748) and Adriaan Verduijn (1672–1749) could never have suspected that their group portrait would be linked today with a case of fraud. Not long after the painting was completed all three had to resign, with the rest of the board. Apparently they had sold surgeons' diplomas like those depicted here for bribes, and kept money intended for surgeons' widows for themselves. Their group portrait was of course paid for out of guild funds.

Here the attention to aesthetic and pictorial matters acts as a preface to the interesting story surrounding the three men represented: a story which postdates the production of the painting. The painting itself is forced into the position of

a document and, in a sense, embodiment, of the men's fraudulent and dishonest behaviour, opening up a vista on to the abuse of status and power, corruption and the exercise of law in eighteenth-century Amsterdam. This is, essentially, what is 'framed' by the interpretation. In one final example from the Amsterdams Historisch Museum we can see closer attention to pictorial aspects, but only in clever pursuit of historical stories about society. In a section themed around charity in Amsterdam we find a civic group portrait representing both men and women (Figure 4.9):

The governors and governesses of the Oude Mannen en Vrouwen Gasthuis
Claes Moyaert (1591–1655), 1640

The Old Men's and Women's Almshouse (Oude Mannen en Vrouwen Gasthuis) was run by four governors and two governesses from the higher middle class. This painting, the only known group portrait by Claes Moyaert, is the first Amsterdam painting of governors to show both male and female administrators.

Around the table we see no fewer than five governors. The figure of Jan Janszn Koeckebacker, in the left background, was probably added later. He became a governor instead of Philip Laurenszn – possibly the man in the chair on the right – who died in 1640, the year in which Moyaert painted this group portrait.

A striking feature is the imbalance between the group of governors round the table and the two governesses to the left. This may be due to a change in the composition after Moyaert had started painting. Possibly, the size of the canvas was already fixed when it was decided to include the governesses too.

FIGURE 4.9 *The governors and governesses of the Oude Mannen en Vrouwen Gasthuis*, Claes Moyaert, 1640; image and reproduction rights courtesy of the Amsterdams Historisch Museum.

Here we see once again some of the notable points of focus of the historical-documentary frame, such as the naming of specific individuals and the accounts of their activities. Consider the precision and centrality of this in comparison with the lesser significance of the individual sitters' identities in the interpretation for Rembrandt's *Syndics*, discussed above. But the unusualness of this portrait is a key point of focus too, and the final paragraph is dedicated to the interpretation of this, as we are presented with a hypothesis about the pictorial composition which relates implicitly to stories of gender relations in the workplace. The painting is presented as an artefact, itself embodying an important shift within society, and not as an aesthetic object in its primary interest.

What we have seen here is a contrast between different frames. In the examples from the Rijksmuseum we see a focus on pictorial, compositional, formal, technical and biographical aspects. In some instances (where a multiplication of interpretive resources occurs) there is a weak focus on socio-economic concerns relating to matters such as the livelihood and working practice of artists: something that is more fully adopted in those museums which focus entirely on one artist, like the Rembrandthuis, which includes Rembrandt's own studio and the room he used to display his paintings to patrons. In the Amsterdams Historisch Museum we see the adoption of a documentary-historical frame. Here the aesthetic dimensions of the paintings and the lives of their makers are practically incidental and the paintings are objects of interpretation in different ways: in themselves, as objects, but more importantly, as lenses through which to view historical worlds. The historical worlds viewed relate decidedly to the paintings' representations and not to their authors or their production. Here it should be reiterated that these framings are nothing less than theories of value. And as stated, in neither regime do we encounter an interpretive frame opening up a view on to the social work of paintings. Moving to another site in Amsterdam we encounter a different frame which is both historical and critical. The Tropenmuseum contains relatively few paintings, and they are not the mainstay of its collections. In this example one painting is contrasted with a tapestry (Figure 4.10) to expose different knowledges and understandings of the past:

FIGURE 4.10 Painting by Andries Beeckman and tapestry by Sitisiwan; photographer Paul Romijn; image courtesy of the Tropenmuseum. Copyright Tropenmuseum.

Two images of colonialism

A seventeenth-century Dutch painting and a twentieth-century narrative tapestry from Java offer completely different images of two periods of Dutch colonial history.

Andries Beeckman was commissioned by the VOC[1] to produce this painting of Batavia in 1656. It shows an idealised image of the company's principal trading base.

The narrative textile, made almost a century ago by Sitisiwan, presents a critical twentieth-century view of Dutch rule in Java. In the nineteenth century, the Dutch extended control into the interiors of all the Indonesian islands. The cultivation system – the official colonial policy on Java – involved the systematic exploitation of the Javanese and led to famine in the villages.

This critical-historical framing embodies a moral criticism of the past behaviour of the Dutch on foreign, but colonised, soil. It is a label which works within postcolonial ethics of guilt, the cultural relativism of postmodernism (which counters notions of superiority of any given culture or civilisation, and the notion of superiority as a justification for domination) and within the demographically plural context of modern-day Amsterdam, which is home to many people of Indonesian origin. The label makes an appeal to a particular art historical tradition – the art history of names, as it were – in the care with which it names the Javanese author of the tapestry; this is in contrast to the nameless exhibition of objects which is more usual in ethnographic museums, where objects do not stand in relation to their individual makers with their own known histories but rather metonymically to, and illustrative of, their societies and cultures of origin. But this very art historical device is used to undermine the primacy and question the veracity of the Beeckman painting by placing the two objects in the same epistemological territory. We have in this sense a very clear view of the contingency of the political maps drawn by the interpretation of the two objects and their potential for conflict with one another. This is an example – perhaps an extreme and certainly a very self-conscious one – of the sometimes acute political significance of the interpretation of art.

This section has explored the interpretation of paintings – sometimes very similar ones – in different disciplinary settings. My purpose in choosing examples from the same city (a city rich in museum holdings and in histories) has been to show the close proximity of such knowledges and their ready co-availability. Any museum-going tourist visiting Amsterdam might well encounter all of these framings and ways of knowing within a visit of a few days, and it is interesting to consider what this might mean for visitors, whether it is possible or natural to seek to reconcile the different knowledges at play (given that each has the apparently solid authority of institutional practice) or whether such interpretive plurality matters. Whatever the answers to such questions might be, this section has allowed us to look at some characteristic

frames and to consider the ways of knowing which they enable and disable, and to begin to consider some of the theories of value which are inherent within them. This relates once again to the interpretive practice of evaluation (alongside identification and narrative) discussed in Chapter 2. We must now proceed, however, to consider one of the most dominant frames in art museum practice, one which both organised the material culture of the past and was organised by such material culture during the development of the concept of the public museum in the late eighteenth and nineteenth centuries.

Evolution as an interpretive frame

As hinted at in earlier chapters, one of the most significant frames within the history of art interpretation in the museum is the evolutionary frame. This term, 'evolutionary', is not one which I use lightly. In the mid- to late nineteenth-century, when this frame was at the avant-garde of practice, conceptual and terminological borrowings from evolutionary theory relating to the natural world came to have special importance within art historiography and ideas about display, allowing for accounts of the development of pictorial style over time, or the refinement of form in decorative arts (Whitehead 2005: 17 and 34, note 99). In relation to art, this is an interpretive frame which involves chronological but also geographical sequences of display. It is similar in some respects to evolutionary frames in other museum-disciplinary contexts, such as the organisation of material culture in relation to notions of the evolution of technology in the archaeology and ethnography displays of the nineteenth and early twentieth centuries.

As we shall see later, the evolutionary interpretive theme has been so entrenched within art museum practice to prompt interpretive revolutions specifically designed to usurp this 'conveyor belt of history' (Serota 2000: 55). But before we consider this, it is worth exploring a few typical examples of evolutionary framing. I take them both from Milan in Italy. The first is from the Pinacoteca di Brera, the principal historical picture gallery in the city and one of the most significant, in terms of the perceived quality of its collection, in Italy and in the world. Housing primarily Italian paintings, the gallery is organised as a chronological itinerary, commencing with fourteenth-century and moving forwards to the nineteenth. In each room handheld information boards (to be consulted and then returned to their holders) are provided which include a main text panel and a succession of labels for individual paintings. For the sake of this analysis (and really at random, for all of the information boards frame the art in the same way), I have chosen to look at the interpretation in room 29, which is dedicated to 'Caravaggio and the Caravaggists'. The nucleus of the room is Caravaggio's well known *Supper at Emmaus* of 1606. The long introductory text (which I have translated[2] – see endnotes for original text) is as follows:

> Here, around the only painting owned by the Gallery (no. 1) by Michelangelo Merisi – known as Caravaggio from the name of the town in the province

of Bergamo from which his family originated – are collected paintings influenced by him in various ways, showing the wide and immediate following, albeit one which was not always faithful and considered, which his works achieved.

The painter, trained in Milan, moved in 1592 to Rome, where he worked mostly for educated patrons able to appreciate the revolutionary novelty of his works. In fact, like the Carracci[3] (room 28) were doing in another way, Caravaggio refused the idea of painting as a body of rules to be studied through the works of past masters, just as he refused the norms of representation of sacred subjects dictated by the Counter Reformation. Rather, he favoured a kind of painting profoundly connected to physical and psychological reality, able to uncover the worldly component of any theme.

From the first years of the 1600s one of his stylistic inventions to be immediately imitated was the construction of images through strong contrasts of light and shadow. This became a sort of hallmark among his followers.

In reality, Caravaggio did not have his own school of painting, or any direct students, but his works were seen with extreme interest, as much in Rome – in particular amongst the 'northern' artists who worked there – as in the other places marked by his troubled existence: Naples, Malta, Sicily and Naples again. The group of 'Caravaggists' is thus very heterogeneous, and a certain difference can be established between the few who knew him directly (nos. 2 and 4[4]) and those who, being younger, worked after his death (nos. 5 and 6).

Whilst among the first group the influence of the Lombard is perceptible above all in the attention to the real, among the second group his teaching was often impoverished and rendered banal, reduced to the use of a very contrasted palette and to loaded expressions, to an insistence on truculent and grotesque aspects which Caravaggio avoided, and to the systematic reduction of sacred episodes to picturesque scenes of daily life.[5]

This is a very specific framing of Caravaggio's work in relation to his 'stylistic inventions': notably the use of strong contrasts of light and dark, or 'chiaroscuro', for which he is known. In the evolutionary discourse of art this concerns the theme of innovation, and how through innovation artists could both depart from, and diversify, the development of style over time. Caravaggio is particularly interesting in this context precisely because, the text informs us, his innovation was no subtle modification of existing stylistic practice (such as might come about by studying 'past masters'), but an unusually notable departure from it. At the same time we learn that he ignored Counter Reformation strictures about the representation of sacred scenes (in contrast to the Rubens painting which we focused on earlier), which is the only link in this text to any socio-historical context. We also learn nothing about the use

of his paintings, and only the faintest sketch of his life is provided (that he travelled and that his existence was 'troubled' ('irriquieta'). Instead, the text proceeds to discuss the nature of his influence, making fine distinctions between its different varieties. What emerges is a kind of family tree. We can see this carried through into the labels for individual paintings. Here is one:

Mattia Preti (Taverna, Catanzaro, 1613 – Valletta, Malta, 1699)
5 *Saint Peter Pays the Tribute*
Oil on canvas, cm 143 x 193.

The canvas, together with its pendant (no. 7) came to the Gallery on 31 January 1812, donated by Viceroy Eugenio de Beauharnais, but its previous provenance is not known. The episode of Christ making St Peter pay the tax owed to the tax collector with the coin found in the mouth of a fish which he had ordered him to catch is translated with an eloquent gestuality, sustained by a dense plot of gazes amongst the protagonists. Executed with all probability in the 1630s, it shows how the paintings of Caravaggio could be interpreted by a much younger painter who had worked in Rome, studying the works of the master directly and meeting his imitators.

Like other artists of his generation, Mattia Preti derives from Caravaggio some exterior motifs which he applies to his own works, almost standardising them: in this case it is possible to indicate the close perspective of the composition, with the three-quarter figures reunited around the table, the luminous rays which highlight the protagonists picking out their wrinkles or the details of their clothing, and the choice to reproduce the evangelical event like a contemporary tavern scene.[6]

Here, after the brief preface concerning provenance, the text gives the briefest possible account of the biblical story represented in the painting. After this, it provides an evaluation of the composition (the 'eloquent gestuality') and frames the painting as an example of work influenced by Caravaggio. The circumstances and effects of that influence are carefully listed in specific ways. The purpose here is to situate and understand the course of stylistic trajectories over the works of different generations of artists: a form of knowledge associated with connoisseurship as it was developed in the context of nineteenth-century art museum practice and art historiography, where nuanced observational methods were adopted to observe the subtle distinctions between the works of different artists or, sometimes, single artists whose work was characterised by different 'periods'. Here, the social histories in which such artworks were embedded, the stories they represent and their significance at the time of production and today, and even the biographies of the artists, are either suppressed or subordinated to the main object of focus which is the evolution of style, an account of similarity and difference as it occurs over time and over generations in the production of visual and material culture.

Similar approaches can be found in more terse interpretation (given in English) in the nearby Museum of Applied Arts at the Castello Sforzesco. Here we can consider two examples of interpretation of wooden sculptures:

> Giacomo da Cattaro
> *Virgin at prayer*
> 1462
> Carved wood, gilded

> An inscription shows that the work was made in Venice in 1462 by Giacomo da Cattaro in the studio of the master Lazaro de' Franceschi. The attribution to the area of Venice is confirmed by the sophisticated repertory of architectural ornamentation and by the Bellini-like composition of the Virgin at prayer.

And:

> Maestro aostano (?)
> *Madonna and Child*
> Fifteenth century
> Carved wood

> Compared with the work placed next to it, which has a similar subject but is of a slightly later date, this sculpture gives us a decidedly more austere and solemn interpretation of the Madonna and Child, and indeed is more in line with the sculptural tradition of the Valle d'Aosta.

Both of these labels adopt an evolutionary frame, although in a slightly different way from the texts relating to Caravaggio and his followers discussed earlier. Here, the frame is used to identify stylistic contexts and to classify the objects in relation to others which are similar to them. This is an action which permits the works to be located in a certain kind of historical time and space: we are informed that it is the 'sophisticated repertory of architectural ornamentation' of the Virgin at prayer and its resemblance to the compositions of Bellini (one of the Venetian painters Giovanni or Gentile Bellini working in fifteenth-century Venice – which one is not stated) that corroborates the evidence provided by the inscription that this object is indeed Venetian. Likewise, it is the austerity and solemnity of the Madonna and Child that situates it as a work of the Val d'Aosta, for these characteristics are parts of a corpus associated with that region.

This is all useful work: it is important to know, and to speculate about, where works were made and what influences lie behind their appearance. It is also not without its uses in the highly charged context of attribution, where assertions like this can alter the financial value of an art object by several orders of magnitude. And in relation to the earlier discussion in Part I about fruition, for some the cultivation of such sensibilities to style and its development and variation undoubtedly provide

a fascinating avenue of intellectual play. But of course we can return once more to the problem of the stories *not* told through the adoption of a dominant interpretive frame like this. We must also recognise that the frame encourages a form of fruition which can require of visitors a pre-acquired erudition – a familiarity with the rules of the game of stylistic distinction and with the historical backdrops (like the Counter Reformation) running behind the evolutionary stories. It requires, in other words, skills equal to the challenge posed by the interpretation. These skills are not possessed by everyone and it is not often that art museums actively seek to help visitors to acquire them by providing the means for visitors to develop metacognitively (we will see an exception to this in a discussion of the Museum of Fine Arts in Boston in Chapter 6). We also need to recognise that while the evolutionary frame is a fundamental instrument of museum practice and it is rewarding for some, for many visitors it may simply not convey or help to represent what is most interesting about objects on display. The notion of evolution when applied to the development of art also smacks of teleology, and of the 'master narratives' of history of which (as Lyotard noted) postmodern thought has been so suspicious. These objections form part of the intellectual context in which some art museums have sought to subvert the dominance of the evolutionary frame by forcing alternative groupings and orders of work, brought together irrespectively of their different age and provenance in adherence to thematic congruence or perceived affinity. This is what we will explore next, in the following chapter, alongside some of the common interpretive frames which characterise the presentation of twentieth-century and contemporary art.

5

INTERPRETIVE FRAMES

MODERN, CONTEMPORARY AND NON-FIGURATIVE ART

In the last chapter we developed understandings of the different ways in which historical representational or figurative paintings have been framed through interpretive practice at a range of museums. This chapter continues this project with respect to other artistic categories, although, as I have tried to indicate in Part I of this book, the logic of such categorisations needs to be questioned. Nevertheless, it is arguable that categorisation is itself constructive of different interpretive frames such that objects seen as part of 'contemporary art' or 'decorative art' are simply interpreted differently, in relation to different theories of value from, say a monumental painting by Rubens, and ultimately such interpretive practices can inform the cultures of their production. In so doing they become different in discourse. While Part I sought to destabilise and question distinctions between fine art and decorative art, and between historical and contemporary art, it is nevertheless the case that such distinctions do their work in the world, creating cultures of discourse and practice which force differences into places where ontologically one might consider that there are none. We begin with an interpretive frame which itself calls into question distinctions, notably between historical and contemporary art, and indeed between positions of authority in the museum–visitor relationship; but in so doing it may well be that such distinctions are subtly but strongly reinforced.

New connections, new voices

In 2000, Tate Modern opened in London; its expansive collections of art since 1900 were displayed in a relatively novel thematic way, consciously and vocally eschewing traditional evolutionary framings. As the Tate Director Sir Nicholas Serota indicated in his short book *Experience or Interpretation*, the aim of art display should be 'to generate a condition in which visitors can experience a sense

of discovery in looking at particular paintings, sculptures or installations in a particular room at a particular moment, rather than finding themselves standing on the conveyor belt of history' (2000: 55).

The displays initially framed works of art according to themes including: 'History/Memory/Society'; 'Nude/Action/Body'; 'Landscape/Matter/Environment'; and 'Still Life/Object/Real Life.' Within this, artworks were grouped or paired according to perceived affinities, and quite irrespective of chronology or geography. These themed environments were intended to 'promote different modes and levels of "interpretation" by subtle juxtapositions of "experience"' (Serota 2000: 55). By 'interpretation' Serota means the arrangement and juxtaposition of artworks 'to give selected readings, both of art and the history of art', possibly where such juxtapositions evoke 'relationships which could not have existed in the minds of the makers of [artworks]' (2000: 8–9), while recognising the visitors' prerogative to explore 'according to their particular interests and sensibilities' (Serota 2000: 55). In the new museum envisioned by Serota in 2000, visitors and curators (which is to say, in his view, all of us) would explore a 'matrix of changing relationships' between works of art, so that we would become 'more willing to chart our own path, redrawing the map of modern art, rather than following a single path laid down by a curator' (ibid.). The frame involved here might be termed conceptual-affinitive, in seeking to identify points of contact between works of different ages and from different places, and also in fashioning a specific kind of supportive dialogue between artworks which are forced into a regime of mutual interpretation. This bold experiment was not universally well received, and many baulked at the curatorial conceit of imposing *a posteriori* thematic categories on to the history of art (although one could argue that conventional periodisation is an equally violent historiographical act), or struggled to make sense of a display which worked against chronology. The critic David Sylvester, for example, pointed out that chronology is not merely an instrument of interpretation, but is rather 'an objective reality, built into the fabric of the work' and into the consciousness of the artist at the moment of material production (in Whitehead 2005: 99). A modified redisplay in 2006 adopted a more complex frame, which emphasises the importance both of conceptual affinities and chronology, overriding the transhistorical working of the original display. This time, though, the chronology is not linear and monodirectional. In relation to the importance of time in the display, an article in *The Times* reported as follows:

> Announcing the rehang last autumn, Sir Nicholas Serota, the gallery's director, said he 'would be surprised' if there was no criticism of the gallery's decision not to exhibit the works chronologically. 'Our purpose is not to deflect criticism, but to present the collection in the strongest possible way.' [The Tate Modern Head of Displays Frances] Morris claims that a chronological history isn't useful. 'The development of artistic practice takes place in moments in time, dialogues over time, how the perspectives of the past form antecedents to the present. The intention is to provide an overview of art history for the broadest

possible audience, so they can see those moments when the game changed, when paradigms shift, while seeing how artists through time became fellow travellers, or overtly rejected one another's ideas.'

(*The Times* 2006)

The displays are nevertheless organised in somewhat abstract thematic groupings, with titles such as: 'Chromatic Structures'; 'Material Gestures'; 'Poetry and Dream'; 'Energy and Process'; and 'States of Flux'. But within these, an attempt is made to identify the 'pivotal moments of twentieth-century art history' in central hubs featuring 'Surrealism, Minimalism, post-war abstraction in Europe and the US, and the three linked movements: Cubism, Futurism and Vorticism' (Tate 2011). Notably, the relative status and importance of each of these movements within art history and art historiography is a matter of some disagreement among those who study the development of modern art (Elkins 2002: 80–5). Something of the bind between chronology and the self-referential, historicising and intertextual nature of much artistic practice in the twentieth century is captured in the rationale for the display's time-travelling character:

Around the focal points, a range of displays move backwards and forwards in time, showing the predecessors and sometimes the opponents of each movement, as well as how they shaped and informed subsequent developments and contemporary art. The introductory room in each wing bring together work by artists from different generations, to reflect this ongoing dialogue between past and present.

(Tate)

Here is an example of this display practice in the form of a main text panel to the 'Material Gestures' wing, displayed in a room with Anish Kapoor's 2003 sculpture *Ishi's Light* (Figure 5.1) and Francis Bacon's 1963 *Study for Portrait on Folding Bed* (Figure 1.1):

This pairing of works by Francis Bacon and Anish Kapoor introduces the Material Gestures wing

At the heart of this wing is a room devoted to painting and sculpture from the 1940s and 1950s, showing how new forms of abstraction and expressive figuration emerged internationally in the post-war period. The surrounding displays suggest affinities between the radical innovations of this era and the work of earlier artists, but also show the legacy of those ideas among contemporary practitioners who have continued to develop the language of art in new and unexpected ways.

(Curated by Matthew Gale)

An example of shift within the 'changing matrix' of the display, the Francis Bacon painting replaced Barnett Newman's paintings *Eve* and *Adam* of 1950 and

FIGURE 5.1 *Ishi's Light*, Anish Kapoor, 2003; image courtesy of the Tate Modern; permission courtesy of the artist. Copyright Anish Kapoor. Image supplied by Tate Enterprises Ltd.

1952 respectively. There are three interpretation resources specific to Bacon's *Study for Portrait*, all set at an adult pitch both in relation to content and the complexity of the language employed. A label stresses the sexuality and violence associated with Bacon's 'tortured' figures on beds, the squalor of the image and the 'dribbles and splatters of paint' which are 'reminiscent of leaking bodily fluids, bringing attention to the physical material of the body'. The remainder of the label explains that Bacon asked to modify the painting after its acquisition by the Tate, but was refused this opportunity by the trustees. A second label – one of a series entitled 'Bigger Picture' in which certain works are interpreted by non-art specialists whose backgrounds are nevertheless seen to equip them to decode works in interesting ways – presents an interpretation by the psychoanalyst Adam Phillips focusing on the drama of the image. Phillips talks about the sense that the figures in Bacon's paintings seem to have been interrupted and might move if we spectate for long enough, and goes on to discuss the importance of confinement – the figures are 'staged and caged' and viewers are kept at a distance because of the daunting nature of the figures and the potential horror implied in the scene. The third resource is yet more complicated: it is found in the digital audiovisual guide and involves four different tracks: About this Work; Bacon's Inspirations; Friends, Lovers and Models; the Artist Speaks. Some of these incorporate other visual images, such as

comparable paintings or images of Bacon's models, and the user can cross-reference between these and the painting on the wall. Much of the information presented regards Bacon's preoccupation with violence, and his own tendency to act violently towards the people he knew not literally but figuratively, through their depiction in his art, and his tendency to destroy his own artworks. In sum, there is a lot of interpretation around this single painting, and as if that were not enough, it is also set in interpretive relation to another, apparently very different, artwork. The potential for a rich experience of the work is established by this multiplication of approaches to and perspectives on the artwork (and perspectives achieved *through* the artwork on Bacon as an unusual individual interested in violence, playing to the trope of the artist as special, unconventional and on the limits or outside society). But this same multiplicity of interpretive resources and perspectives – should visitors have the patience to engage with them all – also establishes the potential for confusion.

The interpretive resources for the Francis Bacon painting would seem to relate only very weakly, if at all, to Kapoor's *Ishi's Light*, a 'futuristic, simple and monolithic' sculpture named after Kapoor's son. Indeed, a text panel within the room makes only limited sense of the pairing, perhaps belying the difficulty of establishing persuasive or suggestive connections between works, or perhaps stimulating visitors to find connections themselves. The panel introduces the memory of World War II and the Holocaust and the 'traumatised image of man' which emerged, 'perhaps most famously in the paintings of Francis Bacon, whose figures are characteristically enclosed and isolated'. Enclosure is used as the connector between the two works, for 'a visual sense of enclosure is equally pivotal' to *Ishi's Light*, although it cannot convincingly be talked about in relation to the trauma of war or man's self-imagining in its aftermath, and the curators do not try to do so. And like any foregrounded connection, this one makes it hard to interpret the works in other ways unless through the conscious effort of making an oppositional reading.

As if to help visitors to make sense of this kind of time travel in which disjunctions are just as possible as the hoped-for connections and continuities, in the non-display concourse spaces the walls are figured by large murals, like reworked horizontal versions of Barr's 'Development of Abstract Art' diagram (Figure 2.3), showing relatively linear chronologies, and mapping movements and individual artists through time (Figure 5.2). Chronology is critical: as we will also see in Chapter 6 in discussions of the complex identity politics bound up in displays of American and Canadian art, through chronology we map the relations between ourselves, our preoccupations, politics and ways of seeing with those of cultures past (or, as Tate claims, never completely past). Identifying continuities is a way of settling the violence between notions of past, present and future, and bears more significance than a simple rethinking of art historical narratives. This is an area of anxiety which has been charted in relation to contemporary art by Douglas Crimp in *On The Museum's Ruins* (1995), as Hans Belting puts it, 'the ruins of the powerful fiction to present art as a coherent system and art history as its ideal order' with temporality as

FIGURE 5.2 *Chronology of modern and contemporary art*, Sara Fanelli, Tate Modern; image courtesy of the Tate Modern; permission courtesy of the artist. Image supplied by Tate Enterprises Ltd.

the key representational system. Belting's own consideration of the tension between the siting of the contemporary within the apparent permanency of museum time adds to this anxiety (that what we value may be only *temporary*):

> Our concept of art is rooted in the Enlightenment age, which credited it with a timeless and universal significance transcending the specificity of individual works or genres: art was declared timeless and universal, much as human rights themselves were meant to apply to all people, however, different they might be in race and origin. But this idea of art was only tenable when phrased in a general art history. The view of art history was needed to frame the individual time of the works since the art history had a universal validity, while the individual works did not. That is why the art museum was to become the spatial equivalent of the time scheme of art history. It offered a place for everything capable of representing the logic of art history, which, when the Louvre first opened, was only old art, while new art had to earn the status of museum art – it had to wait for it.
>
> (Belting 2003: 104–5)

'Museum time' in this context might stand for multiple temporalities: the transcendence of history which art (mythically) achieves, the fixed orders or maps of

influence, interaction and interrelation between generations of artists and successive 'movements', and the present in relation to the past and vice versa:

> The nervous debate over the recognition of today's art proves clearly the degree to which we still cling to an idea not older than two hundred years – regardless of the age (or the youth) of the works of art to which we apply this idea. The idea of art history as ongoing links us to the great tradition of historical culture, since we fear nothing more than art becoming a notion of the past.
>
> (Belting 2003: 105)

Systems of temporal connection, of relational placing, are profoundly important in identifying cultural value, both in external objects and in ourselves as perceivers and actors within histories. It is this knot of anxieties that the interpretive strategy at Tate Modern concerns. In this sense, the interpretive frame adopted at Tate Modern is about identifying continuities and acts of remembering, revisiting and drawing from historical art, presenting the idea of the artist as creative art historian working within, through and on traditions of practice. It is not the same as the evolutionary frame for it does not inch along the slow development of style over successive but closely-spaced generations, but allows for stops and starts and different diachronic throws – forwards and backwards – and connections which loop outside long spans of time and place. What will always be questionable in this way of framing are some of the connections made and the dialogues between works arranged, for unless there is particular documentary evidence of a contemporary artist's interest in a given historical counterpart (and of course the interest will never be mutual) then pairings may seem contrived, fatuous or gratuitous to some, a curatorial story with no truth or proof. Something of this variability in the value of the pairings is evident in Terry Smith's nuanced connoisseurial reading of the display, which documents the 'flows of continuities' in their range between constructive 'provocative shock' and the 'taste for the tasteless match-up ... when the Monet *Water Lilies* (ca. 1916) is paired with a middling Rothko of 1950–2 that happens to have some of the same colours on its surface' (Smith 2009: 65–6).

Within this metaframe – which we might term 'chronological-connective' – individual works tend to be framed in relation to aspects such as the technique employed and the biography of artists, in particular their relations with specific artistic movements, cultures or circles, and questions of artistic intention, supplemented generously by the artists' own words about their work in the form of quotations or paraphrasings. Here is an example: the label for Philip Guston's 1956–8 painting *The Return*:

> Guston was an important Abstract Expressionist painter in the 1950s, who controversially returned to figurative work in the late 1960s. His early abstract paintings were composed of shimmering combinations of short vertical and horizontal brushstrokes in pinks, reds and blues. Discussing The Return, Guston said that he saw the forms in the picture as being like figures who had been away for some time and who were now returning – jostling each other a little as they came.

A particular feature here and in much interpretation of twentieth-century art the world over is the relative absence of socio-historical perspectives of the kind we saw in the examples from museums in Amsterdam in the previous chapter, and which we will see in another form in Chapter 6's analysis of interpretation at the Boston Museum of Fine Arts. The history of art which is presented is an essentially self-referential one, somewhat hermetically closed to 'outside' events except where they visibly affect figurative representation or the lives of artists, as in the case of the world wars, or social and intellectual movements such as feminism. In part this may be a consequence of the production of work within discourse which was discussed in Chapter 3, whereby artworks were created for a gallery environment and were designed to invite a particular kind of self-reproducing critical gaze within a specific elite social and cultural milieu. To frame twentieth-century fine art socio-historically – especially non-representative art – one might have to foreground such cultures of display and consumption, to talk about the functioning of the artworld and the configuration of artist-gallery-patron relations which enabled and were enabled by the production of artworks and discourses about art. A much more typical frame for the interpretation of twentieth-century fine artworks through notions of preoccupation or concern, as we see in the following text introducing paintings by Giorgio Morandi exhibited at the Hirschorn Museum in Washington DC:

> Morandi received classical, academic training at the Accademia di Belle Arti in Bologna, where he developed an abiding enthusiasm for Italian Renaissance painting. His early contact with the Italian Futurists sparked his interest in modern art, but he remained isolated from the mainstream of the contemporary art world of his day. Instead, working in his studios in Bologna and Grizzana, Morandi chose to concentrate with obsessive zeal on deceptively simple still life arrangements of ceramic vessels. While he usually began a painting in bright colours, he deliberately muted the chromatic range of the final version of a painting. Visitors to Morandi's studio noticed a parallel between the subtle tonalities and soft textures of his still life paintings and the 'dense, gray, velvety dust' that enveloped the items in his studio. For Morandi, the everyday objects of his studio became sources for philosophical meditation.

Alongside this we see photographs of Morandi's studios, in one of which Morandi himself appears; a further text reproduces his artistic credo:

> I am essentially a painter of the kind of still-life composition that communicates a sense of tranquillity and privacy, moods which I have always valued above all else … Nothing is more alien to me than an art which sets out to serve other purposes than those implied by the work of art itself.

> Nothing can be more abstract than, more unreal than what we actually see. We know that all we can see of the objective world, as human beings, never really exists as we understand it. Matter exists, of course, but has no intrinsic

meaning of its own, such as the meanings that we attach to it. Only we can know that a cup is a cup, that a tree is a tree.

<div align="right">Giorgio Morandi</div>

What we see in this interpretation programme is a focus on the artist in relation first to his contemporaries – his relations to other antecedent or coeval movements – followed by a poetic evocation of his working practice, located in the physical space of the studio; finally, in the use of the quotation from Morandi himself we encounter the mind of the man in the photographs and his account of the subjects and poetics of his practice. While Morandi's paintings are arguably somewhat hermetic in themselves in their limited subject matter, this interpretive frame, dealing in artistic preoccupations, works to isolate art so that it relates only to the creative impulses and philosophical insights of its creator. The paintings, it might be inferred from the silences in this form of interpretation, exist because of a non-social logic of aesthetic production and individual, innate creative drive.

An alternative would be to frame Morandi's painting in relation to the artworld conditions (which are social, technological, economic, intellectual and philosophical) in which it was first produced and consumed, or indeed in relation to its 'later lives' or subsequent 'critical reception' (although we need here to register a shortcoming of the latter term in that it implies that artworks are merely 'received' and do no work in or on discourse). But there are difficulties with this. On the one hand it may be that explicitly and consciously framing the artworld itself through artworks is somewhat unappealing for those who work in it, perhaps explaining the recalcitrance of many curators involved in the interpretation of recent and contemporary art. On the other hand, there is a sense in which this is simply difficult to do, and that a painting by Giorgio Morandi or Jackson Pollock is harder to talk about in this way than Rembrandt's *Syndics*. Other conventional frames, for example those relating to pictorial, formal, stylistic and technical matters, may be equally difficult to adopt in relation to conceptual art because of a perception that the artworks in question should not be valued in these terms. We might discuss this as a particular set of problems associated with interpreting objects designed for the gallery environment or even for white cube surroundings, and thus designed to be framed in a certain way – as creative and intellectual propositions by individual artists concerned with particular types of art historical referencing, synthesis and self-location within art history.

The stories here are of creative impulses, individuals' artistic preoccupations, 'movements', be they named and consecrated or constantly in formation and disassembly, and of individual figures perceived to be or have been capable of opening conceptual practices and traditions (for example Joseph Beuys). We might ask whether it would be an injustice to frame such works differently, to take them on any terms other than their own. Within this there is a further problem of the simple psychological and social (and possibly also legal) difficulties of historicising the recent past, especially when its protagonists, or those who knew them, may still be alive. Often, as we will see, this, among other things, leads to the very limited interpretation

of art through verbal means, which is to say that art interpretation is enacted not through the provision of text panels and labels but through the organisation of space and artworks within space. Otherwise, in many (but not all) instances where contemporary artworks are subject to significant text interpretation, we see the adoption of a kind of intentional-explanatory frame where the artist's intention and her conception of its significance is of primary importance in explaining a work's intellectual and conceptual basis and reason for being. Both of these approaches capture only a small sense of the social work of art (and contemporary artworks are still very much *at work* for their various producers, and it is possible that too much reflection on this would in fact compromise the work in question). We will look at examples and counter-examples of this later on. But for now let us consider another novel feature of the interpretive strategy at Tate Modern, taking up again a strand of reflection first developed in Chapter 2 – the co-construction of meaning, polyvocal interpretation and the multiplication of interpretive frames.

With the opening of Tate Modern in 2000 came a set of guidelines regarding interpretation at the museum:

- Interpretation is at the heart of the gallery's mission.
- Works of art do not have self-evident meanings.
- We believe that works of art have a capacity for multiple readings and that interpretation should make visitors aware of the subjectivity of any interpretive text.
- Interpretation embraces a willingness to experiment with new ideas.
- We recognise the validity of diverse audience responses to works of art.
- Interpretation should incorporate a wide spectrum of voices and opinions from inside and outside the institution.
- Visitors are encouraged to link unfamiliar artworks with their everyday experience.

(Wilson 2004)

Much of this can be seen to align with the interpretive framing discussed so far, for example in relation to experimental tendencies and the need to recognise subjectivities (in contrast to the ostensible authorlessness of many museum displays, those at Tate Modern are actually attributed, on the walls, to named curators, as in the example from the 'Material Gestures' display reproduced earlier). The final three guidelines are carried through into the design of a handheld PDA (with a standard hire cost, at the time of writing, of £3.50) which allows for the delivery of audiotracks, video footage and, in a few instances in the children's tour, games (for example, composing one's own digital collage from the shapes used in Matisse's *The Snail* of 1953). A number of the tracks for different artworks involve community participation, like the one discussed in Chapter 2 involving the responses of parents with young children to Asger Jorn's *Letter to My Son*. In a track under the 'fresh perspectives' heading for Matisse's *The Snail* we are told that 'Prior Weston School Art Group are about to give you their lively take on Matisse's work', after which a

group of primary school children do just that. Elsewhere, other 'voices' are included: an indie band discusses a Giacometti sculpture, the musician Brian Coxon responds to a Franz Kline painting with a long musical composition (only an excerpt of which is available), scientists discuss Jackson Pollock's fractal motifs and Tate staff tell us what it is like to stand inside Anish Kapoor's *Ishi's Light* (something which visitors are prohibited from doing themselves).

In part, such strategies respond to discourses about the infinite possible signification of art and the equal validity of different responses to it, as highlighted in the guidelines. This connects with a range of theoretical understandings relating to ideas such as the autonomy of the reader and the possibility of understanding artworks as in some degree 'open' in the sense articulated by Umberto Eco, in which meaning is not predetermined at the moment of production (Eco 1989). It also responds to a contemporary imperative to question and reposition power structures in the gallery through inclusionary practice by appearing to open up the authority to interpret to all comers. This is in effect a form of frame multiplication, where visitors are exposed to different and potentially contradictory ways of seeing, responding and interpreting, only some of which will be ascribed to museum professionals. This is an inclusionary gesture suggesting the possibility that different views can cohabit within one institution, and that the institutional walls of authoritative interpretation can be passed through. It reflects new institutional desires to suggest that there are different power relations – or different possibilities of power relations – between museums and visitors. It is, however, a very convivial orchestration of voices, and not the 'domesticated hostility' that Chantal Mouffe has advocated in discussing the democratic politics of participation (2002: 9), where a plethora of contradictory and conflicting voices would sound (Reith 2010). This is an important issue in relation to the cartography of the art museum, which is the extent to which it admits contrary mappings, overcoming the ideological supremacy of accuracy and veracity as ultimate ideals towards which museums have generally tended to strive. One of the inherent problems of recognising the multiplicity of meanings and possible interpretive processes and conclusions within an institutional context is that such multiplicity must be managed, represented and delimited so as to package it for public consumption.

Another element within the production of such multivocal resources is a recognition of the importance of talk and dialogue within the institutional context of the art museum. This recognition consciously works against some of the behavioural codes (notably reverential silence) associated with the modern museum while also aligning with new understandings of the significance of social interaction within interpretive processes, as exemplified by studies in museum learning and museum conversations (Leinhardt and Knutson 2004). Within this, the presentation of multiple voices allows for an evocation of dialogue, but of course it is one in which the visitor who hires a PDA – a visitor-as-user – cannot participate, much like the problem with asking questions of the visitor within label texts – there is usually nobody there (from the institution posing the questions) to listen to her answers. The dialogue is therefore a notional one, a commitment which cannot be made good,

unless more fully interactive technologies and platforms are developed. This has taken place in basic (but welcome) form in interactives in some museums (like the Museum of Fine Arts in Boston, which will be discussed in the next chapter) which allow visitors to vote on problematic issues. At Tate Modern a more multi-directional form of dialogue was enabled by the technological infrastructure of the 2010–11 exhibition in the Turbine Hall of Ai Weiwei's *Sunflower Seeds*. 'One-to-One' allowed visitors to record videos in dialogue with the artist, 'either asking him their question or answering one from him'. The artist, in turn, responded in videos to a selection of questions, and these videos were available in the gallery and online, pointing to new networked places of interpretive dialogue. It can be predicted that in developing a more committed practice of dialogue and debate we will see more experiments of this kind, as well as silent and conservative resistance to them by many artists and curators.

Tate Modern offers one set of solutions for the framing of twentieth-century and contemporary art. On one hand, artworks are made to frame and interpret one another within an organisation based on non-linear chronologies and the identification of conceptual affinities between works. On the other hand, a multivocal, dialogic interpretation is evoked through front-end participation, which is to say that non-professional or at any rate 'other' voices (like those of musicians or scientists) are co-opted and bound into the later stages of the production process. Within these frames we find the artists' voices too, explaining their intentions and bringing out aspects of meaning connected to this.

Contemporary dilemmas

These developments at Tate Modern form an interpretive practice which, irrespective of its perceived merits and problems, works in opposition to what has been a dominant interpretive frame in the presentation of contemporary art, which can best be termed *architectural* in eschewing verbal text and relying on spatial and visual organisation of objects in space. This is also the frame most closely associated with the elite, exclusionary practice of the art museum with its interests in a limited artworld audience. The architectural frame is a cultural artefact connected to a particular social ordering of art consumption which privileges those who have significant agency within the field of art, and whose cultural capital is such that written verbal interpretation would be perceived to be superfluous, distracting and probably objectionable for some of them; it therefore reproduces a particular power structure privileging an aesthetic sensibility 'of undying beauty, of the masterpiece'; and in ratifying this sensibility 'the white cube suggests the eternal ratification of the claims of the caste or group sharing [it]' (McEvilley 1999: 9; O'Neill 2007: 25). This frame suggests dialogue between artworks, but it is not dialogic in the sense discussed earlier: it does not evoke the kind of interaction which we saw at Tate Modern, however limited that was, nor the multitude of interpretive voices. It also protects the multiplicity of meanings which can be found in or borne by artworks and, in so doing, protects the dignities of the artists and curators involved, as discussed in Chapter 2.

As a cultural artefact this frame is also a confused product and remnant of certain modernist aesthetics, which themselves have bound within them romantic notions of fruition, in which the direct, perceptual and affective experience of the artwork is paramount. This led, in the past, to the impossible desire to efface the surroundings – as if this could be done by painting the walls white – and to remove or limit the disruption caused by labels and other written texts in order to minimise both intellectual and visual interference. This is the domain of the 'tombstone' label. It is a commonplace now – not least among curators – to recognise that the idea of a neutral, non-interpretive space or physical frame is an impossibility, and that in the absence of written verbal materials the onus of interpretation is simply shifted to another register. In this context, the pseudo-syntactical organisation of works in space is the medium through which theoretical propositions and arguments are made (Storr 2007). These propositions and arguments make relationships between works and orchestrate a set of encounters between visitors and artworks, working cumulatively to invite and produce a pre-imagined response and aesthetic experience. We see an example of this form of interpretation in Figure 5.3, showing one of the galleries from the Stedelijk Museum voor Aktuele Kunst (SMAK) in Ghent, Belgium. Here, specific aesthetic relations are pronounced through the play of scale, colour, shape, size and positioning (both on the wall and in the room) of the works on display and the creation of a defined field of vision. But these are visual narratives not bespoken in written texts and they are hard, if not impossible, to verbalise.

Another example of this is the Museum Moderner Kunst in Vienna (Figure 5.4) in which the exclusionary dimensions of this practice are most evident. Here the

FIGURE 5.3 Interior in the Stedelijk Museum voor Aktuele Kunst (SMAK), Ghent, Belgium; author's own photograph.

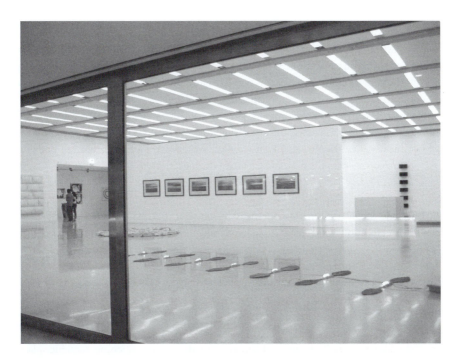

FIGURE 5.4 Museum Moderner Kunst, Vienna; author's own photograph.

organisation of the space is once again the primary means of interpretation, policed by black-uniformed warding staff in an impressive building which is part fortified castle (with its arrow-slit windows), part Death Star. The relative absence of interpretation and the forbidding surroundings must make it difficult for all but the most confident of gallery-goers to feel welcome, appropriately addressed and engaged, and comfortably in place.

There are of course many examples of displays and exhibitions in which the curatorial thesis organised through architectural means is also made explicit in written materials. One of the most prominent cases in point here is the tendency to compromise the architectural frame through the introduction of text panels which rationalise a grouping of disparate artworks by mapping them all in the same conceptual territory. This is a stock in trade in group shows, in which curators assemble in one space the works of different contemporary artists according to a common theme. Ralph Rugoff, the director of the Hayward Gallery in London, explains the poetics behind this kind of project:

> Most types of successful theme shows do not, as a general rule, delimit the potential range of our responses to the artwork they present. On the contrary, even while following a focused curatorial agenda, these exhibitions usually develop by examining variations on a theme, proceeding with twists and turns, and elaborating multiple subcurrents that ultimately open up our readings of

individual works. Such shows set up resonant echoes within the progression of works on display, so that each new art object we encounter informs our understanding of the one we just saw as well as the one we see next. In this way, group exhibitions can create a powerful cumulative effect, immersing visitors in an experience that seems expansive and also responsive to the viewer's own desires to explore a new world. The best group shows thus take on some of the qualities of installation art: rather than a chance to contemplate isolated objects, they involve us in an implied yet elusive narrative that we end up putting together ourselves as we move through the exhibition.

(Rugoff 2006: 48)

But there can be tension between the thematic concerns involved in the production of group exhibitions and their capacity to form the kinds of liberating spaces of connection described by Rugoff. Here is an example, in the form of the main text panel for 'Establishing Shot', a 2003 exhibition curated by Christian Rattemeyer at the Artists Space Gallery in New York and comprising works by Blake Rayne, Carlos Motta, Dee Williams, Gareth James, Liam Gillick, Douglas Gordon, Carsten Höller, Pierre Huyghe, Philippe Parreno and Rirkrit Tiravanija:

In film terminology, an establishing shot defines the opening sequence of a scene. Setting the mood, tone, place, and time for the events to unfold, the establishing shot is inextricably linked to the narrative that follows. Driven by the desire to be as precise as possible, it is often marked by a failure to complete its task. Ultimately, it derives its potential from the friction between its formal qualities – a single, presumably directly intelligible shot – and its function within the narrative sequence.

This exhibition serves as an 'establishing shot' for the following season, comprising a mixture of emerging and more established artists to highlight shared trajectories and concerns. It aims to reinvigorate debate about the different possibilities in defining emerging contemporary artists within the parameters of recent historic practice. It also addresses the potential friction between external narrative function and internal formal resolution, focusing on works that contain a split between their thematic concerns and material manifestations. Engaging themes as diverse as the political realities of kidnapping in Latin America, the history of painting, and systems of order, rationality, and enlightenment as signified by the natural sciences, all of the works in *Establishing Shot* are at once hypothetical and deeply concerned.

Here, the cinematographic theme is applied strongly to the curatorial project, but its terms are later used on the artists' works – the 'friction between external narrative function and internal formal resolution' which recalls the definition of the 'establishing shot' provided earlier. (The confusion as to whether the theme characterises the curatorship or the art or both says much about the explicit

creativity or constructiveness of recent curatorial practice.) Further commonalities across this evidently diverse body of works are nevertheless sought: it does not matter, the proposition goes, that the subject matter of the works on display is so heterogeneous, for each contains 'a split between their thematic concerns and material manifestations'. This thematic interpretive frame is part of the machinery of the economy of the artworld, for the group show is an exhibitionary regime through which artists pass as their status develops and they move towards consecration, for example to 'solo' and 'retrospective' exhibitions – although increasingly blockbuster group exhibitions include the work of very well-established artists. In passing through this regime, artists' works are made to play by its rules, which are about subjection to a thematic concern and a curatorial thesis which may or may not accord with the artists' perspectives. The problem which afflicts the thematic interpretive frame here is not dissimilar to that perceived by critics of the displays of Tate Modern: that the theme (which works as a category) is irrelevant; that connections made are weak; that the curatorial thesis is not convincing and bears little relation to the works, potentially 'miscasting' them and compromising their range of possible meanings; and ultimately that the representation embodied by a display or exhibition is not an accurate representation (or a desirable or responsible construction) of phenomena in the world, and the artists are relegated, as the curator Alex Farquharsen put it in 2003, to 'deliverers of the curatorial premise, while curatorial conceit acquires the status of quasi-artwork' (cited in O'Neill 2007: 24).

Such framings are made in relation to ideas about the value of exhibitions as 'authored subjectivities' (ibid.: 18), and to a general shift over recent decades in the role of the contemporary art curator. Farquharson notes that the emergence of the verb 'to curate' 'may also suggest a shift in the conception of what curators do, from a person who works at some remove from the processes of artistic production, to one actively "in the thick of it"' (in O'Neill 2007: 15; see also Graham and Cook 2010: 10–11). As O'Neill points out, this seems like a self-conscious recognition and embrace of the kind of curatorial agency Bourdieu described:

> The subject of the production of the artwork – of its value but also of its meaning – is not the producer who actually creates the object in its materiality, but rather the entire set of agents engaged in the field. Among these are the producers of works, classified as artists ... critics of all persuasions ... collectors, middlemen, curators etc.; in short, all those who have ties with art, who live for art and, to varying degrees, from it, and who confront each other in struggles where the imposition of not only a world view but also a vision of the art world is at stake, and who, through these struggles, participate in the production of the value of the artist and of art.
>
> (Bourdieu 1993: 261)

This is the context in which we can locate the strongly ideological interpretive plays of biennials, the emergence of the artist-curator and the reconceptualisation

of the white cube model of display as a laboratory, literally engaged in artistic production, the expression of 'connective possibilities' and the making of propositions (Obrist in Bishop 2004: 51, n. 2). These developments are part of a complex of problems relating to power dynamics between artists and curators, attempts to historicise curatorial practice – notably in Hans Ulrich Obrist's interview-based approach (2008), the emergence of exhibitions as the primary explications of the state of art and the commonplace notion of the indeterminacy of contemporary artworks' meanings, making of them potential playthings for signification. We see something of this in exhibitions which seek explicitly to fashion new movements, like the 'Neurotic Realism' mapped in a group exhibition in the Saatchi Gallery exhibition of the same name in 1998, or to characterise new chronological and critical paradigms for the production and consumption of art, as at the 'Altermodern' exhibition at Tate Britain in 2009 curated by Nicolas Bourriaud. The explicit manifesto of 'Altermodern' is worth reproducing (although what follows is the short version) to give a sense of the strong play for meaning involved in this form of exhibitionary proposition:

ALTERMODERN
MANIFESTO

POSTMODERNISM IS DEAD

A new modernity is emerging, reconfigured to an age of globalisation – understood in its economic, political and cultural aspects: an altermodern culture.

Increased communication, travel and migration are affecting the way we live.

Our daily lives consist of journeys in a chaotic and teeming universe.

Multiculturalism and identity is being overtaken by creolisation: Artists are now starting from a globalised state of culture.

This **new universalism** is based on translations, subtitling and generalised dubbing.

Today's art explores the bonds that text and image, time and space, weave between themselves.

Artists are responding to a new globalised perception. They traverse a cultural landscape saturated with signs and create new pathways between multiple formats of expression and communication.

The Tate Triennial 2009 at Tate Britain presents a collective discussion around this premise that postmodernism is coming to an end, and we are experiencing the emergence of a global altermodernity (Tate 2009).

Bourriaud noted that the exhibition 'presents itself as a collective discussion around this hypothesis of the end of postmodernism, and the emergence of a global altermodernity' (ibid.), leaving no doubt about the self-consciously discursive nature of the display. But in each of these instances the intellectual and aesthetic propositions embodied within the exhibitions had a mixed reception and were subject to challenge. 'Neurotic Realism' was dubbed a misleading convenience classification (BBC 1999), and 'Altermodern' prompted the following responses, expressive of a certain frustration at the highly theorised but opaque cultures of production of such propositional exhibitions:

> Walking through the show is like spending a few hours aimlessly surfing the net. A seemingly endless stream of politics, porn, science fiction, history, culture and science flows past you so fast that when you leave it is hard to say where you've been.
>
> (Dorment 2009)

And:

> The theory [of the 'altermodern'] is complex and this is an incredibly uneven exhibition that, like the mind of any French theorist, contains flashes of genius, passages of stomach-churning political correctness, a bit of bean-bag art (art that you enjoy while lying on the bean-bags placed in front of it), and an afternoon's worth of artists' movies (some stunning). The whole mélange is served up with the thick buttery sauce of French art theory, and the catalogue essays will give anyone except a curatorial studies MA student a *crise de foie*.
>
> (Lewis 2009)

There is also a delicate economy of interpretive practice within these live cultures for artists have to play the game according to their position within their artistic field (itself determined by status, fame, and so on), and such practice is not independent from the market for art. It determines how artists are seen and represented, how seriously they are taken, and so on, while curators stake a claim to the legitimacy of their own work as a profession in the literal sense that they *profess* – an iterative act of authoritative and authorial creative sense-making and facilitation of production – a provocative counter to the ostensible authorlessness of the traditional museum. In interpreting contemporary art a lot is at stake for the artworld, the artwork and the artist, and this is precisely why the practice is both so fraught and obtusely theorised. This complex of interpretive matters is too intricate to describe fully here and warrants more space than I can give it, space allowed by other books (Rugg and Sedgwick 2007; Marincola 2007; O'Neill and Wilson 2010). But it is important here to develop an understanding of one of the more tangible interpretive frames adopted for contemporary art – one which finds form in written texts and relates politically and epistemologically to the crisis of meaning to be found within the developments described above. This is the intentional-explanatory frame, which works to explain

the significance of the artwork from the perspective of the artist who produced it, often in a desire to relay her or his creative intention. Here is an example from the Stedelijk Museum in Amsterdam (Figure 5.5):

Job Koelewijn, Spakenburg (NL), 1962
Lives and works in Amsterdam (NL)

Nursery Piece, 2010
Sand, pigment, printed stickers, eucalyptus and Spinoza's Ethics on paper
Courtesy Fons Welters Gallery, Amsterdam

This work is a sand drawing beneath which loose pages from Spinoza's *Ethics* are visible. What appeals to Job Koelewijn about the influential book by philosopher Baruch Spinoza (1632–1677) is the philosopher's attempt to lift the reader to a higher plane, offering a way out from the inescapable ethics of everyday life. Made up of blue and green sand, the work is like a ritual mandala, painstakingly built up and swept together with equal care. Koelewijn makes an indirect connection between the philosophies of Spinoza and Buddhism. The powerful optical effect of the drawing and the penetrating scent of eucalyptus massage the wisdom of Spinoza into our minds.

This interpretive frame works like the narrative-formal frame discussed in the last chapter in relation to Tintoretto's *Susannah and the Elders*. In that example,

FIGURE 5.5 *Nursery Piece*, Job Koelewijn, 2010; image courtesy of Gallery Fons Welters.

the viewer was told precisely what to notice, what to look at and in what order. The text above which relates to Koelewijn's work presents a narrative itinerary of a different kind, moving from the artist's interest in Spinoza to the conjoined material formation and significance of the work. Our attention is then explicitly drawn to the optical and olfactory aspects of the work and a particular process of affective and intellectual meaning-making is prescribed for us as an aesthetic experience. In some ways this frame is inclusionary in decoding for us the meanings embodied within the work – meanings which would no doubt be difficult to access for many visitors in the absence of written interpretation which characterises the architectural frame. (Of course it helps if visitors are familiar with mandalas and, perhaps, Marshall McLuhan's dictum 'the medium is the massage'!) But the text does prescribe and delimit understandings, and works against the notional possibility of infinite meanings which has characterised much discourse in contemporary art: the potentials for ambiguity and obfuscation are reduced and in the distant aftermath of the birth of the reader, the author's intentions and signifying desires are reinstated as an interpretive key. It is also notable that the text speaks confidently *for* the artist, as though written with his consultation. This is a practice which we will discuss again in Chapter 7. This interpretive frame is particularly effective in overcoming the barriers of comprehension related to visitors' understandings of art theory and in particular where value lies. But in such instances, close attention to the accessibility of concepts and language is required in demystifying content, for the philosophical and political ideas and precedents involved in some contemporary artworks may well require explication and mediation in order to be comprehensible to non-specialist audiences. It could be argued that Koelewijn's work does involve the hard work and skill which are so important to many visitors in ascribing value to works of art (although we do not learn from the text whether he was responsible for materially producing the work or whether he oversaw its production by others), but for more conceptual works which pose a greater challenge to conventional understandings of art (like Willem de Rooij's *Route Along 18 Corners* in the same museum, in which a brochure guides visitors around the corners of empty gallery spaces), this frame is a powerful play within the relationship between different currents in discourse and interpretation: intellectual accessibility and the protection of the multiple meanings of artworks.

A similar example is provided in the long interpretive text in the brochure accompanying the 2010 'Material Mutters' exhibition of Pae White's work at the Power Plant – a contemporary art gallery in Toronto:

> American artist Pae White's exhilarating oeuvre roams across different material forms – including expansive sculptures, textiles and animation – with a sense of glorious abandon. In examining the intersections of art, design, applied arts, and architecture while ignoring the traditional boundaries between them, White encourages viewers to take a closer look at familiar objects, processes and spaces. Simultaneously evoking the material and the immaterial, White's major exhibition at the Power Plant surveys her work from the past five years in a range of media, with a focus on her monumental tapestries.

The text goes on to survey White's career as a 'brilliant manipulator of materials', outlining the various types of work and individual projects for which she has become 'internationally known', before explaining the technical dimensions of her tapestries as 'ambitious artisanal undertakings'. Within this, previous works are characterised:

> The sublime Still, Untitled, featured at the 2010 Whitney Biennial, stages what White describes as cotton's 'dream of becoming something other than itself' by contrasting immaterial smoke with the tactile physicality of cotton fabric.

We then learn that the new commission on display forms both 'a new visual direction in her work [as well as] representing her continued practice of blurring materials and appropriating scraps and ephemera', and that the accompanying works on paper 'appear to be drawings of smoke but are in fact carvings into pigmented paper accomplished with a laser'. After further technical explanations of this kind relating to some animation works on display, the text concludes with a brief account of the numerous exhibitions around the world, both group and solo, in which her works have figured. This guide to White's artistic preoccupations and techniques is a set of invitations to the visitor that works through adjectives ('*expansive*' sculptures; '*glorious* abandon'; '*brilliant* manipulator'; '*sublime*' and so on, which form terms of reference for the act of viewing. The artist's voice is co-opted too, both in her reported encouragement to viewers 'to take a closer look at familiar objects, processes and spaces' and in the quotation encapsulating the intention and significance for her of *Still, Untitled*. All of these strong hints let visitors know how to look at White's work and how to interrogate it for meaning. The interpretation works within specific cultures of consumption: the Power Plant is sustained financially through its membership, and it is important to demonstrate to them the international significance of the artists who exhibit there and the profound significance and complexity of the artworks (hence some of the superlative language), while also providing some of the intellectual tools to apprehend their value. The interpretation situates the Power Plant itself in relation to prestigious venues which have shown White's work, according status to the institution itself while also affirming that what can be seen there is novel, and represents a shift in the artist's practice. But once again this form of interpretation is characteristic of a new emphasis on the importance of the artist's voice, which is a dynamic countercurrent in the interpretational economies of the artworld which privilege the curatorial thesis within exhibitionary practice. This is also a tendency which plays out in the provision of film documentaries about artists' practice showing in exhibition spaces or adjacent information spaces, and in public events programmes featuring artists' talks and artist-led tours. The close examination of these forms of interpretation is outside the scope of this book, but they do indicate the developing hold of this interpretive frame as a means of negotiating some of the dilemmas and anxieties about conveying and discussing meaning in contemporary art, not least because the availability of a brochure, a carefully sited screen showing a documentary or a programmed event can circumvent the need to interfere with the visual orchestration of display by including wall texts.

This final example – from the Institute of Contemporary Art in Boston – is similar in some respects to the preceding ones in relation to its explanation of the meanings of the artwork in question – a single-channel video of motor oil being poured over a block of sugar cubes:

> Kader Attia, born 1970 in Dugny, France; lives and works in Paris and Berlin
> *Oil and Sugar #2*, 2007
> Video on DVD 4:13 minutes, colour, with sound, promised gift of Audrey and James Foster

> Kader Attia's *Oil and Sugar #2* invites us to consider how both traditions and materials change over time. The pristinely stacked block of sugar cubes evokes the 'white cube' of the modern museum space or art gallery. As a stream of motor oil gradually saturates the crystalline volume, another reference emerges: the Kaaba, a black, cube-shaped building in Mecca that is one of the most sacred pilgrimage sites of Islam. In the video's final moments, as the structure buckles and dissolves, it suggests the fragility of a global economic system built on fossil fuels (the stream of motor oil) and unchecked wealth accumulation (the stock-piled sugar). By the end of the video, the pooling, viscous blend of ingredients eludes binary oppositions we often take for granted: solid/fluid, stable/fragile, black/white, food/fuel.

This label is notable in precisely deciphering the symbolism of the artwork, but also in explaining its meaning as an interpretation and critique of an external object – the 'global economic system'. The questioning of abstract binaries at the end of the label then becomes a game of relations as we are implicitly invited to think of them in relation not just to the immediate objects of the video – the oil and the sugar – but also to the external object: what does it mean to think about the global economic system in relation to solidity and fluidity, black and white, and so on? Notably, the label does not seek or achieve an overall intellectual resolution of the disparate references marshalled – for example, we are not told what the relations might be between the white cube and the Kaaba, but we are enabled to speculate. One of the areas of tension in this political-explanatory framing is the political and politicising nature of the artwork itself, so that issues of focus on signifiers or signifieds are confused; what we find in the label is an interpretation of an interpretation. One might suggest that this is an interplay which is always obtained between label texts and artworks of all sorts, but arguably it is at its most obvious in examples like this, and has the most obvious potential for dialectical work within curatorial interpretation – something we will explore in Chapter 7 in relation to practice at the Northern Gallery for Contemporary Art in Sunderland, UK.

These then form some of the characteristic frames of interpretation of contemporary art at present, and within them we find contradictory tendencies concerning the matter of who speaks and for what – whether we are dealing with curators speaking theory through artworks, or speaking for and with artists – and what is being

framed. We see the persistent hold of a form of silence in some interpretation, where artworks are not framed through written text but removed from everyday existence and consecrated through the mere physical conditions of their display, countered by interests in intention and preoccupation that invite visitors once again to experience the artist-as-individual through engaging with the complex of artworks and other texts. We see a contest for meaning in and of contemporary art, and anxiety about its fixity and status. Some of these issues will be taken up again in relation to the case studies of contemporary art galleries presented in Chapter 7, where we will see the institutional forces at play in the production of interpretation in closer focus. In the remainder of this chapter, we will consider another highly particularised artistic categorisation and its interpretive framing: decorative art.

Decorative difficulties

As discussed in Chapter 2, categorical divisions between 'fine' and 'decorative' arts are questionable, and have been questioned by theorists of material culture at least as far back as the mid-nineteenth century. Indeed, the making of such divisions has as much to do with institutional and professional divisions in the museum world at that time, for the emergence of the South Kensington Museum in 1852 was made possible by an insistence on the economic imperative to improve British manufacture and consumer taste through exposing the public to good historical examples; and this museum model was replicated all over the West. This alone reified a category, but the category itself was difficult to define. Did it contain sculpture (and what is sculpture), figurative vases, or armour? What about when objects are not merely or even predominantly decorative, but functional? Cannot a painting be decorative, or indeed functional? At the same time, the panoply of names associated with art-which-is-not-fine-art then and now – decorative, ornamental, applied, useful, design, craft, handicraft, manufacture, folk, vernacular and (sometimes) aboriginal or indigenous – suggests an extremely confused cultural cartography. But while it is tempting to contend that similar frames of interpretation might be applied to all sorts of art forms in a kind of epistemological levelling act, in practice, interpretive emphases have developed within the framing of the decorative art which, while they sometimes resemble those pertaining to fine art, are more attenuated in specific ways. One example of this is the material-technical frame, which assumes particular importance in explanations of how objects were made and from what. The label for the Mérode cup at the V&A involves the adoption of this frame with strong reference to the material composition of the object; the technical process of its production is somewhat left to inference and the label concludes with notes about ownership which establish the importance of an object which we already know to be 'remarkable':

> The Mérode cup
> About 1400

Set with tiny inset windows filled with transparent plique-à-jour enamel, this remarkable cup is the only medieval example of a rare technique. The body and lid are decorated with a pricked pattern of vine scrolls and birds. The leafy finial would once have been set with a gem. Similar cups are described at this period among the possessions of the French king Charles V and his brother, the great collector Jean Duc de Berry.

This label also shows some of the terminological issues relating to this frame, for, to ensure intellectual accessibility, it requires the explanation (and often the translation) in adjacent texts or other interpretive resources of the features, materials and techniques involved (e.g. 'finial', 'enamel' and 'plique-à-jour'). A similar text from the display of Korean decorative art at the Royal Ontario Museum provides comparable pointers to the visitor as to what to notice about the object (Figure 5.6), while explaining the technique and providing a physical description so comprehensive that only curators and connoisseurs might benefit. Indeed, the last sentence of the label resembles the kind of information to be found in object records used in museum documentation, and this level of description, as Baxandall notes, may seem otiose because the object is there to see (1991: 35):

Repoussé knife sheath
Silver
Tenth–fourteenth century, Goryeo dynasty

FIGURE 5.6 Repoussé knife sheath, 10th–14th century, Korea; image reproduced courtesy of The Royal Ontario Museum; author's own photograph.

This silver knife sheath typifies advanced metalwork production of the Goryeo dynasty. Its surface is textured with a fine mesh pattern to attract a delicate play of light. It also features fine repoussé decoration – achieved by hammering on the reverse side – in the shape of phoenixes, writhing dragons, ducks and chrysanthemums set in ornate frames. Motifs are grouped in seven horizontal sections with phoenixes at the top and ducks at the bottom.

This is a technical framing within a metaframe in which the essential characteristics or principles of Korean decorative art are established in a main text panel:

The principles that guide Korean decorative art place equal emphasis on form and function. Simplicity and practicality are stressed in the production of objects for daily use. Yet, even seemingly mundane household items such as eating utensils, tools, hairpins and lacquered containers feature meticulous skill, a vibrant colour palette and rich symbolism. The subtle balance between utility and elegance is a distinctive quality of Korean decorative art.

This text introduces a key preoccupation within the framing of decorative art, which is its close relation to its place of production. But while this metaframe works to provide ways of seeing and to invite visitors to bestow a specific kind of regard on the objects to which it relates, it does not seek to explain why such 'principles' came to obtain. It is, in this sense, a kind of geo-essentialising frame in that it presents the characteristics of decorative art in a given place (in this case Korea) as essential, and not obviously related to questions of taste, consumption and markets. We will encounter the importance of place again shortly, but before we do, here is another label, this time from the Istanbul Archaeology Museum, in which the technical framing predominates almost entirely, leading to an extreme level of connoisseurial intensity:

Slip ware

[This] group of polychrome ceramic vessels dating from the second half of the 16th Century employs the slip technique and displays a preference for naturalistic flowers. In this technique objects were covered with a coloured slip – often tones of red or lavender in Iznik specimens – following which decoration was applied in other coloured slip mixtures and covered with a transparent colourless glaze. In order to increase the limited range of coloured slip mixtures underglaze pigments were also used sometimes.

It is clear that this kind of explanation requires a large amount of prior knowledge from the visitor, as well as prodigious attention to detail and the ability to refer between the dense and somewhat dry text and the visual characteristics of the objects on display. This is a significant challenge, and, it might be guessed, can easily induce disengagement in many visitors. The following text panel, from the Freer Gallery of Art in Washington DC, relates to similar objects:

Later Islamic ceramics:
Iznik ware

The tradition of under-glaze painted ceramics reached new levels of artistic and technical achievement in the early fifteenth and sixteenth centuries under the Ottoman dynasty (1453–1922) based in present-day Turkey. The main center for this development was the city of Iznik in northwestern Anatolia, where potters succeeded in producing vessels with a hard, white body and a crystal-clear glaze. Chinese blue-and-white porcelain, which enjoyed tremendous popularity at the Ottoman court during the fifteenth century, provided a vital source of inspiration for early Iznik ceramics. Lotus flowers, peonies, and many other Chinese decorative motifs were skilfully combined with Islamic floral and vegetal designs. In the second quarter of the sixteenth century, Iznik potters added new hues, such as sage green and manganese purple, to the colour scheme of Iznik wares and expanded their decorative repertoire. Iznik ceramics reached a high point by the middle of the century when potters introduced a brilliant iron-rich red, which is largely responsible for the fame and popularity of Iznik ware. This vibrant palette, one of the greatest technical and aesthetic achievements of Ottoman art, coupled with exuberant designs, was adapted to both Iznik ceramic vessels and architectural tiles, which still adorn many Ottoman buildings.

This text combines interest in the material dimensions of the production of this body of ceramics while also accounting for the ornamental motifs adopted in relation to patterns of influence. In this context, the text somewhat resembles the evolutionary frame discussed in the previous chapter in relation to painting, for what is at play is the transference of influences (of Chinese blue-and-white porcelain) and the divergences this creates within a single geographically-located artistic practice. Aside from this, the account of practice is a sophisticated guide to looking, but it is also quite hermetic. It is only at the very end that we learn something about the role of this material culture – for example that it played a part in the adornment of buildings (but how, which or whose buildings, and why?); there is a brief note in the main text panel on the 'Arts of the Islamic World' to explain that some objects on display, 'were the result of secular patronage, intended for personal and private enjoyment', but this only hints obliquely at cultures of consumption. Otherwise, the account of the work of Iznik potters brings to mind the attempts of horticulturalists to create new varieties of flowers, and this hothouse representation suggests an artistic culture set apart from social worlds.

In the same gallery a different framing, emphasising the functional role of objects, can be found in the label text for an oil lamp:

Throughout the Islamic world, mosques and other religious structures were illuminated with rows of oil lamps suspended from the rafters or ceiling. During the fourteenth century, hundreds of such lamps were commissioned

by the powerful Mamluk ruler and patron of the arts, Sultan Hasan (reigned 1347–51 and 1354–61), for his vast religious complex in Cairo. These mosque lamps were elaborately painted, gilt, and enameled and often included the Sultan's name and calligraphic emblem. In addition to their practical function they also served as symbolic representations of a specific Koranic verse (24:35), known as the Light verse, which encircles the tall neck of this lamp:

'God is the light of heaven and earth: his light is like a niche in which is a lamp.'

In this label we read only summary details of the material and technique and the only account of the aesthetic properties of the object lies in the adverb 'elaborately'. Rather than standing as an individual art object, the lamp is in fact made to stand for a set of cultural and religious practices and to a specific historical regime of rule. Elsewhere, the Freer Gallery of Art involves successful syntheses of these technical, evolutionary and functional frames, but the extent of text required to do this suggests very literally the great intellectual lengths which it is necessary to go in order to do so. The text panel for the 'Shades of Green and Blue: Chinese Celadon Ceramics' display is 338 words long and is accompanied by a map of the geographical areas of celadon production. It 'presents the technical and aesthetic evolution of the Chinese green and blue glazes known collectively as celadon' and explains the materials and techniques involved in stoneware and porcelain celadons. It goes on:

> Some celadon glazes were developed to provide a nonporous coating for storage jars; others, such as the Guan glaze created for imperial court ceramics during the Southern Song dynasty (1127–1279), exemplify a rarified aesthetic that reached unparalleled sophistication. All celadon glazes use iron as the main colorant.

After this, the evolutionary frame is adopted as we learn about the influence on celadon vessels of bronze and lacquer ware and follow the development of celadon glazes in different dynasties, provinces and 'kiln complexes' in China, mapping different celadon traditions. The text concludes by briefly adopting a socio-historical and functional framing in highlighting 'the impact of patronage and the use of celadons for burials, everyday life, the imperial court, and as export goods', before emphasising the historical significance, value and influence of Chinese celadons. This is not all: another extended text panel entitled 'What's In A Name?' frames the ceramics etymologically and colouristically, explaining the origins of the term 'celadon' and the difficulties of relating it to its Chinese equivalent *quingci*, which connotes a broader range of colours. This rich overlaying of interpretive frames provides an extraordinarily rich range of possible comprehensions and intellectual challenges for attentive visitors. But the disadvantage here lies in the same plurality of interpretive frames, the complexity and length of the communication, the technicality of the language and the likelihood that few but the most committed of visitors will be inclined to explore fully the interpretive territories mapped out in the exhibition texts.

In many of these examples the significance of place is clear in relation to the development of specific centres of production (like the city of Iznik) and artistic traditions and even highly localised phenomena such as 'kiln complexes'. But in other displays elsewhere this is foregrounded by much more emphatically geo-contextual framings of the objects in which cultures of artistic production are accounted for in relation to the morphology of the landscape (i.e. the characteristics and availability of materials like wood or minerals which make manufacture possible), political and infrastructural factors (e.g. power structures and trade and transport links) and the development of local cultures and markets. Here is an example of this from the Metalwork Gallery in the Millennium Galleries in Sheffield, in the UK, in the form of a text panel explaining why Sheffield became an important metalworking centre:

Why Sheffield?

Fast water supplies, forests, and mineral deposits in the Sheffield area were crucial elements in knife making.

Knife makers, known as cutlers, needed a few simple things to practise their craft. They required fast flowing streams and ready supplies of charcoal, iron ore, and gritstone. Timber was burned to make the charcoal needed to smelt iron ore.

Cutlers sharpened iron blades on the rough gritstone grindstones powered by water wheels.

Cutlers in Sheffield had the support of a powerful local lord, the Earl of Shrewsbury. These unique advantages helped establish Sheffield as an international metalwork and cutlery centre by the early nineteenth century.

Place and the objects which are produced within it are dual foci in this framing, and the display functions as much as a history of work in the locality as it does as an exhibition of art objects. This metaframe enables the mobilisation of several others in subordinate displays, making for a rich set of encounters:

- a biographical frame is adopted, for example in introducing the work of the designer Christopher Dresser in Sheffield;
- materials and processes are explored in a substantial display (Figure 5.7) in which there are 'objects in focus' – for example a fish slice, whose label tells us of nineteenth-century etiquette of serving fish, or a candelabra, whose neoclassical style is analysed;
- socio-historical frames open vistas on to cultures of snuff-taking, shaving, eating, drinking and writing, in all of which Sheffield metalwork has played a part; here interpretation takes the form of responses to imagined questions (What is this object? How was it made? Who used it?);

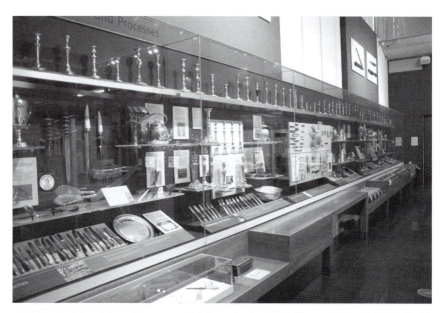

FIGURE 5.7 Materials and processes display, Metalwork Collection, Museums Sheffield: Millennium; image reproduced with the permission of Museums Sheffield; author's own photograph.

- a participative frame is adopted in co-opting the voices of contemporary people talking (in audio recordings or on wall texts) about their own histories and memories, from Rashida Islam, who learned about Sheffield steel in geography lessons at school in Bangladesh to officers of the Cutlers' Company and Mrs Margaret Cannon, a sometime scissors maker at a prominent manufactory.

This multiplication of frames coheres only because of the geo-contextual metaframe. By this means many different comprehensions of the objects are rooted to a single geographical and conceptual place, which is the immediate locality of the gallery itself. This means that the representation involved in the display has particular bearing on the identities and life histories of many who might visit from the area, and this is a burgeoning emphasis in a number of displays: other examples in the UK include the 'Northern Spirit' gallery at the Laing Art Gallery, Newcastle, which 'celebrates the achievements of artists, manufacturers and makers from the North East of England', the Manchester Art Gallery's 'Manchester Gallery' which forms a 'celebration of the creativity of Manchester, from the city's 200-year-old textile industry to today's thriving contemporary art and design scene', and the 'Arts of Living' display of decorative arts (including Norwich shawls and stained glass) at Norwich Castle Museum and Art Gallery. This forms in some sense a turn away from the 'universal' histories associated with the encyclopaedic art museum, in which place figured more as an organisational container for stylistic developments than as an object of focus in its own right, and decorative art museums looked outwards beyond

their own localities to accrue collections. At the same time, such displays are attentive to the imperatives to include and represent the interests of local communities, while also helping to show (if often in a celebratory way) that places can be both constitutive of works of art and, in some ways, constituted by them, either through topographical representation or through the dominant importance of cultures of production and consumption. We will encounter a more integrated focus on locality – this time the locality of Boston and New England – in the next chapter's analysis of the Arts of the Americas wing at the Boston Museum of Fine Arts. In this example we will also follow through with questions of the interpretation of decorative art, looking at the ways in which interpretive frames are applied over mixed displays which also include fine art in order to understand the work done by artworks in society.

This chapter has surveyed some of the most prevalent interpretive frames associated with the display of recent, contemporary and decorative art. Key themes encountered include contests over and anxieties about meaning, the authority to speak about or through art and the relationships between display, consumption and inclusion, and between art and place. Through these encounters we have also seen examples of different ways of understanding works of art, invitations to undergo different kinds of aesthetic experience and different political standpoints in imagining, positioning and potentially including the visitor, whether as elite consumer and connoisseur or 'expert' of her own world and interests. Another notion which has begun to emerge is that of the work done by artworks in the world, whether as functional and symbolic objects, or as objects produced within discourses of art which they may reproduce or renew. Here we come close to a significant problem, which is, on the one hand, that of interpreting objects which are themselves complex interpretations, amongst other things, and, on the other, that of approaching the indissoluble nexus of object, discourse and interpretation. Such conceptual matters will be taken up again in Chapter 7, the second of the next two chapters, which will focus on case studies of institutional contexts to look more closely at the deployment of interpretive frames and the development of practice in relation to displays of historical and contemporary art.

6

CASE STUDIES

INSTITUTIONAL APPROACHES TO HISTORICAL ART

This chapter is one of two in which we will look in greater depth than hitherto at interpretive practice within specific art museums. All of these case study museums have undergone, or are (at the time of writing) still undergoing, significant redevelopments which afford the possibility to review and renew their interpretive strategies; they therefore represent some of the most cutting-edge and interesting examples of practice today. This chapter will seek to contextualise interpretive practice within two art museums: the Art Gallery of Ontario in Toronto in Canada and the Museum of Fine Arts in Boston, in the United States. In each case the analysis of the interpretive programme and its strategies will be supported with data obtained through semi-structured interviews conducted by me with some of the key figures involved in interpretive planning. Unless otherwise stated, the factual information in what follows is attributed to them or to textual materials available in the museums themselves.

The Art Gallery of Ontario

After a redevelopment project launched in 2002 and a year of full closure, the Art Gallery of Ontario (henceforth AGO) reopened in November 2008 in a building extended by Frank Gehry (an architect known for being at the forefront of museum architecture, and notably for his design of the Guggenheim Museum in Bilbao) and with fully redisplayed collections. These changes amounted to a major capital and endowment project worth some $300 million, with about a third of that coming from one individual – Ken Thomson (1923–2006), who also donated much of his private collection of mainly European and Canadian art. The redevelopment was also funded by numerous other private and corporate donors as well as the Government of Canada and the Government of Ontario (AGO 2008); there were nearly 4000 donors to 'Transformation AGO', representing a broad range of communities and

gift levels. Since then, AGO has seen visitor numbers of some 800,000 per year, of which about 83,000 can be disaggregated as educational school group visits. AGO charges for admission, currently around $20 for an adult. AGO's mission statement is 'we bring art and people together and boldly declare that Art Matters', and it works with guiding principles:

Diversity: Our programming will recognize and reflect diversity by: engaging artists and audiences from a full spectrum of demographic and cultural groups; encouraging the exhibition of diverse artforms; encouraging multiple meanings and interpretations of art and related issues; and recognising a variety of teaching, learning and communication styles.

Responsiveness: As a learning organisation, our programming will be responsive to our communities by: creating and responding to indicators that measure visitor experience; listening to community input and feedback to incorporate needs and desires into programming.

Relevance: Our programming will be relevant to our communities by: supporting visitors to make personal connections; facilitating and supporting a mix of voices; having the flexibility and agility to identify and make connections to emerging social issues through art.

Forum: Our programming will provide a forum for active dialogue by: building and sustaining relationships based on mutual trust and respect with all constituent groups; sparking formal and informal debate about art and related issues: encouraging spontaneous interaction and generating multiple strategies for interpretation; confronting issues of importance.

Creativity: Our programming will reflect and inspire creativity by: encouraging imagination and contemplation related to art experiences; making new connections between the familiar and the unfamiliar; fostering art making; and encouraging experimental and experiential engagement with works of art and their accompanying bodies of knowledge.

Transparency: Our programming will contribute to transparency by: increasing understanding of what art museums and their professionals do and why; representing art as not only a finished product but also as a process; demonstrating the breadth and scope of the AGO; and being accountable to all our constituents. (AGO 2011)

The display of the permanent collection is diverse, as are the collections themselves. On the ground floor are a series of rooms showcasing the heterogeneity of the Thomson collection, which ranges here from medieval alabasters, African religious and ceremonial objects and Chinese snuff boxes to Rubens' *Massacre of the Innocents*.

The theme of the display is the collector's taste, insight and instinct. Downstairs on the concourse level is another gallery showing Thomson's collection of ship models. Other parts of his collections are to be found elsewhere in the museum in the two main suites (or 'hubs' as they are called) of galleries with permanent displays: these are the 'European hub' and the 'Canadian hub', and Thomson himself was involved in many of the aesthetic and interpretive decisions involved in the display of his collections. There is a temporary exhibition space, dedicated, at the time of writing, to an exhibition on the Maharajas which originated at the Victoria and Albert Museum in London, while the uppermost floor is dedicated to contemporary exhibition space. I will not explore these temporary exhibitions here for reasons of space and the focus of this chapter. Rather, I will focus on the interpretive dimensions of the organisation of the collections in space and through text (there are some other resources such as listening posts). What interests me here is the literal configuration of the stories told through the permanent displays. I shall provide a brief account of this based on my own observation, supported where relevant by interview data.

This data comes from a semi-structured interview held in December 2010 with Judy Koke, Deputy Director of Education and Public Programming and leader of the Interpretive Planning and Visitor Research Team, part of the core group involved in the work of interpretation. Within the transformation of AGO the processes of planning for and producing interpretation were also transformed, involving a move to a way of working in which curators are the primary source of ideas for displays and exhibitions but work with interpretive planners, who 'help shape displays, contributing to the identification of key messages and visitor outcomes, as well as of works that need interpretive support or extended labels'. Within this process curators produce a brief explaining the reasons why a given object is important to the exhibition or display, what ideas it illustrates and what it demonstrates. An interpretive planner then writes the relevant text, in line with a number of institutional norms and standards. The text is then developed collaboratively and iteratively with the curator, for, as Koke notes, 'the interpretive planner [has the] expertise in how to communicate ideas to a general public whereas the curator has the expertise in why the art is important or why the ideas are important'. The text is then submitted for approval to the Director of Curatorial Affairs and the Director of Education, ensuring that both scholarly and visitor requirements are met in the framing of text. This thorough and rigorous process is, for AGO, a new way of working and represents a relatively new shift in working practices of interpretation in art museums, although to Koke, whose background is not in art museums but in science museums, it is a familiar one: she notes that 'we went through this in natural history in the early '90s'. Another point of interest here (and in all art museums) are the bodies of theory upon which those responsible for interpretation draw. While some are obviously drawn from the discipline of art history, others relate more closely to museum studies, visitor studies, communication, psychology and learning; even where gallery staff claim little knowledge of or interest in the latter area they still inevitably adopt and adapt received wisdoms in this regard. But at AGO this use of theory is much more conscious, and Abraham

Motivational level	Description of person at this level
Self-actualization	Seeks fulfillment of personal potential.
Esteem needs	Seeks esteem through recognition or achievement.
Belongingness and love needs	Seeks affiliation with a group.
Safety needs	Seeks security through order and law.
Physiological (survival) needs	Seeks to obtain the basic necessities of life.

FIGURE 6.1 Maslow's Hierarchy of Needs, based on the summary of Maslow 1943 in Koltko-Rivera 2006: 303.

Maslow's 1943 hierarchy of needs (Figure 6.1) together with John Falk's theory of motivational identities introduced in Chapter 1 (Falk 2006 and 2009) are at play within the interpretive programme, precisely because their focus is on the imagined visitor, helping staff to think about: why is the visitor here and what does she need out of her visit? These frameworks act as the 'filters' through which the interpretive planners work (Koke 2010: personal communication). Alongside the AGO 'guiding principles' reproduced above, these bodies of theory also underpin the training of docents, some of whom provide standard tours while others are roving. Use of Maslow's hierarchy of needs has encouraged docents to suppress the 'natural inclination to provide "art" knowledge' and rather to start with the visitor, whereupon it can become clear that other kinds of information and interaction are more effective. Koke cites George Norwood's adaptation of the hierarchy to understand the kinds of information that visitors seek at different levels, from the lowest to highest[1] (Norwood 2009):

> Individuals at the lowest level seek *coping information* (to deal with and attempt to overcome problems and difficulties) in order to meet their *basic needs*. Information that is not directly connected to helping a person meet his or her needs in a very short time span is simply left unattended.

> Individuals at the *safety level* need *helping information*. They seek to be assisted in seeing how they can be safe and secure.

> *Enlightening information* is sought by individuals seeking to meet their belongingness needs, in order to afford insights into their sense of belonging.

> *Empowering (enabling) information* is sought by people at the esteem level. They are looking for information on how their ego can be developed.

> Finally, people in the growth levels of cognitive, aesthetic, and self-actualization seek edifying information (to instruct, improve, especially in religious/moral knowledge).

> (Koke 2010; Norwood 1999)

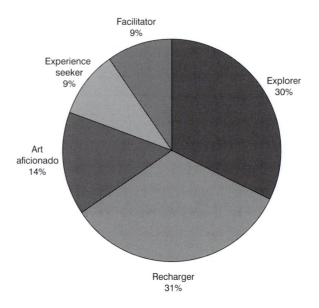

Facilitator
9%

Experience
seeker
9%

Explorer
30%

Art
aficionado
14%

Recharger
31%

FIGURE 6.2 Art Gallery of Ontario audience segments data collected from 304 interviews in March 2009, using Falk's motivational identity categories. Courtesy of the Art Gallery of Ontario.

Koke explains the interplay of these different frameworks, noting that the AGO Guiding Principles inform the choice of art and theme, and the ideas presented, while the text guidelines inform the panels and labels. Meanwhile, Maslow's hierarchy informs interpretation practices which involve human interaction between visitors and docents, and Falk's motivational identities inform the attempt to ensure a breadth of opportunities for engagement. Recently, 695 randomly-selected visitor interviews were conducted over two seasons in an attempt to map visitor distribution according to Falk's motivational identities; the results are as follows (Falk's term 'professional/hobbyist' has been replaced by 'art aficionado' at AGO) (Figure 6.2).

As Koke notes, at AGO there is a tendency to cater to the professional/hobbyist or 'art aficionado':

> Most of the people who work here would consider themselves and most of their friends, the people they talk to art aficionados. Art Museums are traditionally, in my opinion, set up for the recharger. So if we design exhibitions for the AA and Rechargers – we're only serving half of our visitors well and, I would posit, not in a position to grow our audience significantly.

Koke goes on to show how the motivational identities can inform interpretive planning, and stresses that it is possible to focus on building audiences in different sectors at different times:

If we know that Facilitators, for example, are looking for opportunities to 'work' together – multi-sided activity tables, questions on labels, the summary panels will encourage a positive visit for this audience segment. Denver Museum of Art did a great rock posters exhibition when visitors ended up in a space to design rock posters. These folks like the voting exercises such as 'rate which of these 10 paintings best captures the spirit of Canada' because they foster a lot of conversation. More practically, this segment likes group seating rather than individual seating – and seating in a conversational format rather than all in a straight line.

Another shift within 'Transformation AGO' was the decision not to employ an evolutionary frame and to organise the displays through 'issues and ideas rather than by art historical chronology'. Indeed, there is no real regard to chronology in the overarching organisation of material and this is made explicit in the juxtaposition, in some places, of historical and contemporary art in a strategy reminiscent of similar experiments at Tate discussed in the previous chapter. This is most emblematic in the accommodation of works by contemporary artist Shary Boyle in a suite of rooms at the start of the European circuit, closing in a gallery where the artist has selected works to display from the permanent collection which she has intermixed with works of her own. This arrangement is temporary, and will in time be replaced by displays of works from the permanent collection in which the historical and the contemporary will continue to be juxtaposed. These 'injections' of contemporary art are intended to suggest the perpetual importance of some of the key themes identified in the interpretation, 'connecting ideas through time' and 'stimulating a conversation' between the works on display and between visitors (Koke 2010: personal communication); they also align with the guiding principle of creativity, in 'making new connections between the familiar and the unfamiliar'. The main text panel for the European hub explains this logic, priming the imaginary visitor for an itinerary that does not flow in any linear way through space or time:

European painting, sculpture and decorative arts 900–1960

These galleries showcase four areas of strength of the AGO's European collections. To the left of the museum entrance, in display cases designed by Frank Gehry, you will encounter the Thomson collection of decorative arts, sculpture and Old Master paintings and drawings. In the large galleries around the courtyard, you will encounter Netherlandish art from the 1600s, French painting from the 1800s, and Italian Baroque art from the 1600s. These galleries are connected by smaller rooms that feature artists from many different periods, including work by contemporary artists. These smaller galleries are designed to link the past and the present, by exploring issues such as the role of women in art, our relationship to the land, and encounters with diversity.

It is worth looking in detail at a few of the galleries described here to gain a sense of the interpretive strategies at play. First, we shall consider the gallery dedicated to Italian Baroque art, which contains seventeen artworks and placed a few rooms into the European hub circuit. The gallery has multiple entrances and depending on which one the visitor uses the text panel is placed either directly in front on the far wall or half way around the room, where it will only be encountered after a number of the works it introduces have already been seen. Because of the non-chronological itinerary it is perhaps less important to introduce topics at the beginning of the route through them, and indeed visitor traffic through the circuit can be somewhat multidirectional. Here is the text panel:

In search of eternal life: art in seventeenth-century Italy

By the early seventeenth century, the Catholic Church had lost millions of followers to the new Protestant religion. To make Catholicism more appealing, the Church turned to art. Numerous painters and sculptors were commissioned to depict key stories from the Bible in new and engaging ways. By focusing on emotions, facial expressions and gestures, these artists infused their work with dramatic realism. Their art was meant to inspire the faithful and guide them to eternal life through images of self-sacrifice and love.

This text effectively characterises some of the key visual features of the artworks displayed in the room as well as setting them into the religious context of their time. The brevity of this text is compounded by the fact that of the seventeen artworks displayed, only three have extended labels (all have 'tombstone' labels). This is in alignment with the 'exhibition and interpretive text standards' adopted at AGO, which note that:

- The longer a text is, the less likely it is to be read.
- The more text there is in total in an exhibition, the less likely it is to be read.
- The more difficult the text is to see, the less likely it is to be read.
- Visitors read, on average, 20 per cent of the text in any given exhibition.
- Of the 20 per cent who read the text they spend, on average, two seconds reading any given text in an exhibition.
- The most read texts are about things – tombstone labels or captions.
- The least read texts are about ideas – labels not immediately associated with objects. (AGO 2008: 3)

But this strategy also leads to some surprising and forthright departures from conventional practice. The artworks which are interpreted are not necessarily the most famous or consecrated, but rather those which best illustrate the themes delineated in the main text panel. So Tintoretto's *Christ Washing His Disciples' Feet*, a painting of a canonical value such that it would be a likely focal point of copious interpretation in a more conventional display, is shown with a mere tombstone label. Meanwhile,

paintings by Luca Giordano and the exponentially less well known Giovanni Battista Langetti are each given extended labels:

Giovanni Battista Langetti
Born Genoa, Italy, 1625; died Venice, Italy, 1676
Isaac blessing Jacob
Oil on canvas, gift Miss L. Aileen Larkin, 1961

Langetti invites us to participate in an intimate family drama. This biblical tale of deception is told through facial expressions and hand gestures. As he lay on his death bed, the nearly blind Isaac wishes to bless his eldest son and make him his heir. But Isaac's wife Rebekah substituted the eldest with her favoured son Jacob. She covered Jacob's hairless arms in goatskin so Isaac would mistake him for his more mature brother. The trick worked and Jacob received his father's blessing.

And:

Luca Giordano
Born and died Naples, Italy, 1634–1705
Christ before Pilate, around 1670–75
Oil on canvas, on loan from a private collection

In the seventeenth century the Catholic Church used art to make biblical stories more accessible. Here Giordano has found dramatic new ways to involve the viewer in a critical moment of Christ's life. Christ has been bound and brought before the Roman governor Pontius Pilate (in red). Pilate must decide whether to crucify Christ for claiming to be the son of God. As Pilate gestures towards the viewer, he appears to be implicating each of us in Christ's imminent death.

Both of these labels take opportunities to recapitulate the principal messages of the main text panel, notably the importance of gestuality, storytelling and the enagagement of the viewer, and in the Giordano label the seventeenth-century viewer is elided with 'us', as the interpretation frames the painting so as to interpellate us personally. The labels also include some subtle repetition of the information in the main text panel, something foreseen in the interpretive brief provided for staff in advance of the redisplay:

Remember that visitors read on average 20 per cent of the text in an exhibition. Repeat ideas or information throughout all interpretive vehicles, especially if they are central to the main issues and visitor outcomes. Say them in slightly different ways; some redundancy can be a virtue.

(AGO 2008: 10)

We might also note some further characteristics here. First, the narrative is briefly but coherently described, so that the story represented can be understood at least in its outlines. Compare this with the perfunctory description of biblical narratives in the interpretation of the paintings by Tintoretto and Preti discussed in Chapter 4. Also, we see a careful attention to terminology, balancing the imperative not to 'talk down' to visitors with the use of a non-academic, relatively conversational tone (indeed, as we will see some of the labels go so far as to pose questions to visitors) and a non-specialised language. This permeates not just the descriptive text of the labels but also the standard data about authorship, date and provenance – for example in the way in which Latin terms like 'circa' which are naturalised within the disciplinary lexicon of art history are avoided in favour of the English 'around'.

In addition to this, further interpretive resources are planned to diversify the formats in which information is available. In relation to Bernini's *Corpus* of 1655 a listening post is in development which will include the commentaries by a curator, a priest and expert on Bernini, and recordings of some of the music contemporary to the sculpture which might have been heard in church settings at the time. The use of a main text panel in which the 'big idea' is summarised, together with a sparse deployment of extended wall labels for individual works has, according to AGO research, worked well. This research has noted that groups (such as families) read the summary panel and then attempt to view the works in the gallery to see how each one fits with the theme. Meanwhile, the lack of an evolutionary frame aligns with aspirations and interests at AGO, which are to inspire visitors to want to learn more and to forge 'a personal connection' with art, rather than helping them to develop an understanding of art historical chronologies and period distinctions (for example, understanding differences between High Renaissance and Baroque). As we will see later, this relates closely to the importance for AGO of the principle of relevance.

The account of the 'Eternal Life' gallery has shown some of the main characteristics of the interpretive strategy here in relation to depth, coverage and tone. It is worth exploring a few more of the AGO galleries to pursue these considerations but also to think about the conjoined political and historiographical dimensions which are brought into play through interpretive choices. In some places these relate very strongly to well known preoccupations in art historical practice over the last three or four decades, as we can see in the small gallery entitled 'History and Her Story' (Figure 6.3), the main text panel for which is as follows:

> The works in this gallery explore the roles of model-muse-mistress and mother often ascribed to women in society and art. The sequence of works in this room reveals women's increasing independence and liberation during the past two centuries. By placing images of women next to images by women, two issues become clear. First, women have gradually evolved from passive subjects of works of art to their active creators. Second, women artists have often made art that embodies the values of empathy, inclusion and interdependency in human relationships.

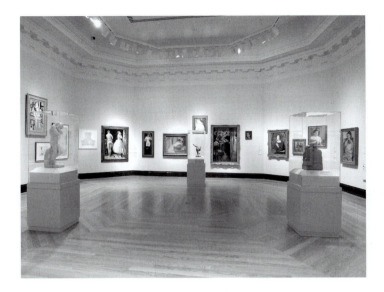

FIGURE 6.3 'History and Her Story' Gallery; image and reproduction rights courtesy of the Art Gallery of Ontario.

The gallery, once again, is not ordered chronologically (although as we will see a chronological story emerges in places) and includes works which exemplify the notion of the male gaze, such as Degas' *Woman at her Bath* of around 1895, and others such as Mary Ann Alabaster's *The Artist's Painting Rooms* of 1830 – the only pre-twentieth-century painting by a woman in the AGO collection. Prominent themes within the interpretation are the role of male desire within the paintings and the availability of women to male desire, the male-dominated social order of art, the growing independence of women, and motherhood. Some of these themes are encapsulated in the following label:

Nicolas-André Monsiau
Zeuxis choosing his models, 1797

For centuries the female nude has been a key subject in male-dominated western art. Here Monsiau shows Zeuxis, an ancient Greek painter, awarding a wreath to his model. The work depicts the search for an ideal of female beauty, while highlighting the male artist as genius and the female model as muse. Since Greek antiquity, the majority of female models had been prostitutes and lower-class women. But by the 1800s, modelling had become a more respected profession, and by the mid-1900s a growing number of women represented themselves in self-portraits and other types of art.

This shows a notable adoption of a thematic-historical frame which places no value on the artistry of the work itself, or on the details of the artist's life and work,

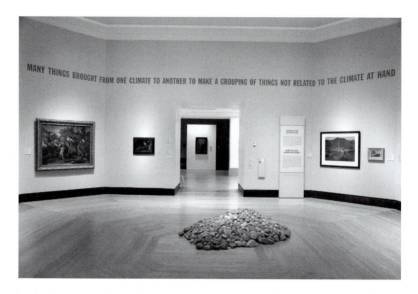

FIGURE 6.4 'Arcadian Land: Seized or Lost?' Gallery; image courtesy of the Art Gallery of Ontario. *Chee-to* by Liz Magor reproduced courtesy of the artist; copyright Liz Magor.

or the circumstances of the production and consumption of the painting. Indeed, the content of almost half of the label is not directly related to the painting. Rather, it tells a story about the development of women's involvement in art, tracing a trajectory in which female modelling became more respectable (postdating the painting itself) and in which, ultimately, women themselves became practising artists working in specific genres such as self-portraiture, something borne out by some of the paintings on the walls such as the one by Mary Ann Alabaster mentioned above. Inevitably these stories can be questioned. Does art made by women typically embody 'the values of empathy, inclusion and interdependency in human relationships'? And does art made by men typically not do so? What are the roles of social regulation and the performance of gender in such evaluations? Did large numbers of women produce art only after the mid-1900s? What counts as art in this gendered narrative? Why was self-portraiture so significant and what were the 'other types of art' which women produced? Notwithstanding such questions, the gallery coheres as a provocation about the place of women in art inspired by aspects of feminist critique within the practice of art history.

A gallery with yet more political charge, notably because of its context within the Art Gallery of Ontario in Canada, is 'Arcadian Land: Seized or Lost?' (Figure 6.4):

> Inspired by French and British landscape art, the works in this gallery treat nature as a wilderness that needs to be tamed for human survival. At the root of this notion lies the widespread acceptance of the myth that North America was empty land which could be conquered when the Europeans arrived. Therefore, landscape painting is often considered by Canada's First Nations to be an

expression of ownership justifying the colonization of their land. In their haste to press on the land, people had forgotten that nature also impresses on us: it remakes us as much as we remake it. A new worldwide consciousness of this process is reflected in current art and environmental debate.

As we might anticipate there is no chronological order to the display, for historical and contemporary works are evenly interspersed. Nor are there obvious geographical limitations, although this gallery acts as a connection between the European focus of this floor and the Canadian focus of the one above, for it includes works deeply associated with European traditions of landscape painting (by Jan Breughel, Hans Rottenhammer, Claude Lorraine, Nicolas Poussin, John Constable and Paul Cézanne) as well as historical works by painters working within such traditions in Canada, such as Emily Carr's *Hagwilgate* of 1912–13. A further discursive layer is added through the inclusion of contemporary works such as the Canadian artist Liz Magor's, *Chee-to* (2000), comprising what appears to be a pile of stones with Cheesies 'peeking out from beneath the pile' and Lawrence Weiner's 1981 MANY THINGS BROUGHT FROM ONE CLIMATE TO ANOTHER TO MAKE A GROUP OF THINGS NOT RELATED TO THE CLIMATE AT HAND (this work and its title, painted high up across the gallery walls, are one and the same). Within individual labels we can trace a story of sorts, wherein the idealised and often pastoral or Arcadian landscapes represented in paintings by artists like Claude Lorraine fuelled a tradition which influenced empathetic but patriarchal white Canadian representations of Canadian territory and its indigenous inhabitants, through to recent and contemporary critiques of the thoughtless occupation, urbanisation and besmirching of nature. A further theme in this story is the issue of veracity – where once landscape paintings were seen to represent truth they should now be subject to a more challenging gaze which interrogates the politics of representation which they embody. Here is an example of an individual label from the gallery:

A.Y. Jackson
Elevator, moonlight, around 1947

Dominated by vast skies and unlimited horizons, the prairies embody an archetypal landscape known for its intense weather conditions. Prior to the arrival of the transcontinental railway in the 1880s, the prairies were home to nomadic indigenous inhabitants who dwelled in transportable tepees. The colonization of the land transformed the prairies into an instrumental landscape, laid out as a grid with farm allotments, towns and rail networks to maximise its productivity. Grain elevators and barns prominently stand as testament to the modernist project of domesticating and industrializing this vast territory.

In some ways this is a label which works at a traverse angle to the painting with which it is associated. The painting itself is not overtly critical of the 'modernist

project' of domestication and industrialisation, in keeping with the artist's primary preoccupation with representations of the landscape as picturesque rather than as social comment. Indeed, Jackson was an early member of the 'Group of Seven', a group of Canadian landscape painters influenced by aspects of European Impressionism and dating from the first decades of the twentieth century; their works have been critiqued precisely because of their lack of political consciousness about the status of the lands they represent (O'Brian and White 2007), and this is at odds with the interpretation of the Jackson painting. But the interpretation frames the work, and those around it in a critical fashion, somewhat as we saw in the interpretive pairing of a Dutch painting and a Javanese tapestry in the Tropenmuseum in Amsterdam, discussed in Chapter 4. These works, themselves about territory, are firmly mapped in the territory of critique, and the interpretation works once again in the contexts of postcolonial discourses of colonisers' guilt and the ethics of continued occupation and memory, as well as the pluralised identities to be found among the inhabitants of Ontario.

These charged politics of interpretation are at play again in the Canadian hub on the floor above, which unites the works of 'Euro-Canadian' artists such as those belonging to the Group of Seven with historical and contemporary works by First Nations artists, sometimes within the same galleries. This approach to display involves a significant cartographic act within the context of the disciplinary traditions of museum practice, so that First Nations material culture is pulled out of the territory of the ethnographic *object* and into that of the art*work*. (Notably, across town at the Royal Ontario Museum, historical First Nations material culture is, on the whole, framed much more conventionally as ethnographic.) Nevertheless, some striking contrasts can be seen, for example in moving from uniformly-lit, white cube galleries dedicated to the landscape paintings of members of the Group of Seven and their associates to a gallery of First Nations material culture characterised by heavy spotlighting and long shadows cast by three-dimensional objects/works such as masks. Lighting conditions involve tacit interpretive frames, and in their recall of historical display practices they make appeal to specific types of regard: to see things as aesthetic or exotic objects, or to gauge the relative importance of these ways of seeing and comprehending within a single gaze.

Very often, however, there is an attempt to blend the works produced from within the European tradition of art with those produced by First Nations, and there is a continued attention to the problematic issue of the representation of Canada and the work that such representation does in constructing and reproducing discourse. We see this most explicitly in the 'Constructing Canada' gallery, which contains landscapes, illustrated books and travel guides, photography albums and First Nations tourist objects which 'all shaped the world's perception of Canada' and perpetuated its 'mythology'. Other contemporary concerns are brought into play in galleries such as 'Art and Power' (Figure 6.5), which situates artworks within power relations in a way which can be seen to recall and relate to art some of the major preoccupations of Marxist and later postmodern theorists of society such as Michel Foucault and Pierre Bourdieu:

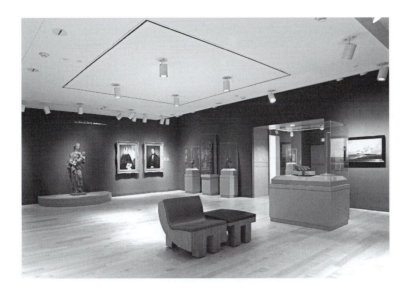

FIGURE 6.5 'Art and Power' Gallery; image and reproduction rights courtesy of the Art Gallery of Ontario.

Art and power

Relationships of power are complex and dynamic. They are at play in our institutions and governments, as well as in our social and cultural groups. These dynamics of power are often documented through art while art has frequently been used to promote the values of those in power.

As you examine the works in these galleries, contemplate the forces that might be at play. Consider how they may have shaped both Canadian art and identity.

How do the power dynamics around you play themselves out in your life?

The gallery contains a mixture of First Nations objects, some of them ritual ones such as a clan helmet, a painting of the Madonna and Child from around 1750 by a provincial Canadian artist, portraits by 'Euro-Canadian' artists, a coat, some leggings and mittens from the early nineteenth century by a 'Central Cree artist' (note the use of the term 'artist' to describe the producer of a costume – an act of naming with strong epistemological and political connotations) and small sculptures by late twentieth-century or contemporary First Nations artists, some of which are on the theme of seafaring, such as Joe Talirunili's *Migration* (around 1974). Near the latter is John O'Brien's 1854 oil painting *The Ocean Pride Leaving Halifax Harbour* (Figure 6.6):

Large ocean-going ships were a sign of wealth and power for Euro-Canadians. The Ocean Pride is shown here with a schooner under the ship to signify the

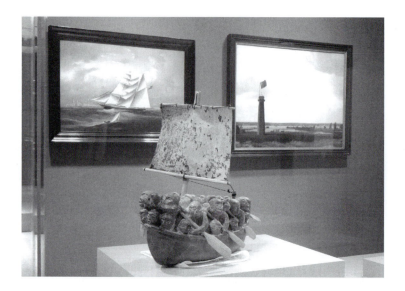

FIGURE 6.6 Display of John O'Brien's 1854 oil painting *The Ocean Pride Leaving Halifax Harbour* and Joe Talirunili's *Migration* (around 1974); image courtesy of the Art Gallery of Ontario; *Migration* reproduced with the permission of the Inuit Art Services, Inuit Art Foundation.

> importance of marine travel between Canada, the United States and Europe. Aboriginal peoples travelled Canada extensively by water. Their journeys created a cross-Canada thoroughfare long before the arrival of the Europeans. The Inuit used umiaks to transport many people at once, while a kayak often carried just a single person.

Here once again we see a familiar pattern, where the painting itself is considered only very briefly and is then used as a departure point for exploring a wider story which relates implicitly to the theme of the gallery. In the phrase 'long before the arrival of the Europeans' a postcolonial critique is embedded, for the seafaring practices and seaways of the aboriginal peoples pre-date, and (it is implied) were disrupted by, those of the European settlers. We may also recall the assertion in the main text panel that 'art has frequently been used to promote the values of those in power', and seek to see the painting in this light. The label thus stands for a set of power relations between peoples and invokes the theme of the violence done to longstanding ways of life by conquest and colonisation. In this interpretation, sea vessels symbolise wealth and power to the Euro-Canadians, attributing the interest in dominance to them rather than to the aboriginal peoples, whose seafaring practices and vessels are described in merely functional terms. As Koke notes, one of the key points both here and in the overarching organisation of all of the AGO collections is that 'there are 11,000 years of visual history here in Canada; it didn't start [in the 1530s] when Jacques Cartier hit the coast: that's the political statement'.

Here we see, once again, the adoption of a critical-historical frame with continued political relevance in the present day. O'Brien's rather conventional and perhaps even unremarkable maritime painting (conventional and unremarkable that is within western traditions) is framed not so much as a 'work' of 'art' to be understood aesthetically but rather as a memento of oppression and an opportunity for the critique of historical social relations.

The main text panel provides a corresponding metaframe, in challenging us to question essentialised notions of 'art' and 'identity' by considering how dynamics of power work to construct them. Further to this, we are challenged to proceed to a further level of interpretation concerning the play of power dynamics in our own lives, making it clear that our own identities are at stake. This level of provocation, interpellation and the pointed use of first-person pronouns recalls Freeman Tilden's 1957 dictum on the importance of relevance and provocation in interpretation, and is all the more notable given the AGO brief on this score:

> Avoid loose use of the first person plurals: we, us and our. Are you using them to project inclusiveness to the readers? There are dangers. If you intend the use of we to be inclusive, ask yourself if every reader will be comfortable in identifying with you. On the other hand, using the second person you in your writing can help to create the informal tone and feeling of dialogue you are striving for.
>
> (AGO 2008: 9)

In galleries such as 'History and Her Story', 'Arcadian Land; Seized or Lost?' and 'Art and Power' we see the adoption of critical-historical frames which relate to ongoing intellectual and social movements of the past century or so and which have been at play within the disciplinary confines of art history in recent decades, involving concerns with gender, domination, inequality and injustice, and colonisers' encounters with the other. We also see, as a corollary to this, a conscious impulse to make strident political points of continued relevance. Relevance, as stated, is one of the AGO guiding principles and it manifests itself in the curatorial desire for the imagined visitors to 'see themselves here – to see themselves in art and art in their lives', and even in ongoing visitor research to understand the importance, post-visit, of art in the fabric of people's lives (Koke 2010: personal communication). It also manifests itself in the kinds of provocation and interpellation evident in the 'Art and Power' gallery, as seen above. This political and personal dimension is, as Koke notes, 'why art matters':

> In any city, the natural history [museum] or the science museum gets two to three times the visitors as the art museum. That's our fault! Parents understand why it's important for their children to learn about climate change or biodiversity; they don't understand why it's important for them to understand – and maybe it's not even so much 'understand' art but to be able to draw what they can draw from art. This was a very conscious effort. We were, prior to

our transformation, serving about half a million people a year, which, in the Greater Toronto area of 5.5 million, doesn't make a very grand statement about [our] relevance to [our] community. So our goal is to serve a million visitors a year, and to do that, we have to be different.

This case study has revealed much about the complex political dimensions of interpretation in a specific institutional context, a context where art itself is firmly recognised as political, and part of constructive historical stories which make representations which themselves fashion realities too (the realities of gender relations, or of the exercise of power). We are, it is implied in the interpretation, ourselves bound up in these stories, and in this way art is mapped away from conventional territories of aesthetic value or the hermetic genealogies of traditional art history, and mapped into the spaces of the personal and the everyday. The next section focuses on another North American museum of comparable size with a similarly ambitious interpretive project.

The Museum of Fine Arts, Boston (MFA)

The Museum of Fine Arts (henceforth MFA), is a private organisation, partially funded through entrance charges (currently around $20 per adult). Notwithstanding this, it has a public mission. Its ultimate aim, stated within a long mission statement, is 'to encourage inquiry and to heighten public understanding and appreciation of the visual world', and:

> The Museum has obligations to the people of Boston and New England, across the nation and abroad. It celebrates diverse cultures and welcomes new and broader constituencies. The Museum is a place in which to see and to learn. It stimulates in its visitors a sense of pleasure, pride and discovery which provides aesthetic challenge and leads to a greater cultural awareness and discernment.
>
> (MFA 2010)

Within this statement are embodied particular theories of the value of art and fruition, recalling the discussion on this topic in Chapter 1 and highlighting the institutional contexts in which such theories are sometimes fashioned. The MFA has averaged around 1 million visitors per year since the mid-1990s (comprising about 60,000 educational visits per year). Demographic analyses of the adult visitor population suggest that most are university-educated, although not necessarily in disciplines related to art. In the scope and size of its collections it classes as a universal survey museum (Duncan and Wallach 1980); indeed, it was one of the signatories of the 2004 Declaration of the Importance and Value of Universal Museums which, while it mainly concerns issues of the repatriation of cultural property, is also a positioning statement about the worth of quasi-encyclopaedic museums which aim to maintain a global breadth in their representations of the world (see Curtis 2006). The MFA collections span:

- the ancient world (beginning in around 6500 BC) and comprising Egypt, Nubia, the Near East, Greece, Italy, Cyprus, and Anatolia
- Asia, comprising Japanese, Chinese, and Indian painting and sculpture; Japanese prints and metalwork; Chinese, Korean, and Vietnamese ceramics; and the arts of the Islamic world
- Europe, from the seventh century to the late twentieth century, including over 22,000 paintings, sculptures and works of decorative art, including furniture, metalwork, ceramics and glass, and architectural elements
- prints, drawings and photographs
- musical instruments from around the world, numbering about 1100
- textiles, comprising about 27,000 objects ranging from American needlepoint to European tapestries, Middle Eastern rugs, African kente cloths, and haute couture fashions
- jewellery from 'almost every culture'
- contemporary art, which is understood to be 'art made after 1955, international in origin, and without restriction to media'; the MFA website notes that unlike the other collections, the collection of contemporary art 'is far from encyclopaedic in its representation of critical artistic movements of the late twentieth century through the present'.

Finally, the collection has particular strengths in aspects of the Art of the Americas, from the pre-Columbian era until the third quarter of the twentieth century. This is the focus of a display opened to the public on 20 November 2010 in a new wing designed by Foster and Partners comprising forty-eight galleries. It is on this area of the collections that we will focus, partly because of the intrinsic interest of seeking to understand the conjoined interpretive, intellectual and political dimensions of the galleries and partly because it allows us to analyse a major and very recent example of practice. The new wing is the product of many decades of development, and it is not feasible here thoroughly to track its history or indeed to consider its displays in their entirety. Rather, we will focus on specific instances of interpretation which can help to provide a sense of the interpretive strategies adopted and of some of the historiographical approaches involved. Within the Arts of the Americas wing sit four 'Behind the Scenes' galleries which explain some of the working practices of the MFA and seek to convey a sense of the political decisions involved in working with objects in museums; we will explore these as well as a significant experiment in interpretation and institutional transparency. My account will be supported through data derived from a semi-structured interview held in December 2010 with Barbara T. Martin, Alfond Curator of Education, who was extensively involved with the design and development of the interpretive strategies adopted, and of subsequent correspondence with her and with Ben Weiss, Head of Interpretation.

The Art of the Americas wing is ranged over four floors, covering respectively: ancient American, native American, seventeenth-century and maritime art on the lowest level; eighteenth-century art of the colonial Americas and early nineteenth-century art on level 1; nineteenth-century and early twentieth-century art on level

2 and twentieth-century art until the mid-1970s on the uppermost level. The two middle levels also include 'Behind the Scenes' galleries which we will explore later. The brochure given to all visitors includes a floorplan of this imposing arrangement and explains its expository logic, priming visitors to design their own itineraries according to their needs (although if, how and when visitors read the brochure would be a useful focus of research):

> A new approach to gallery design integrates works in all media – paintings, sculpture, furniture, decorative arts, works on paper, musical instruments, textiles, and costumes, throughout the wing …

> In the center of each level are large galleries designed to give a general overview and a dramatic visual introduction to the MFA's collections. If your time is limited, you can travel from floor to floor and enjoy a 'broad brush' introduction to the wing and the Art of the Americas, by visiting just these central galleries.

> Surrounding each level's central spine are galleries where you will find displays on more specific topics. The opportunities to explore an artist, period, or style in greater depth are many, from John Singleton Copley, American Impressionism, and the Jazz Age, to nine period rooms located in the pavilions flanking the central building on levels 1 and 2.

> Enjoy the journey. We hope you will come back again to discover your own favourite paths while exploring the great breadth of the Art of the Americas.

As an example of this organisation, the central narratives of the middle two levels 'tell the big stories', while the lateral galleries 'amplify' those stories as Martin notes:

> on level one the big story is very [much] American history in the old-fashioned sense: revolution, Paul Revere, George Washington, heroes, etcetera. And on level two it's more an art world story: how was art shown, who were the great superstars [like John Singer] Sargent and the salon …

In many ways the wing presents an unusual story of American art. It eschews the historiographical commonplace that American art's moment of glory, when it 'took centre stage' and overcame the primacy of French art, was in the aftermath of World War II, for example with the development of abstract expressionism, a historiographical tradition characterised by James Elkins in his *Stories of Art* (2002: 81–3). This is a story which obscures from view many artistic cultures, from those associated with European settlers onwards. Of course it also obscures the artistic cultures of indigenous populations and holds the definition of 'America' in constructive ambiguity. One of the first epistemological and intrinsically cartographical acts encountered when we engage with the new wing is the choice of its name: 'Art of the *Americas*' in the plural. This counters the tendency to historicise American art as an offshoot of the European

tradition, and it counters the violence that such exclusionary practices perpetrate. As Elizabeth Crooke has noted, excluding a cultural group from the 'canon of the established notion of history can be interpreted as a deliberate act of suppression' (2005: 135). Barbara T. Martin notes that this political awareness developed as the project for the new wing progressed, and that by 1997, 'all of the increasing emphasis on being a more diverse community, more global, and that American does not just mean North American … [led it to become] part of the thinking that we want this to be the Americas from as far back as we have, all the way up to close to the end of the twentieth century'.

At the same time, the broadly chronological framework means that the galleries run upwards through time over four floors, meaning that 'yet again we are putting the art of the other cultures in the lower level', as if to suggest, no doubt unintentionally, a hierarchy of cultures. Visitor tracking and research, however, have indicated that a chronological framework is appreciated by MFA visitors. In fact, while cultures such as that of the Maya are treated historically, the Native American gallery includes both historical and contemporary works, 'making the point that … the Maya culture is over, but the Native American culture has been revived in various ways and that [the curators] wanted to work with that as a continuity'. This raises interesting questions about whether some of the Euro-American[2] cultures represented in the Art of the Americas wing are also 'over', given the chronological termination of these stories of art at the end of the twentieth century. Are there no continuities or connections between artistic practice now and Euro-American art of past centuries? Of course there undoubtedly are, but perhaps there is not the same political imperative to make this point as there is to suggest that Native American artistic cultures are historical continuities stretching vitally into the present. This is a dilemma about the political dimensions of chronology (recalling the discussion of the significance of this at Tate Modern in Chapter 5), and how this can map cultures differently in relation to issues of ethnicity and cultural legitimacy.

Another interesting aspect here surrounds the local history of Native American tribes in the Massachusetts area which, by dint of their location at the point of first settler contact, were some of the most affected by disease and displacement. This is a silence within the gallery, in part due to the historical development of the MFA's collections into which Native America material culture did not flow consistently, as we will see later on in an example of interpretation where this is acknowledged. In such historical ebbs and flows interpretive choices are made by curators past, which ultimately help to determine which stories can be told in the present, and how. But of course contemporary collecting and inventive interpretive strategies can obviate some of the political-epistemological problems generated by working in the present with historical collections. The gallery dedicated to Native American Art is but one out of forty-eight within the wing as a whole, and makes up only a small proportion of the entire display, but as Martin notes, this is a significant advance on the previous display of Native American art in a hallway space.

Another reason for the unusual historical trajectory of the wing lies in the nature of the museum's collections, which include large numbers of Euro-American objects

from the seventeenth, eighteenth and nineteenth centuries and an unparalleled selection of works by artists like John Singleton Copley and Paul Revere. In the twentieth century, Martin explains, Boston's artistic culture could be characterised as more conservative than that of other large US cities (such as New York), meaning that particular strengths to balance those of earlier centuries did not emerge; we see a legacy of this in the 'far from encyclopaedic' collections of contemporary, or post-1955, art. At the same time, the perception that a collection contains particular 'strengths' is a contingent one: it can only come about through discourses which positively evaluate the works of the likes of Copley and Revere as worthy of significant focus within the history of art. There are, in this qualitative sense, no 'natural' strengths and weaknesses in a collection, and it is quite feasible for notions of value to change, and for things to sit unloved in a store for decades before some act or acts of interpretation change this. So, while the story of art told in the Art of the Americas wing is partly determined by the collection, it must be understood that this is not simply a structural determination, for the collection itself is structured through interpretive acts of evaluation.

In another strong cartographical act, many of the galleries in the Art of the Americas wing include numerous juxtapositions of fine and decorative art, for example in the form of paintings displayed alongside furniture and silverware. In places this practice assumes some of the dimensions of a period-room approach, presenting synchronic snapshots of the artistic cultures of a given historical era by way of the organisation of objects in a reconstructed or imagined interior, usually a domestic one. This is not something done lightly, for it is tantamount to a rethinking of the roles and places (literally and figuratively) of objects within society and a commitment to present them in such a way as to reveal the complexities of the cultures in which they were used. As Martin notes, this is an approach with relations to aspects of scholarship:

> The strongest governing principle is this bringing together of media to create more of a sense of the time and atmosphere in which these objects were originally created and enjoyed and purchased. And that comes from a number of things. I think it comes from a general increase in interest in material culture ... that people are now interested in treating paintings and recognising paintings as objects of material culture. One part of the New Art History ... is the [study of the] market and patterns of use, collecting, who bought what and what did it say about status, as opposed to just 'here's this pure arrangement of shape and colour and let's take it out of its tawdry human beginnings and just contemplate it'.

This approach is also a commitment in terms of preventive conservation, given the sometimes very different environmental requirements of objects of different type, to the point where textile material on display in the galleries must be rotated every nine months to preserve it from the damage caused by light.

This interpretive choice is also connected to developments within the structuring of curatorial staff at the museum, showing how institutional structures are constructive

of knowledges. The curatorial staff was restructured in 1999, before which there were separate departments of Paintings, American Decorative Arts and Sculpture and European Decorative Arts and Sculpture. These departments were amalgamated into two: the Art of the Americas and the Art of Europe:

> Then you had curators of furniture and curators of paintings living together as department mates, and it took a while [to get used to]. But this [the Art of the Americas wing] is the fruit of that reorganisation.

In a very day-to-day sense, who one works alongside and how teams are composed are matters which create possibilities for different knowledge relations. At the same time, over a long sweep of time, curators and education staff, comprising interpretive planners, developed a collaborative working process similar in principle to that which we have encountered at the AGO in Toronto, partly because of the burgeoning interest in interpretation practices in recent decades, so that, as Martin notes, 'everybody began to accept that the visitor needs a way in, a hook; when you say that the object speaks for itself, usually you're somebody with a PhD who has read a lot of words to get to the point where the object can talk to you'. This form of collaborative working and the involvement and authority of interpretive planners is, like the restructuring of curatorial departments, in part the result of interests of the current director Malcolm Rogers, who has encouraged the adoption of a more informal and conversational tone in interpretation along with more direct address. In the words of Benjamin Weiss, Head of Interpretation, who was primarily responsible for creating this tone, the guiding principle was as follows:

> whatever the texts, they should be direct and communicative and somewhat less Olympian than museum texts tend to be. There's always been a tendency for these labels, wall texts, whatever, to sit quietly on the wall and you're supposed to go and read them. My goal is that instead of having you read the walls, the walls speak to you. It's not really a change in what they say. The information that's getting across is likely to be the same sort of thing. Instead, we want to reframe the question from 'What is this thing?' to 'Why am I looking at this thing?' and 'Why should I care?' We're trying to take interpretative strategies a little further than they've gone before: more direct, more colloquial, more informal.
>
> (Weiss, quoted in Feeney 2010)

We will see these principles in action in the examples below.

So, museum management at all levels is itself an interpretive force, both in relation to the content and the tone of interpretive resources produced for visitor consumption. However, the curators too were interested in questions of interpretation and shared the belief in the need to make text accessible which developed in the 1980s and 1990s. Meanwhile, curatorial staff were also influenced personally, not just because of the departmental restructuring, by socio-historical questions about the works of

art; as Martin notes, these include: 'who would have owned them, what did it mean to own them, what did their neighbours think when they looked at them?'

This tells us a lot about one of the dominant interpretive frames used in the Art of the Americas wing at the MFA, which might be called 'socio-objective' because the focus it encourages is the object within society. However, it should be noted that there are numerous interpretive resources allowing for the mobilisation of multiple interpretive frames. A key example of this is the hand-held audio-visual guide, which is a menu-based system allowing visitors to pick and choose from interpretive recordings (of some of which transcripts are available). For instance, the tracks (no. 113) for Thomas Smith's oil on canvas portrait *Mrs Richard Patteshall (Martha Woody) and Child* of 1679 include:

- one which gives information about the composition, the facial expressions and gestures of the sitters, the pictorial style and some biographical information about the artist;
- 'looking closer', which encourages visitors to compare the painting with another shown on the screen in order to understand some of the technical aspects of the painting;
- 'behind the scenes' which involves footage of a conservator explaining her remedial conservation work on the painting;
- finally, 'MFA connections' which details a research discovery pertaining to the painting made by the curatorial team, i.e. that the sitter is the great-grandmother of Paul Revere.

The final track concludes with an imperative challenge to the visitor aligning with the interest in conversation and direct address discussed earlier:

> Take a look at the MFA's portrait of Revere by John Singleton Copley. Do you see any resemblance?

We shall now look at some good examples of the dominant, socio-objective frame. The first of these, the *Sons of Liberty Bowl*, is linked to the 'big story' of the American Revolution:

> Paul Revere, Jr.
> American, 1734–1818
> *Sons of Liberty bowl*
> Massachusetts (Boston), 1768
> Silver

This bowl is a declaration of political defiance. It honours members of the Massachusetts legislature who refused to rescind a letter protesting the Townshend Acts of 1767. The acts taxed tea, paper, glass, and other imported English commodities. This act of civil disobedience was a major step toward

the American Revolution. The bowl was commissioned by fifteen members of the Sons of Liberty, a secret, revolutionary organization to which Revere himself belonged. The MFA bought the bowl in 1949 with funds that included seven hundred donations by Boston schoolchildren and the public.

This text works to frame the object in terms of its political and symbolic importance, not just at the time of its creation but also subsequently as a testament to its continued cultural significance for later generations, most especially those connected to Boston. This kind of interpretive frame is, it might be argued, quite limited in encouraging aesthetic understandings of the bowl, but nearby visitors can find interpretive text with biographical information about Revere and more pronounced aesthetic dimensions. An example of this can be seen in relation to another silversmith, Jacob Hurd (1702/03–1758), who is introduced in a biographical label explaining his importance as 'Boston's most outstanding silversmith of the mid-eighteenth century', his many commissions, prolific output and large studio and staff, followed by his bankruptcy in 1755 and subsequent death. A nearby object label reads:

Cup
Massachusetts (Boston),
About 1740–50
Silver

Graceful in stance and majestic in bearing, Hurd's two-handled cups are among the masterpieces of Boston silver. This one was made for merchant John Rowe, and bears his coat of arms. We do not know how Rowe acquired this piece, but rich Bostonians often gave Hurd's cups to reward sea captains and military heroes. At least one was used to hold 'bishop', a sweet drink made of wine, oranges or lemons mixed with mulled and spiced port wine.

While this text involves some of the elements of age-old art historical discourse – notably the qualitative appreciation and the 'masterpiece' appellation of the first sentence – its primary focus is the use of such objects within society and within social practices. We learn, implicitly, that there were particular kinds of individuals (sea captains and military heroes) whose endeavours were valued, such that there was a social practice of rewarding them with objects like this. This has something of a ritualised feel, and also involves the reproduction of discourses about social worth, masculinity, and so on, as well as reproducing a cultural economy of patronage which kept Hurd in commissions. Beyond the solely symbolic functions of the cup we also learn that it was used to hold a particular kind of drink, pointing to its role in patterns of consumption and, we might assume, the practices of convivial society. This is a lot of information – a lot of vistas opened – for such a short text. We will return later in the context of another example to the issues involved in the use of the personal pronoun 'we' in this text and the recognition of the limits of museum knowledge (i.e. 'we do not know').

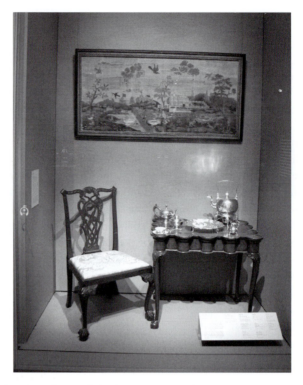

FIGURE 6.7 'Tea Time' period display, Museum of Fine Arts, Boston; photograph © 2011 Museum of Fine Arts, Boston.

In relation to the socio-objective framing which characterises this, we can observe a number of instances of interpretation focusing on cultures of consumption of foodstuffs and beverages like chocolate, sugar, punch, tea and coffee. The following wall text, which accompanies a small period display (Figure 6.7), typifies this in its references to social practices of consumption, wealth and the symbolic and political significance of objects:

Tea time

In the mid-eighteenth century, Bostonians consumed vast amounts of tea. The objects shown here suggest tea drinking in the home of an affluent local family. The table is set with imported English ceramics and tea wares made by Boston silversmiths, including Hurd's magnificent teakettle-on-stand, and a salver (to catch the drips when pouring and to hold used spoons). At the time of the Revolution, English tea became a highly politicized commodity. Loyalists continued to drink their tea, but many patriots chose rum instead, which became known as 'Boston tea.'

This socio-objective frame is also adopted in relation to questions of style, which, in this example excerpted from the 'New Nation' text panel, is viewed in relation to historical and political developments:

> Political independence did not mean cultural independence. Throughout Europe and the Americas, the decades around 1800 were dominated by a renewed interest in the art of ancient Greece and Rome. The United States was no exception, but that classical revival had special resonance here. The new country had consciously adopted the ancient Roman republic and Greek democracy as its political ancestors; in turn, it took ancient symbols and motifs, such as eagles and buildings that looked like temples, as emblems for the young nation.

This is taken up in another text panel entitled 'At Home in the New Nation'. Here style is linked to morality, gender roles, industrialisation and transport infrastructure, which is at odds with some traditional museum representations in which style is seen as an object of hermetic development, an intrinsic principle of art not visibly influenced by or active within wider social and economic developments and practices. Here is an excerpt:

> After the American Revolution, the classical themes deemed fitting for the new republic's government also resonated with ideas about domestic life. Etiquette manuals advised women to 'elevate, refine, and embellish' their homes, and neoclassicism, which emphasized symmetry and restraint, seemed well suited to the task. Domestic objects in this style were thought to reinforce rational, virtuous behaviour, and encourage appropriate roles for men and women. Neoclassicism spread across the nation in the years after 1800, aided by improvements in transportation, the beginnings of industrialization, and the increasing use of pattern books that provided designs for craftsmen. One result was less regional diversity, making neoclassicism the nation's first unified style. The objects here were owned by the wealthy, but the new taste influenced cheaper goods, too.

This way of accounting for the appearance of things is carried through into some of the labels for paintings, such as Gilbert Stuart's (1806) monumental oil painting *Washington at Dorchester Heights*, which is discussed in relation to the topic of neoclassicism introduced in the above text panel. This label explains how Washington and his troops occupied Dorchester Heights, overlooking Boston, and that their occupation of this commanding position forced the British fleet to abandon Boston harbour. The painting, it is noted, was commissioned in commemoration of this some thirty years later, leading to an interpretation which interrogates the veracity of the representation and alerts visitors to the complex politics and strong imperatives which regulated the production of such paintings:

The scene is idealised. Stuart gives Washington a heroic pose similar to that of the Apollo Belvedere, a famous classical statue [seen in photographic reproduction to the right of the label]. Washington also appears considerably older – and more presidential – than he would have been at the time of the battle.

While the socio-objective frame is less explicitly mobilised in relation to paintings like this, it is nevertheless a significant element within their presentation in the implicit connections made between appearance (Washington is made to look older than he was and more presidential) and function (commemoration and idealisation). A further example of the interpretation of paintings in the Puritan gallery adopts a slightly different frame. Here the paintings stand as conspicuous representations of wealth, both in themselves as material, commissioned objects of value, and in relation to the treatment of their subject matter:

Freake-Gibbs painter
American. Late seventeenth century
Robert Gibbs at 4½ years
1670
Oil on canvas

Young Robert poses stiffly in a petticoat (worn by young girls and boys alike), and stylish, square-toed shoes. The square collar and leather gloves identify him as a male, and the long sleeves that hang behind him – called 'false' because they had no practical purpose – serve as a reminder of his family's wealth. Robert's father, a merchant also named Robert, emigrated from England to Boston in 1658. He prospered, and in 1670 commissioned portraits of his three children – a rare luxury. All three portraits (the MFA owns two) show the children standing on a black-and-white checkered floor, which allowed the artist to create a rough sense of three-dimensional space receding from the painting.

The portrait, rather than being evaluated qualitatively (apart from the ambiguous comment that the sitter 'poses stiffly') is connected interpretively to questions of consumption, fashion and clothing, luxury and representation. The presence of two such paintings means that each can be interpreted in slightly different ways:

Freake-Gibbs painter
American. Late seventeenth century
Margaret Gibbs, 1670
Oil on canvas

Young boys and girls dressed much alike in the seventeenth century. So it is not the dress but her fan that identifies this seven-year-old as a girl. She is Margaret Gibbs, sister to Robert, whose portrait is to your left. Her sleeves

have the single slash allowed by Puritan laws, which regulated personal display according to social class. We do not know the name of the artist who painted Margaret and her brother, but similarities in style, technique, and pigments link these paintings with two portraits of Boston's Freake family – hence the designation 'Freake-Gibbs painter.'

At the same time the tone of the text is highly significant. As discussed before in relation to interpretation at the AGO, the use of pronouns is significant in establishing relations between author and reader and in the simple act of highlighting authorship in the first place, where conventional practices so often adopt the passive voice, leading to a sense that interpretation is not produced by humans with identities but rather by institutions with their mechanised authority of truth. This label identifies 'we', perhaps in relation to those who work in the museum and write interpretation, perhaps in relation to the wider communities of expertise and interest. At the same time there is also an admission that the knowledge of the authors is not complete ('We do not know the name of the artist …'). This is very significant in relation to interpretive strategy, for it counters the tacit presentation of museums as expressions of infallible authority. There is an important difference in meaning between the two statements: 'it is not known …' and 'we do not know …', for in the former there is no sense of human agency and failure, as if there were the possibility that something 'cannot be known'; in the latter, the limits of historical research are acknowledged and there is a sense of human beings actively seeking to discover information. This acts to humanise the interpretive processes of the museum and in so doing to establish the possibility of common grounds of knowledge and lack of knowledge between producers and consumers. Learning that the museum staff entrusted with display and interpretation do not know something is potentially empowering to visitors conscious of the limits of their own knowledge about art, for it legitimises the state of owning such limits. We will now look at some further dimensions of the politics of transparency in interpretation in relation to other interpretive initiatives within the Art of the Americas wing, including the 'Behind the Scenes' galleries, other interactive displays and resources and the hand-held digital audio-visual guide which is available for an additional fee ($6 for non-members, $5 for members).

Let us begin with a brief look at the 'Behind the Scenes' galleries, because they exemplify some of the epistemological and communicative strategies involved here. There are four of these galleries, somewhat tucked away within the visitor route so that they literally have a feel of being behind the scenes. They are thematic, dedicated respectively to the museum actions of 'Classifying', 'Collecting', 'Caring for Works of Art' and 'Making Choices'. Each gallery explains that these actions are not merely technical but political too. The 'Collecting' gallery is introduced by a panel explaining that the museum's aim 'to present all the cultures of the world' is regulated by the history of its collection, which is made up of the vagaries of the influx of objects over the years, whether by purchase or gift. 'A museum is a collection of collections', each with perceived strengths and weaknesses, and visitors can become aware of the contingency of the museum's representations through actions like reading the credit

FIGURE 6.8 Touchscreen interface at MFA showing chronological trends of collecting Native American art; photograph © 2011 Museum of Fine Arts, Boston.

line at the bottom of labels, which 'tells where each piece came from – whether it was a purchase or a gift – and when it entered the collection'. Display cases and interactives represent the shifting cartography of the museum's collections, for example the nineteenth-century impulse to provide exemplars of design for contemporary artisans (in imitation of the South Kensington Museum, later the V&A, in London); another case looks at changes in collecting patterns in relation to changing tastes. A touchscreen makes a similar point (Figure 6.8). The 'Caring for Works of Art' gallery explores the complex decisions involved in conservation practice, analysing works (like needlework samplers) that have undergone remedial conservation, and comparing works (such as a pair of Copley portraits) which have with those which have not, and presenting the contrasting views of curators and conservators as to whether and why specific works should be conserved and allowing visitors to vote (Figure 6.9). The 'Classification' gallery, like the 'Collecting' gallery, is in many ways an attempt to explain the complex cartographical function of the museum which was discussed at length in Part I of this book. Here is the main text panel:

> As a museum gathers objects, how are those objects studied? How are they identified, organized for storage, sorted for scholarly comparison? Classification is part of understanding an object more fully. But which classifications are the most useful? Sorting objects by material is practical for storage or conservation: silver needs the same care whether it's in a Colonial teapot or a Navajo necklace. But classification by type or style or nationality is more complicated. Is a weathervane sculpture? 'Would you call that clock an example of art deco?' Is an artist who arrived from England at the age of twenty-four British or American?

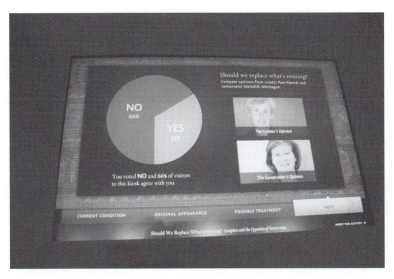

FIGURE 6.9 Touchscreen at MFA showing contrasting views on the conservation of samplers and visitor voting; photograph © 2011 Museum of Fine Arts, Boston.

What may seem hairsplitting distinctions can lead to closer looking, to philosophical discussion. If a twentieth-century ceramic piece has the form of a teapot, but is so elaborate and fragile it could hardly be used, is it a vessel or is it sculpture? The objects do not change, but the context in which we see and understand them may shift. The largest question of all is itself a form of classification: what types of objects are classified as 'appropriate' for the Museum's collection in the first place? What belongs, or doesn't belong, at the MFA? In this gallery, you can consider some of these issues.

This final question is addressed in a small display nearby (Figure 6.10):

What should be in the collection of a fine arts museum? When the Museum opened in 1876, plaster casts representing great works of classical art, like this head of Athena, were considered essential. Today we would very rarely exhibit reproductions. The work of indigenous people of the Americas, like the small Maya figure and gold pieces seen here, was collected at first, then ruled out for decades, considered more appropriate for natural history institutions than for fine arts museums. And finally – what is the MFA passing up today? Should we collect sewing machines?

The text panel on 'Making Choices' explains how curators, designers and educators make decisions about the different stories to be told in different galleries:

Should the gallery be a survey of a whole period or should it showcase just a few artists in depth? Should it provide variety or set up close comparisons?

FIGURE 6.10 'What belongs in the MFA?' display in one of the 'Behind the Scenes' galleries; photograph © 2011 Museum of Fine Arts, Boston.

Re-create a sense of a historical period, focus on a specific style, or feature the character of individual objects?

To many, such art museum practices may seem mysterious; this interpretive strategy opens them up. It works, in Martin's eyes, as a 'way in' because it 'connects to everyday life, that everybody has a job, everybody works with colleagues, everybody does things they have to do very carefully, or makes decisions about value'. In this sense it works to make transparent the authority of the museum and to invite scrutiny of its representational practices. In this alone the galleries form a significant repositioning of relationships between institution and visitor.

Another significant interpretive strategy within these galleries is the incorporation of metacognitive activities – which is to say the provision of interpretive resources that teach specific approaches to interpretation associated with art historical practice. This is, in effect, interpretation about interpretation. An example is the touchscreen on 'Style' in the 'Classifying' gallery which explains the practices of stylistic labels and distinctions, giving hints in relation to reproductions of objects; the 'Federal style' is exemplified by a woman's dress and a chair, and we are told, if we press the 'hint' button, to 'Look for simplicity – straight verticals and horizontals, flat, two-dimensional ornament, crisp edges and forms inspired by classical antiquity'. This strategy is not limited to the 'Behind the Scenes' galleries. It is true that the socio-objective frame dominates in the Art of the Americas wing, but others like the stylistic frame are also adopted, notably in galleries dedicated to understanding regional variations in style, particularly with regard to furniture and decorative arts (Figure 6.11), or in digital interactives such as the one dedicated to 'Comparing Copley portraits' which focuses on matters of style and technique (Figure 6.12). While these pertain to relatively

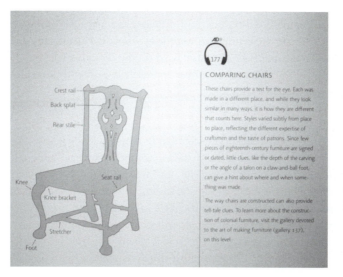

FIGURE 6.11 'Comparing Chairs' text panel, MFA; photograph © 2011 Museum of Fine Arts, Boston.

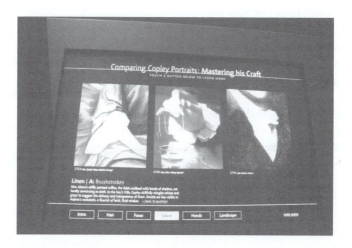

FIGURE 6.12 'Comparing Copley portraits' touchscreen, MFA; photograph © 2011 Museum of Fine Arts, Boston.

conventional and longstanding preoccupations in art history and art curatorship, what is innovative here is the attempt made to explain the principles involved in such projects of discernment: to set out, as it were, the rules of the interpretive game. And in these cases it is presented quite literally as a game, where the visitor is prompted with questions: in the interactive on Copley portraits we are asked to decide 'What are the differences [between, for example, the painting of clothing in different portraits]?' and given hints to guide us to the answers; in the 'Regional Accents' gallery we are

asked to develop the skills to distinguish between regional styles (for example in the design of chairs), an 'opportunity to test the eye: how is Philadelphia different from Boston? New York from Barbados? And what are the clues that tell you?'

As Martin notes, this metacognitive approach is a recently developed strategy which was experimented with in the exhibition 'Titian, Tintoretto, Veronese – Rivals in Renaissance Venice' which ran at the MFA from March 15 to August 16, 2009:

> [This] was really a dream show, in that its scholarly point was seeing how those three artists bounced off each other, competed for the same commissions, influenced each other … and the show was actually able to do that through a lot of … here they all are doing St Jerome … so it was fascinating to laypeople [who understood that] 'wow, it's like a game that I can play'. And we've been trying not to assume that people will get that, but [rather to say] 'here's the game; here's how you play it', because it takes a long time but you finally realise that it doesn't just come naturally if you don't spend a lot of time in museums.

This approach has become more explicit in recent years with the introduction of more distinct signalling to visitors about ways and techniques of interpretation. Citing Thomas Campbell's 2008 comment that upon becoming director of the Metropolitan Museum in New York there was nothing in the building to explain why Rembrandt is important (in Landi 2008), Martin notes that developing metacognitive interpretation is something which has been done for decades in other types of museum, notably science museums, while art museums have been reluctant to do the same:

> Science museums have done a better job than we [in art museums] have in stepping forward and teaching people things and we haven't been willing to do that yet. The difference between an art museum and a science museum is, on the whole, scientists don't go to science museums, whereas in an art museum the scholar the connoisseur, the deep devotee of art is sharing the space in front of the painting and reading the same label as the eighteen-year-old. That is one reason that art museums have kept their tone – 'we don't want to talk down to people'. But there's a lot of research to show that people know less than you think.

This relates to some of the main theoretical underpinnings of interpretive practice at MFA, drawn from Abigail Housen's theory of aesthetic development discussed in Chapter 1. For Martin, the value of Housen's studies has been to 'tell us that the majority of museum visitors are at Stage 2':

> They're figuring it out, they are getting an idea of what determines value: how does art relate to a particular culture, what is style, etcetera. Whereas Stage 3 – which is full-blown art history, studied in college etcetera – most people aren't there, and for years that's where almost all museum programming was aimed;

that was the wavelength we were broadcasting on and going right by people. So we're starting to think more imaginatively about how to engage [people who are at] Stage 2.

Stage 2, we need to recall, is the 'constructive' stage:

> Constructive viewers set about building a framework for looking at works of art, using the most logical and accessible tools: their own perceptions, their knowledge of the natural world, and the values of their social, moral and conventional world. If the work does not look the way it is supposed to, if craft, skill, technique, hard work, utility, and function are not evident, or if the subject seems inappropriate, then these viewers judge the work to be weird, lacking, or of no value. Their sense of what is realistic is the standard often applied to determine value. As emotions begin to go underground, these viewers begin to distance themselves from the work of art (VTS).

However, a full subscription to the pedagogic method of VTS is not evident in the MFA's interpretation (although it is a key element of their teaching approach with school groups). This approach is primarily geared towards face-to-face live interactions, for example between students and a teacher in museum contexts and involves extended engagement with an artwork, typically a pictorial one, followed by framed enquiries beginning with 'What's going on in this picture?' (Subsequent questions include 'What do you see that makes you say that?' and 'What else can you find?' (Housen and Yenawine 2001)). Martin clarifies that it was not the intention to translate these VTS methods from interpersonal student-teacher dynamics into the static interpretation on the walls, 'but rather that Housen's stages and description of the interests and questions of viewers at various stages formed a valuable touchstone'. The tone of the labels is based more 'on a desire to be transparent, direct, and informal, than to apply a theory of learning', but nevertheless, commonalities exist, perhaps co-incidentally. For example, 'What can be seen?' is also a question which figures in some of the abstract and semi-abstract works shown on the top floor of the Arts of the Americas wing, dedicated to twentieth-century art. Consider, for example, the following:

Jackson Pollock
American, 1912–56
Troubled Queen, 1945
Oil and enamel on canvas

Troubled Queen comes from a transitional moment in Pollock's career as he moved away from the stylized works of his early years toward the 'drip' paintings for which he is best known. In the mid-1940s, Pollock often built works around disturbing images from his subconscious, rendering them with a highly textured and energetic technique. In this painting, two face-like forms

emerge from churning coils and jagged lines, one a leering mask, the other a one-eyed diamond shape.

Here, however, the socio-objective framing which dominates in the representation of earlier centuries of American art is not as strong in its operation. The abstract works of the twentieth century prove difficult to place within the same rich networks of stories of society and history, although attempts at contextualisation are made. Unlike careful framing of neoclassicism in relation to the social and cultural politics of the new nation which can be encountered a few floors down, the text panel introducing abstraction between 1940 and 1970 includes no references to wider histories: rather, 'a group of New York painters, including Jackson Pollock, invented a radical new approach that critics immediately labelled Abstract Expressionism'. In this sense the development of art is placed firmly within the sphere of a few individual artists, and removed from other determining forces. As discussed in Chapter 5, perhaps this is a consequence of new (in the twentieth century) notions, and forms of consumption, of art, and new conceptions of the artist, and perhaps these factors make a rigorously socio-objective frame much more difficult to wield, with the potential for opening up confusing vistas. It is not surprising that the interpretive frame here is predominantly biographical, abetted by the psychological subject matter (if such it is), and in correspondence with the biographical mythology of the artist in thrall to his own creative ability. Alongside the label is one of Hans Namuth's intense photographic portraits of the artist. The inclusion of the photograph perpetuates the cult of the individual artist and allows for the same kind of connective biographical experiences of the painting which we encountered in Chapter 4 in the discussion of the museum interpretation of the work of another artist historicised as 'great' and as a cardinal force in the history of art: Rembrandt. It is indeed harder to talk about the function and social role of a Jackson Pollock painting than it is to talk about the function of a Copley portrait, or a silver teapot. But as discussed in Chapter 5, it can be instructive to confront such difficulties. At the same time, it should be noted that in the development of the displays there was a conscious attempt to vary the tone and approach, in order to encompass 'socio-objective' and other framings. As Ben Weiss puts it, this was intended to allow for 'different sorts of ways in, both to reinforce the idea that there are various ways of looking and thinking and also to provide some rhetorical variety' (Weiss 2011: personal communication).

This case study has shown up some of the constructive tensions between cultures, types of objects, types of history and types of discourse and address which emerge in a large-scale interpretive project with such local, national and indeed international resonance (it is after all the 'Art of the *Americas*'). My impulsive response to the display was to worry about the complexity and pitch of the interpretation, but on consideration it occurs to me that it is simply of a different kind of complexity than much art museum interpretation (consider the Milanese examples in Chapter 4). And it may be that it is a complexity which can be more easily penetrated by those without advanced disciplinary knowledge of art history. And a key innovation here is the depth in which the cartography of art museum interpretation is explained through

metacognitive exercises embedded within the displays, and in particular within the 'Behind the Scenes' galleries. So while the intellectual demands made of visitors by the interpretation may be considerable, the means to learn to meet these demands are also provided, as though to allow visitors to find the right balance between challenge and skills, avoiding both anxiety and boredom. The Art of the Americas wing is most obviously a multi-dimensional map, charting geographical territory and different epistemological terrains, each framing art within different ways of knowing. It works too as a narrative in the sense described in Chapter 2, although it is a narrative – the social fashioning of artworks and the place of artworks in the fashioning of society – which enfolds others such as histories of style. Recalling the discussion in Chapter 5, the narrative ends somewhat unclearly with the breaking of the socio-objective frame in displays of the art of the later twentieth century, as it becomes seemingly less fruitful to talk about the cultural function of art beyond the walls of the modernist gallery. The wing is large enough to mean that many visitors may not follow such narratives in the chronological, bottom-to-top route suggested by their architectural disposition, but it is evident from the guidance given in the brochure to visitors that this is not of paramount importance, and that there are other routes to fruition. This is also stressed by Martin, who outlines an aesthetic of discovery:

> What most people are less able to do is to spend time really connecting with a work of art, looking longer, noting more, whatever it has to send, receiving more of that. My ideal for a visitor is that they connect with a group of objects or an object that that night at supper they would be able to say to their companion 'I went to the museum today and I saw this one strange little bowl ...' And they might also have seen rooms and rooms of other things that they enjoyed. But ideally I would like them to have some things that they really spent a little bit longer with and asked themselves a question about or something that perfectly answered a question ... What I would want is that visitors should feel empowered to engage ... part of what aiming information correctly does is it empowers visitors; it gives them a sense that they do have the tools to engage; there isn't some mysterious practice that you're supposed to know if you're in this kind of place and they don't know, but they can look and make connections to their lives and compare this thing with the thing next to it.

What we see both in the AGO and the MFA is an emphasis on the need for visitor-oriented interpretation which is written in everyday language and facilitates the discovery on the part of visitors of the relevance of art and the possibility of personal connections of some kind. The AGO does this most strongly through the socio-critical frame which it adopts, while at the MFA a key strategy is the sharing of the tools of interpretation. Neither museum relies on the comprehensibility to visitors of overarching art historical narratives, and both represent, in different ways, the development of different pedagogical relations between the fixed interpretation of the museum and the visitor, in which the pitch and mode of address of interpretation

changes and the hermetic system of references embodied by more traditional practice is opened to allow new points of entry and new, more personal forms and processes of understanding. While the museum is always a map, in these examples it is also a mapping technology for visitors to use, mapping our relationships with the past; our relation to material legacies, our place within and outside cultures of nationhood, enquiry, identity, selfhood and – especially in the case of these two museums – contact with alterity in its broadest sense. This represents not just a shift in interpretive practice (and there are other institutional examples which could be chosen to demonstrate this shift); it is also part of a shift in the conceptualisation of art and the experience of art. Through these two case studies we have looked at the very complex political work of the interpretation of historical art in large metropolitan museums. In the next chapter we will consider some of the different imperatives associated with the interpretation of contemporary art in different kinds of institutions.

7

CASE STUDIES

INSTITUTIONAL APPROACHES TO CONTEMPORARY ART

This chapter continues the work done in the last chapter, which is to look in depth at interpretive practice within specific institutions; this time, however, we will focus on two organisations which concern themselves solely with contemporary art. This chapter will seek to contextualise interpretive practice within two art museums: the Northern Gallery for Contemporary Art in Sunderland, and BALTIC Centre for Contemporary Art in Gateshead, both of which are in the north east of England. Although they are relatively close to one another geographically, these two institutions differ in relation to their spaces, audiences, the emphases and type of exhibition programme and their interpretive practices. However, they have both achieved a national and international profile and in each one the difficult question of how to interpret contemporary art for diverse audiences has been addressed and not avoided. The two institutions represent, in my eyes, models of responsible practice, and while issue may be taken with some of the interpretive strategies employed, they nevertheless suggest interesting and thoughtful ways through some of the interpretive problems discussed in Chapter 5. Here, as with the examples discussed in the previous chapter, in each case the analysis of the interpretive programme and its strategies will be supported with data obtained through semi-structured interviews conducted by me with some of the key figures involved in interpretive planning. And once again, unless otherwise stated, the factual information in what follows is attributed to them or to textual materials available in the organisations themselves.

Northern Gallery for Contemporary Art (NGCA)

NGCA opened in 1995 as part of the Sunderland City Library and Arts Centre. It attracts 35,000–40,000 visitors per year, and occupies the top floor of a multi-use building, with the city library on the floor below. Sunderland is an urban centre with a population of around 280,000.[1] While Sunderland has become an important, if not

always thriving, centre for motor production, the industries on which the city's fortunes were once based have gone, with the last shipyard closing in 1988 and the last colliery in 1993. Within the UK Department of the Environment's Indices of Deprivation the city is ranked in the thirty-third worst position among 366 English districts, but here adverse scores in economic, social, health, educational and environmental indicators were offset by others relating to housing, without which the city would actually have been ranked fifth worst in England (Sunderland City Council), and levels of wealth and people's attainment in formal education are generally lower than elsewhere in the country. This non-metropolitan, predominantly blue-collar context, as we will see, is significant within the interpretive planning undertaken at NGCA.

The NGCA's mission statement is as follows:

> Northern Gallery for Contemporary Art presents changing exhibitions of new work by artists from around the world, bringing new art to new audiences.

> It offers opportunities to emerging and established artists to present work at critical points in their careers and audiences the chance to see the stars of tomorrow today.

The gallery is large, comprising a 35 × 17m space. Here, ceiling-mounted screens can be used to create suites of rooms or spaces, or the space is sometimes left undivided depending upon the curatorial approach to given exhibitions. Alongside the exhibitions, there is a programme of talks, tours, educational activities, workshops and artists' residencies, and a drop-in Activity Space provides art resources for young children and their parents or carers. While recognising the importance of this in relation to the NGCA's overall interpretive programme, it is the fixed interpretation in the galleries upon which I will focus in this chapter. The Gallery has no art collection, and holds five to six exhibitions every year, which frequently achieve significant national press coverage.

This chapter will focus on some of the interpretation to be found within the 'Hints to Workmen' exhibition which ran in Winter 2010–11. Like many of the exhibitions at NGCA, this is a group show with a difference. The works of a number of contemporary artists from around the world were shown together, alongside some twentieth-century works, but also on display were nineteenth- and early twentieth-century documents of one kind or another, including pamphlets and advertisements from newspapers and periodicals. These were collected by the exhibition's curator, Alistair Robinson, and were dismembered and framed for the purposes of the exhibition; they are now housed within the gallery's archive. These documents, broadly speaking, are paternalistic texts aimed by the political elite at 'working' people (a term whose ambiguity is at play in the exhibition). The texts set out moralising and prescriptive 'hints' about how to make responsible choices in life, although these choices seem geared to perpetuate existing social orders and to fulfil elite interests.

The documents, which are recontextualised and literally reframed within the new intellectual game of the exhibition, appear in the first of the spaces to be encountered

by visitors and they act themselves as a frame for the contemporary artwork on display, forming a prompt to reflect upon historical continuities of coercion, inequality, class positioning and the interplays between power, protest and civility. There are lots of them – seventeen in total as compared to nineteen individual artworks or art installations. This is then an exhibition with a strongly authorial sense, in the identification and constitution of a theme, the assembly of objects (some of them 'non-art' objects and therefore unconventional inclusions within the institutional parameters of the art gallery), the mapping of artists' works within the critical terrain of the show and in the playing-out of a narrative of connection and continuity. The historical objects are necessarily aestheticised in their presentation, carefully mounted, framed (the frames are brown, distinguished from those of the artworks which are white) and lit in accordance with museum standards (Figure 7.1), and their assembly and reconfiguration for exhibition can be seen as a form of installation. This creative and strongly authorial aspect recalls some of the discussion in Chapter 5 about the confusion, constructive or otherwise, surrounding the role of the contemporary art curator. The exhibition's main text panel characterises and itself exemplifies this exhibitionary metaframing by bookending the text with references to the 'non-art' content of the exhibition:

> 'A few small hints ... a few nudges can help a lot ... Libertarian paternalists should attempt to steer people's choices in welfare-promoting directions. "Choice architecture" can be established to nudge us in beneficial directions'.
>
> From *Nudge*, Cass Sunstein and Richard Thaler, 2008.

FIGURE 7.1 'Hints to Workmen' at the Northern Gallery for Contemporary Art, Sunderland; image and reproduction rights courtesy of the Northern Gallery for Contemporary Art.

Harun Farocki (Berlin), *Peter Watkins* (Felletin, France), *Gailan Abdullah Ismail* (Erbil, Iraq), *Rainer Ganahl* (New York), *Vinca Petersen* (Kent), *Stuffit* (Bristol), *Anna McCarthy* (Munich), *Baptiste Debombourg* (Paris), *Keetra Dean Dixon* (New York), *Robin Bhattacharya* (Zurich), *The Economist, King Mob* (London), *Misteraitch* (Sunderland), *The Diggers* (San Francisco), *The Open Council, Fiona Bimson* (Northumberland)

'Hints to Workmen' takes its theme from two texts that have aimed to improve the lives of the majority of ordinary working people. 'Hints to Workmen' is the title of an educational pamphlet written when capitalism was in crisis – the mid-1840s. Its ideas seem to strangely parallel recent political advertising campaigns, and 'Nudge' theory beloved of the current leaders on both sides of the Atlantic. Both 'Nudge' and 'Hints to Workmen' suggest that 'libertarian paternalists' in positions of power should provide their people with 'hints' as to how best to live. But whose interests are at stake?

The exhibition offers a sequence of 'hints' that international artists suggest will help shape a better world. It brings together documentation of interventions that artists have realised in public spaces, and in the wider public sphere. The works examine the possibilities for new forms of direct action, from politicised forms of play to outright civil disobedience. They range from inventing your own currency to spearheading full-blown protests, to staging absurd events that bewilder the authorities. The exhibition asks us to re-imagine, to use historian Tony Judt's recent words, what our 'collective ideals [are] around which we can gather, around which we can get angry together, around which we can be motivated collectively?'

It begins with a series of bracing and bitterly funny advertising images for major banks from the 1930s, during the last major financial crisis. Surprisingly, they include a campaign by the 'Church of England Building Society' selling mortgages to a new class of potential homeowners. These images hint that what define the English are faith, hope and usury: faith in liberty, or else the freedom of the market; and hope for property and prosperity – with both obtained on credit.

The artworks on display were mostly pre-existing, encountered by Robinson in the course of visits to exhibitions, artists' studios, through word of mouth and general research over the course of years. The theme for the exhibition did not precede these encounters – indeed, Robinson notes that he had known of, and wanted to show, Peter Watkins' 2000 single-channel video *The Commune: Paris, 1871* for some ten years before the idea for the exhibition crystallised. Rather, the works in the exhibition and the theme organised each other in a chicken-and-egg sense. Artists were then contacted and in each case a protracted process of collaboration ensued, in which the thematic structure of the exhibition was clarified and a shared sympathy for this

was established, so that Robinson gained a clear sense of 'what artists' intentions were and how far you could stretch them within the context of a show, without them feeling that they are being used or manipulated'. As part of this relationship, artists read and approved proofs of the interpretive texts written by Robinson, and had the opportunity to correct misunderstandings or misrepresentations which they identified. The artists whose work Robinson tends to select are those who welcome discourse about their own work and who, in many instances, are not household names (in line with the NGCA mission statement reproduced earlier), as Robinson clarifies in relation to the local and artworld politics of selection:

> Reliance on the brand recognition of 'name' artists wouldn't achieve much here in itself, though it has some uses. 'Names' seldom signify far outside the profession or possibly the press, and the proportion of the audience that have vested interests in the field is too small here in Sunderland for us to function in that way ... In a capital city one could rely on people attending because of the prestige of the gallery, or of a named individual, but I don't think we can get away with that – the proportion of negative comments from before I started signified that squarely. More broadly, I'm sceptical that there's a straight equation between an artist's profile or media presence and their interest ... The potential costs of doing this, when the primary route to advancement or to media coverage are associating yourself with others' status, are fairly clear. No curators can avoid considering the status character of the artists they show wholly, but my thoughts are that if one can attempt to be 'status blind' – to judge individual works on their interest for a situation rather than their authors' imagined image – well, it's a start.

As stated, the historical documents are distinguished from the artworks by being housed in brown frames as opposed to white, but one thing which connects the two groups of objects is their proposal of models of behaviour. In the case of the historical documents, hints are given by those in authority to those without as to what they should be and do, including how working people should invest their money (something with obvious currency today, given the contemporary financial crisis). Meanwhile, many of the artworks propose models of direct action, subverting questionable social norms, or suggesting collective interventions in social space where governments no longer guarantee civility. This too came to have a certain resonance as the last months of the exhibition coincided with the 'Arab Spring' of 2011, in which media representations of civil unrest and conflict between state and citizenry abounded. In the first room of the gallery, which houses the historical documents, the most noticeable artwork is the aforementioned Peter Watkins black-and-white film of a re-enactment of the 1871 founding of the Paris Commune, in which amateur actors take sides and are interviewed by reporters holding microphones. This work sets up possibilities of protest as well as of connection, intermixture and cross-reference between past and present, and has an emblematic and educational function in the exhibition in enabling certain types of comprehension and response.

But before thinking directly about other artworks, it is worth reproducing the text for some of the documents which frame them:

'Hints to Workmen', 1847
From Information for the People
By W. and R.C. Chambers
'The ruling object [here] has been to give what may be expected to prove the means of self-education to all such of the humbler classes of society as are debarred from the receipt of knowledge … The working classes generally are remarkable for their credulity.'
From 'Hints to Workmen., 1847, W. and R.C. Chambers

'Hints to Workmen' might be described as a schizophrenic publication, combining two competing voices. One provides ordinary labouring people with sage advice as to their livelihoods, means of getting on in the world, and self-improvement. The other 'voice' is, to modern ears, almost wildly patronising. 'Hints to Workmen' strangely echoes some of the political thought of recent times, which has been aimed at 'nudging' people towards their own best interests rather than short-term indulgence. One of the largest British parties originated an online public information campaign in 2006 whose advice was summarised as 'Don't give in to your inner tosser'.

The campaign in question was the Conservative Party's 'Sort-It' campaign based on the web and accompanied by a video (not present within the exhibition) showing a young man engaging on a profligate spending spree, encouraged by a garishly dressed older man – a personification of temptation or 'the tosser within'. This character tells the young man that his expenditure will lead to success with women, something which appears to be untrue as a woman later seeks to avoid his clumsy advances on the high street. A voice-over towards the end tells us:

Inside all of us lives a conniving, dirty little parasite – the tosser within – he wants you to spend, spend, and keep spending, until you're in terrible debt. Ignore the tosser inside of you, and take control of your money, at sort-it.co.uk.
(Conservative Party 2010)

Unsurprisingly, most traces of this campaign have been eradicated, and it is indeed fortunate for the Conservative Party that it had apparently been forgotten by the time the UK Parliamentary expenses scandal hit in 2009, where elected politicians' illegal misuse of allowances and expenses (which was ultimately the misuse of taxpayers' money) led to widespread public anger. At the same time, the onset of the economic crisis means that ideas of responsibility have shifted from 2006, when profligate spenders could be the target of a political party campaign; now (at the time of writing) one might more readily accuse banks and building societies (whose concerns are not separate from those of the state) of profligate and

irresponsible lending. The 'Sort-It' campaign is merely alluded to at the end of the label reproduced above, partly because NGCA is a local-authority organisation and thus cannot risk being seen to be partisan or express views about individual political parties, but it effectively frames the exhibition politically and acts as a response inviting structure, encouraging us to be critical and indeed suspicious of the coercive and often self-serving acts of those in authority and to take issue with their implied view of the electorate (with which many visitors will self-identify) that is bespoken in such material.

In some of the interpretation a basic critical challenge is established, where the mismatch between the historical document and other textual material quoted in the label invite visitors to identify what Robinson calls 'missing' information. For example, a 1930 advertisement for Legal and General Assurance, 'The prime minister of success is a sound education' is contextualised with a BBC2 quotation on the unequal opportunities and reduced educational attainment of poor children. The use of quotations is widespread within many of the labels – from 'authority' sources like the BBC to artists like Andy Warhol and Joseph Beuys, writers like John Lanchester as well as George Bernard Shaw's 1903 *Maxims for Revolutionaries* and Hewlett Johnson's 1939 *The Socialist Sixth of the World*. The juxtaposition of such texts (including the documents and artworks which they frame) forms an implicit challenge to the visitor to notice the lack of ideological coherence between them, and one way of viewing the exhibition's workings is as a game in which visitors are provided with the means to develop particular critical skills which they are then challenged to exercise in response to specific stimuli. As Robinson notes, 'if people read [the labels] carefully, there should be sufficient warnings that not all is well'. A multiplicity of voices is arranged, but this multiplicity is not one of agreement; and of course, the voices are corralled into place rather than invited to speak as we saw in some of the examples of co-constructed interpretation discussed earlier in this book. This exhibitionary strategy is also reminiscent of the attention to metacognition which we have seen elsewhere (for example in Chapter 6 at the Museum of Fine Arts in Boston) and of the positioning of visitor experience in a balance of skills required and challenge posed, like in Csikszentmihalyi's notion of optimal experience (Figure 1.5). But it clearly works on a different level, pertaining to critical and political understanding rather than primarily aesthetic or art historical engagement. It also problematises the gallery as a place of unitary authority and unified, accurate interpretation – as an institution, in other words, which purports to make sense of phenomena for people.

Another historical document within the same area of the exhibition provides the focus of more provocative interpretation, establishing the conditions for questioning the legitimacy of interventions in people's lives of those vested with authority or status – in this case the religious authority of the Church of England:

> *Advertisement for the Church of England Building Society, 1939: '54 Years of Service'*
> 'He that is Prodigal is prey for the Devil'. Edward Misselden, 'Free Trade, or the Means to make Trade flourish', 1622

Edward Misselden, was a rich merchant who exploited credit channels, but also wrote that 'prodigality' – conspicuous consumption – was the devil's own work. There are, similarly, several ironies in the Established Church running an ad campaign in *The Economist*, to promote its money-lending business. It has been speculatively suggested that the Church's money lending began, in 1885, to divert workers away from socialism and its atheistic ideas. Naturally, it only lent to consumers in the South-East.

This advert allows us to imagine a magical 'what if' scenario: what if the building society had survived and been ruined by the credit crunch? Could it have bankrupted the church (whose head is the reigning monarch)? Would the Government have had to step in to nationalise it? Or could another religion have mounted a corporate takeover?

While these are labels for the 'non-art' inclusions within the exhibition, they form (together with the historical documents themselves) an interpretive complex which frames our experience of, and prescribes our behaviour within, the rest of the exhibition, which proceeds to show artworks which are positioned to prompt us to question our subject position within the state.

Let us take a few examples of these, beginning with a series of Vinca Petersen photographs:

Vinca Petersen
From the series *'Raves and riots'*
'The new adventurousness towards public space has deep roots. Britain has long been a centre for experiments in land use: squats in the 60s, free festivals in the 70s, raves in the 80s', Andy Beckett, 'Another world is being built', 2010.

Petersen has spent the last 15 years around those opting out of mainstream society: travellers, protestors, and those who are part of the free party scene. Her work examines the ways in which hedonism and political idealism are intertwined. In seeking out the lifestyles of libertarian rather than puritanical idealists, she provides 'hints' as to how other ways of living can genuinely be realised. She has written, 'Mine is a quiet, optimistic, undercover 'revolution'. I've always believed we can become free through the way we live our lives. This is a subtle, undercover form of rebellion. It is not so much about fighting but laughing. To be unpredictable and open-minded not only allows one to be free but makes one very difficult to sell stuff to – someone who does not buy things really is the greatest enemy of capitalism …'

This is not interpretation which works in direct relation to the pictorial aspect of the photographs – issues of composition, technique and immediate visual-aesthetic concerns are left out, in favour of an account of the artist's intertwined lifestyle and political preoccupations, out of which her photographs seem to flow, as if naturally.

This resembles, to a certain extent, the framing of works in relation to the political preoccupations which they reflect and construct as, in Chapter 5's discussion of the interpretation of Kader Attia's *Oil and Sugar #2* at the ICA in Boston. In addition, though, we also see significant recourse to the artist's own voice (reprised, in fact, from conversations with the curator in advance of the exhibition), another one of the stock strategies for the interpretation of contemporary art. Together with the supportive Andy Beckett quotation which prefaces the text on and by Petersen, the interplay of photographs and interpretation present the visitor with a clear model for subversive action, albeit a modest one. A more ambiguous interplay can be found in the following example, a photograph by Robin Bhattacharya showing him raising a Jolly Roger flag on a yacht on Lake Zurich:

Robin Bhattacharya
Raising the Jolly Roger, Lake Zurich
'Business art is the step that comes after Art. I started as a commercial artist, and I want to finish as a business artist', Andy Warhol

Bhattacharya's photograph documents an intervention in the unlikely 'public space' of Lake Zurich, by the city where he now lives. Zurich is one of the world's richest cities, as an international banking capital: it has been claimed there are more millionaires than unemployed people there. As land values are so high, 'public space' is at a premium and carefully policed. The lake, therefore, is one of the few spaces in the city where protests can be staged. Bhattacharya himself raises the Jolly Roger, the pirate's flag – from a private yacht. Is he glorifying modern business's swashbuckling ways (as seen on the adverts on the opposite wall)? Or is he an anthropologist, working within the belly of the beast in order to discover more about this strange, distant tribe – financiers – and their rituals of celebration and sacrifice?

In some ways the questions at the end of the label might be seen in relation to ideas about open interpretation discussed in Chapter 3, in which meanings are not foreclosed and ambiguities and uncertainties are recognised, while prompting the visitor to engage in her own creative and intellectual work to make meanings. Seen otherwise, the interpretation works constructively in connection with the ambiguity of the image (for a precise, singular meaning is not given by the artist), in order to pose questions which are themselves inflected with political ideas. These ideas are that modern business might be 'swashbuckling' or a 'beast', while financers are a tribe, an 'other' with cultural practices as disquieting to us as were those of 'primitive' tribes once encountered by western explorers, or indeed, the pirates who, in the stereotypical associations which might be conjured up, appropriate violently for themselves and stage merciless killings. In other words, even the interrogation of the image for meaning – the identification and framing of questions – embodies the possibility for and necessity of political statement, reminding us once again of the status of the exhibition as an 'authored subjectivity' (O'Neill 2007: 18) with its own political orientations.

The last text which we will consider is in some ways a more straightforward description of the artwork – a single-channel video showing a group of people forming a circle in the middle of a busy road:

> Gailan Abdullah Ismail
> 'Traffic' 2008. With thanks to ArtRole
> '"Temporary Autonomous Zones", as radical writer Hakim Bey calls them – [are] short-lived environments full of alternative social possibilities. These experiments have often begun as an irritation to the authorities, but they have absolutely shifted official thinking about public places … [because] where artists go, estate agents follow …', Andy Beckett, 'In gaps left, another world is being built', 2010.
>
> As so many of the images that the media present of Iraq are horrifying or tragic, remembering ordinary life continues can be difficult. Ismail's actions discuss the state of Iraq indirectly – through actions enacted in public space that 'make good' the public works that are needed so badly. They are an attempt to make a personal contribution to making daily life better for his fellow Iraqis. His video 'traffic' addresses a simple problem: the absence of a roundabout in the centre of Erbil, his home town. His temporary solution, made at great risk to himself, has been to create a human roundabout which cars have to negotiate instead of driving directly across the square.

While this text may seem more value-neutral than others it nevertheless works within the overall interpretive frame established through the objects and order of the exhibition: a frame opening vistas on to the tension between the state and the power of the citizen to act for collective ideals of civility. It also works interpretively through the immediate juxtaposition of other works, notably Rainer Ganahl's dizzying videos, filmed by the artist as he cycles the 'wrong' way along the major thoroughfares of Moscow and Bucharest, weaving recklessly through oncoming traffic in what is (according to the interpretation) a metaphorical representation of 'how, after 1989, to be on the left is to "swim against the tide"'. The artist is positioned, in this interpretive complex and more specifically in the label for Ismail's work (note that it was made 'at great risk' to Ismail himself, although the risk to his collaborators is not foregrounded), as heroic dissenter and near martyr for a cause of political and/or civil ideals.

This discussion has shown up a number of interesting things. The first of these is that the curatorial thesis is quite pronounced, even if it is too sophisticated and playful to settle into a proper manifesto. But the invitation to respond is not ultimately dissimilar in principle from that which characterises some of the compositional framings discussed in Chapter 4, in which visitors are shown what to look at and in what order within an artwork. The difference is that here the response required is not ocular or aesthetic (in the more limited sense of the term) in nature, but rather political, intellectual, ideological, ethical and moral. Second, the relationship between objects and interpretation is far from straightforward, and there is little sense, in my

view, that the 'traditional' interpretation embodied by text labels is focally subservient to the 'artworks', and this confusion is compounded by the inclusion of historical documents which both frame, and are framed within, the exhibition. This leads to a third point, which is to question what exactly is being interpreted. On the one hand, the artworks, documents and labels may be seen to interpret one another; on the other hand, together they interpret a set of external objects, which are social relations within the world. It is this potential for flipping or reworking the interpretive relations of the art museum and gallery, and for rethinking questions of focus, which can make contemporary group shows – especially very complex ones like this – so compelling in providing structures for reflection about political issues often of the highest order. It is also what can make them such fraught enterprises where (in other instances) the thesis and interpretive game are less well developed and the artists' works are less fitting and expressive within the specific propositional-political context of the exhibition. Lastly, in 'Hints for Workmen' we see a thoroughgoing alternative to conventional framings of contemporary art in museums and galleries discussed in Chapter 5 by way of its architectural and pseudo-syntactical placement and ordering, and the eschewal of 'text' interpretation. We will now explore the political dimensions of this curatorial choice.

Robinson explains the imperative to provide textual interpretation, first in relation to the heterogeneous nature of the material included in the exhibition: the co-presence of a mid-nineteenth-century moralising pamphlet and a twenty-first-century artwork simply requires explanation if its dialectical possibilities are to be fulfilled. Second, there are ideological and local considerations at play relating to questions of access. Talking of practices of interpretation which eschew the use of verbal text Robinson notes:

> At the very least there's a slight duplicity, for with so much contemporary art meaning is located in authorship. To take a famous example, Damien Hirst's spot paintings: why does someone pay something like five million pounds for a colour chart painted in spots on to a big piece of white canvas? The only possible rationale, other than the economic one, is because the meaning is secured by the authorship, and therefore the story is tied to the authorship, not the object, first and foremost, so the mythology is tied to the individual. But if you're not party to that then the meaning evaporates very quickly. Without knowing what the conventions of contemporary art are or what the individual's reputation is, you've got very little to go on. If you [as a curator] don't reveal what those are, then you're only communicating to people who have a vested interest in the field. And that's not really acceptable here [in Sunderland]. It's not going to play very well.

He continues, explaining his choice to write interpretive texts:

> Here, the central problem is that only a small proportion of the audience are aware of the protocols of contemporary art before they enter the gallery. But

there is an 'art world' here as well – and a small proportion of people who will feel highly patronised if you spell those protocols out. Obviously the vast majority of visitors may feel bewildered if you don't. So there is a serious challenge: to formulate a mode of address able to engage both those with vested interests in the field, and those entirely new to it – to offer something new to even the most dedicated visitor whilst providing an introduction to someone visiting for the first time.

At the same time, this belief can bring with it certain elective responsibilities with regard to the mutual framing of artworks and texts, and the approach here is to position texts in such a way that they are encountered only after the work has been seen (they are often positioned some 80 cm to the right, or further away, depending on the physical nature of the artwork). By these means visitors engage iteratively with the artworks, being prompted to look and think again through having read the label texts:

> The argument is whether having a text panel automatically detracts from the work, or whether, if you place it in a position where a visitor can only see it after seeing a work, it can help them reflect on what they saw and thought. There are obvious things we avoid: if you merely repeat to someone what they've already thought, you've failed to stimulate their imagination. If you can add to their reading, amplify it, or even challenge it, to make people re-examine their first reactions, then the text serves its purpose. In a group show of young artists, you're dealing with visitors' initial thoughts about their first encounter with them, so texts provide an introductory function as well as one of offering counter-readings or implied contradictions between text and image. But the texts also reflect the fact that in a group show there are competing stimuli – so you're providing an impetus to increase 'dwell time' by encouraging people to stay with a work – to reconsider it rather than moving on to the next room. The texts can slow a visitor's pace around the space, and allow them to rethink their first impressions. Stating bald facts about an artist wouldn't achieve that, so we don't put biographical details on labels unless they are strictly relevant to the individual work. Rather, our process is anticipating what kinds of imaginative journeys people are going to take, and avoiding merely describing or duplicating them.

In practice this means developing provocative labels which open questions and prompts rather than labels which classify and explain artworks, encapsulating and finalising their meaning. This means satisfying a desire to 'open' artworks imaginatively for individual visitor understandings *and* the need to attend to the constructive ambiguities and the sometimes purposefully obfuscated significances of many contemporary artworks: no easy task. On one hand this is one kind of manifestation of the impulse towards increasing dwell time discussed in Chapter 1. On the other hand, in Robinson's thinking, it corresponds to ideas developed by Michael Baxandall about the desirability of providing incomplete cues which prompt

the visitor to engage actively rather than passively: 'to offer a pregnant cultural fact and let the viewer work at it is surely both more tactful and more stimulating than explicit interpretation' (Baxandall 1991: 41).

One of the ways of demystifying contemporary art adopted at NGCA is precisely to exhibit it within the thematic context of 'real-world' concerns such as the political ones that 'Hints for Workmen' explores, to map the art in relation to everyday life, recalling our discussion in Chapter 3. It is Robinson's feeling that an exhibition of work framed in a purely aesthetic way would not work within the 'ongoing story' of the NGCA's programme, and would alienate local audiences because of the lack of a 'way in' through contemporary practical concerns which affect us all. 'You can't get away from the fact that the gallery is in Sunderland', notes Robinson, 'so if you want any kind of story for the gallery, for it to have any real currency with people it has to relate to the fact of where it is', and the political concerns of exhibitions like 'Hints to Workmen' function in this urban and demographic context in a way that they may well not elsewhere. At the same time, it should be evident from our discussion of the interpretation that it is not in any way simple or easy; the exhibition works as a sophisticated set of communications with constructive incoherences and makes considerable intellectual and lexical demands of visitors. In this context Robinson points to the gallery's situation above a library and indications that many of the NGCA's visitors are literate and interested in reading, and argues for a level of comprehension such as might be required upon reading a broadsheet newspaper, well above the reading age at which much museum interpretation is pitched. This is, perhaps, the cost to access of interpreting contemporary art, and interpreting *through* contemporary art, in so vocal a way and with such discursive fit in relation to complex themes and questions about art, society and life. It is here that we may have to say that it is not feasible to accommodate all audiences at all times within our interpretive practice. One strategy which Robinson adopts in relation to this is the notion that, as a 'backstop', an exhibition should still be comprehensible in its basic message even were visitors to ignore the label texts, although this requires a careful selection of works and a predominance of recognisable, representational art as opposed to those which might simply leave many visitors 'at a loss' to find any way of grasping at meaning:

> Reading the texts isn't a prerequisite to engaging with a work, but they are a means of deepening that engagement. Even if you solely relied on visual recognition, there are two different but near-universally legible 'subjects' in the show which are announced unambiguously at the outset: protest and authority. How these two might have problematic relationships can be left to visitors to think through, and bring their own resources to. We're facilitating first encounters with unfamiliar artists, and these can be made smoother through introductions in the form of texts. But they should open up new imaginative avenues as well. Asking visitors to undertake new encounters with fifteen artists from different continents, and artefacts from three different centuries, is obviously an ambitious task. Ideally, the passage of making their acquaintance

and engaging with them should be able to be made without additional cues, but it can certainly be smoothed along, and made more complex by their presence.

What we have seen in this discussion of the NGCA's 'Hints to Workmen' is a sophisticated, politicised (on different levels) and committed approach to interpretation of and in relation to contemporary art, as much through the medium of verbal text as through the selection, inclusion and juxtaposition of objects and artworks to raise themes, histories and questions. While this approach is attentive to the vexed questions which surround the issue of meaning of contemporary art and to those of intellectual access, it is arguable that the art itself is not an autonomous centre within the exhibition, and rather that the propositions and dilemmas which emerge from the interplays between objects and texts are paramount. At the same time, the very pitch of intellectual sophistication requires a clear-headed commitment from visitors, who, as a group, may be somewhat delimited (it is not a family show, for example). This is not to devalue the interpretive work of the exhibition in any way, but merely to point out that such strong work has consequences and that practice which aims at inclusiveness will always exclude some. However, the commitment to verbal interpretation and rendering (somewhat) accessible the complex intellectual work of the exhibition is nevertheless an example of the kind of curatorial courage, which, as I argued in Chapter 3, is more usually found wanting in museums and galleries of contemporary art. In the final part of this chapter, an entirely different, but equally committed approach to interpreting contemporary art will be explored.

BALTIC Centre for Contemporary Art

BALTIC Centre for Contemporary Art (henceforth BALTIC) opened in 2002 as a high-profile, publicly-funded capital development (Figure 7.2). As noted on its website:

> Housed in a landmark industrial building on the south bank of the River Tyne in Gateshead, BALTIC is a major international centre for contemporary art. BALTIC has no permanent collection, providing instead an ever-changing calendar of exhibitions and events that give a unique and compelling insight into contemporary artistic practice. BALTIC's dynamic, diverse and international programme ranges from blockbuster exhibitions to innovative new work and projects created by artists working within the local community.
>
> BALTIC is a place where visitors can experience innovative and provocative new art, relax, have fun, learn and discover fresh ideas.

Gateshead is a post-industrial urban centre with some 'gentrified' areas but many others which figure, in official measures, in the 20 per cent most deprived in England (Government Office for the North East 2007), and BALTIC was part of an imposing regeneration project which also saw the opening of spectacular landmarks such as the Sage Gateshead – a large concert venue – and the Millennium Bridge. However,

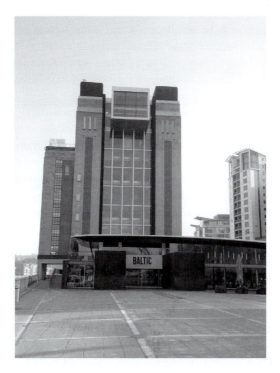

FIGURE 7.2 BALTIC Centre for Contemporary Art; author's own photograph; reproduced with permission from BALTIC Centre for Contemporary Art.

this contextualisation is somewhat misleading, for BALTIC is as close to the centre of metropolitan Newcastle (on the north side of the Tyne) as it is to Gateshead, and BALTIC has both local audiences and significant tourist audiences numbering around 400,000 visits per year. BALTIC itself has over 3,000 square metres of gallery space ranged over four floors (another two floors are dedicated to services, retail and catering, including a high-end restaurant). The organisation is positioned as one of the premier contemporary art venues within the European and indeed international context, offering a number of exhibitions at any one time in a complex programme, including relatively small shows of the works of mid-career artists like the photographer Dan Holdsworth to large-scale shows of the works of very established artists such as (to name just a few) Anselm Kiefer, Yoko Ono, Brian Eno, Antony Gormley, Susan Hiller and Edward and Nancy Reddin Kienholz.

BALTIC knows its audiences, having recently commissioned extensive quantitative visitor research by Morris Hargreaves McIntyre, in which 657 visitor questionnaires were administered. This showed that 59 per cent of BALTIC's visitors are local, i.e. residing within a half-hour drive of BALTIC, with 36 per cent from elsewhere in the UK and 4 per cent from overseas. Of these, 44 per cent describe themselves as having 'little or no knowledge of contemporary art', with 43 per cent having 'general knowledge' and 13 per cent having 'specialist' knowledge. The high (but perhaps not unusual) proportion of uninformed visitors relates to another statistic, which is that

over half of visits appear to be socially motivated, with people coming to BALTIC as much for the overall experience of the café and spectacular views over the river and the two cities (there is a 'viewing box' on level 5 reached via a vertiginous glass lift) as they do for the exhibitions. However, the research shows that the exhibitions are nevertheless an important part of the overall experience, for only 5 per cent of visits are solely for the café or shop. However, many visitors, it seems, come to BALTIC without knowing or needing to know the artists whose works are being exhibited at any given time. Different conclusions might be drawn from this: one is that a level of trust exists among visitors that the exhibitions (whatever they are) will be stimulating enough to warrant a visit; another is that BALTIC is one of a limited number of leisure destinations in the area and this alone affects the incidence of visits. These are not mutually exclusive, and other interpretations are possible too; it would take complementary qualitative research to unpick the complexities of visitor motivation in this instance.

When asked whether visitors perceived BALTIC to be 'designed for art specialists and not the general public', 60 per cent either slightly or strongly disagreed; 9 per cent had no particular opinion, 16 per cent slightly agreed and only 6 per cent strongly agreed with this statement. Similarly, when asked whether BALTIC provided visitors 'with an opportunity to see innovative and provocative art' 96 per cent either agreed or strongly agreed; only 2 per cent strongly disagreed. These are blunt statistics achieved through Likert scale surveying (with all of its limitations), and they need to be set against 'deeper' qualitative data from smaller samples. And of course, the data comes from visitors who have already stepped over the threshold but they give a sense of some basic dimensions of visitor motivation and response and, more importantly, guide the strategic and interpretive planning of BALTIC staff.

We will see shortly how BALTIC's understanding of audiences plays out in interpretive strategies, but first, we can point to an awareness of the difficulties of interpreting contemporary art: their research has shown that some visitors 'felt the information offered about exhibitions at BALTIC was too 'difficult' or inaccessible for the non-specialist' (BALTIC Interpretation Policy 2010). This has been shored up by other research such as that discussed in Chapter 1 in relation to people's understandings and definitions of art at BALTIC, and has led to a willingness to experiment with interpretive practice in an audience-responsive way. What is evident from visitor research is (and this may be true of contemporary art galleries in general) that visitors with high levels of interest in historical art and high levels of self confidence in dealing with the historical art museum environment and interpretive resources therein can be novices in the different context of a venue like BALTIC. Alex Elwick's research has looked at the competencies in this regard of the Friends of the Laing Art Gallery. The Laing is the principal historical art museum in Newcastle (although it also has a small programme of contemporary art exhibitions and installations), and it is situated about two miles from BALTIC. At BALTIC and other such venues, the Friends talked about their own confusion: 'we used to go in and just say "what's this all about?" and we'd wander round being totally confused' – and a lack of understanding: 'when they put the explanation underneath [an exhibit in a contemporary art gallery] I can't make that out at all ... I don't really follow those so well'. Another noted:

I don't go as regularly to the BALTIC as I used to, simply because I've been quite disappointed the last few times ... because, contemporary art to me, personally, it's almost another country, it's like studying another subject, like the difference between physics and chemistry.

(Elwick 2011)

Meanwhile, within its 400,000 visits per year, BALTIC has a loyal core audience: some 75,000 people who visit at least three times a year.

However, the qualitative research by Newman and Whitehead (2006) and Goulding *et al.* (2012) shows that some of these people make repeat visits almost out of frustration rather than because of the unadulterated enjoyment of what they find and see at BALTIC. Contemporary art can be challenging and these people are attempting to understand something which is alien to them, something which is celebrated – incomprehensibly to them – by others in society, paid attention to by the media, and paid for with taxpayers money – and this requires repeat visits. This casts statistics about repeat visiting in a new light, problematising their use as an indicator of 'successful' performance on the part of any art museum or venue (i.e. do brute visitor numbers equal success?), much as it can also complicate notions of fruition as discussed in Part I of this book. In this context an exhibition programme which challenges visitors can be something to celebrate and to calibrate sensitively. In 2010, data was collected about which exhibitions were best received by visitors. Notably, the exhibition of Martin Parr's photographic work and memorabilia collection was best received and the exhibition of video artist Jordan Baseman was least well received. There is a place in the programme for more challenging exhibitions if BALTIC wishes to represent cutting-edge artistic practice. As noted by Thomas, 'visitors do not necessarily come to a contemporary art venue to "like" the content of the exhibitions in a traditional sense'.

As an organisation which is still relatively young, interpretive practice at BALTIC is still developing. In its first years, BALTIC's exhibitions featured little static interpretation and showcased artists' works in white-cube conditions in the kind of architectural and spatial framing discussed in Chapter 5, although orientation spaces at the beginning of exhibitions usually included a main text panel and sometimes a video showing an interview, or the artist at work. Take-away guides were also introduced, for which a small donation is suggested, and we will look at an example of these below. From its first opening in 2002, however, BALTIC employed the relatively unusual strategy of live interpretation on a widespread basis through the use of a team of staff called 'Crew', who are the human face of BALTIC and its custodial staff, but as well as this they interact with visitors, answering questions and engaging in conversations about the art on display (Figure 7.3). This strategy is not unique to BALTIC, but it is well developed and sophisticated there, which is why it is worth looking at in detail.

However, the static interpretation (like the take-away guides) and the live interpretation offered by the Crew are parts of a multifaceted interpretation strategy aimed to satisfy the different needs of BALTIC's diverse audiences. From its inception, BALTIC had a prominent Education and Public Programme, now the Learning

FIGURE 7.3 Image of BALTIC Crew and visitors on Level 5; photographer Colin Davison; image courtesy of the artist and BALTIC Centre for Contemporary Art, Gateshead; reproduced with permission from BALTIC Centre for Contemporary Art (BALTIC).

and Engagement department headed by Emma Thomas who was interviewed for this book. In 2009, BALTIC repositioned learning and engagement at the core of the organisation, moving the Crew and Team Leaders, previously working in the stand-alone Visitor Services department, to the wider Learning team. Along with a revised organisational mission statement, 'to create exceptional access to important and innovative contemporary art in a unique setting, that encourages and enables learning and transformational thinking', the aim is 'to embed learning in the visitor experience, helping them to navigate through contemporary visual art and enhancing their engagement'.

In addition to looking after the daily operation of the galleries, the Learning and Engagement team co-ordinate learning, creative and interpretation activities with schools, colleges and universities as well as adults, families, community and youth groups outside the education system. In this context artists' talks and artists' tours are particularly important, and as discussed in earlier chapters, work to ground interpretation in relation to artists' individual creative choices and careers.

Freely downloadable podcasts provide people with pre-visit resources, explorer packs for families (often with question-based itineraries) are available for each season of exhibitions and video interviews with artists are shown on the level 2 'Quay' space (Quay is a play on words, implying a departure point for a learning journey, while also referencing BALTIC's riverside location), which also houses the library and archive. (In itself the fact that this large space is given over to interpretation and learning resources and activities shows the importance given to these within BALTIC.) In addition to this, BALTIC holds 'Big Participation events' at intervals, in which thousands of people contribute to an artwork over the course of several days; an example of this was the 'ADD COLOUR' event held in correspondence with the exhibition 'Yoko Ono:

Between the Sky and My Head' which ran from December 2008 to March 2009. Here, over the course of a week (a school holiday), visitors were invited to 'take part in adding colour paint to a giant 60-metre-long plain white banner' in a project using Ono's 1966 instruction piece *Add Colour Painting*. The finished artwork was installed outside the BALTIC building and later recycled into objects, for example into pencil cases, sold in the shop generating revenue for the learning programme. This panoply of interpretive resources takes away the pressure for single formats, like the take-away guides, to be accessible to and suitable for all audiences. Interpretive resources also vary across the different exhibitions in a form of sensitive experimentation, so that some exhibitions have little conventional interpretation while others, like the Anselm Kiefer exhibition in 2010, have museum-style labels.

But before we consider some of these interpretive resources let us look at the kinds of information present in the take-away guides, as possibly the most prevalent and most readily accessed form of interpretation. In this context we can take the example of the two-page guide for the exhibition 'Dirk Bell: Made in Germany' which ran from 8 October 2010 to 16 January 2011. This begins with a general account of the nature of Bell's work and attempts to give the visitor an immediate key to understanding what might otherwise seem to be a random assemblage of objects, including a pulsating 'sun' made up of fluorescent tubes, a suitcase, a car and an IKEA sign (Figure 7.4) – the kind of assemblage that no doubt provokes some of the abject confusion characterising the responses of some non-specialist visitors discussed earlier:

> Born in Munich in 1969, Dirk Bell is best known for his delicate, romantic drawings and paintings that are infused with myth and legend. Sensual, lyrical and almost hallucinogenic, they are indebted both to Symbolism and

FIGURE 7.4 'Dirk Bell: Made in Germany'; photographer Colin Davison; image courtesy of the artist and BALTIC Centre for Contemporary Art, Gateshead; reproduced with permission from BALTIC Centre for Contemporary Art (BALTIC).

Surrealism. Visually direct, Bell's work is laced with references and associations that question our various attempts to make sense of the world, our belief systems and the structures that control our societies.

Notably in the last sentence of the above text, the possessive adjective 'our' is introduced and repeated, setting the tone for an example of interpretation that works through interpellation, or through bringing the significances of the work to bear on a notional 'us' and thus on visitors' lives and spheres of existence. The guide continues:

> This exhibition of Bell's most recent work expands his interests and reveals his search for an alternative to the cynicism that characterises a generation that has seen its hopes for social change crumble. The exhibition continually evolves, creating new associations and encouraging alternate readings of the works. The one constant is Revelation Night Sun, a pulsating, inescapable light that dominates the larger of the two gallery spaces. The sun is apparently wired to and controlled by a suitcase, a found object, its 'revelation' label suggesting that religious enlightenment acts as a controller. The pervasive nature of the light from the work perhaps warns of the potential dangers of such enlightenment. The sun that gives warmth and light can also blind us, bringing us back to earth to accept our restrictions. The work alludes to the mythical Icarus, son of a master craftsman, who using wings constructed by his father and ignoring his instructions, flew too close to the sun and fell to his death.

Here once more we see interpellation in action ('The sun that gives warmth and light can also blind *us*, bringing *us* back to earth to accept *our* restrictions'), but also the provision of an intertextual reference that may be difficult for many visitors to notice in the absence of the interpretive text, the allusion to the story of Icarus. What we see here is a rather complex intentional-explanatory framing of the work, much like the interpretation for Job Koelewijn's *Nursery Piece* which we examined in Chapter 5. Here, the various possible meanings and references of the work are unpicked and presented as keys to aid in the scrutiny of the work itself, but they are never pinned down or fixed. And while the voice of the artist is not invoked, there is a clear sense that the interpretation is speaking with him, and that a complex process of negotiation and approval between artist and interpreter has taken place. The text continues:

> Revelation Night Sun radiates a dense network of meanings and generates signals, patterns of light or meditations that reveal a variety of symbols. In the light of the sun, our attention is drawn to the immensity of the universe, the overwhelming power of nature and of the sublime. In the darkness, we are reminded of what makes us human. During the weeks of the exhibition Bell's own car will make a physical, metaphorical and spiritual journey from Gateshead to London, Glasgow and beyond. When in the gallery the car will become an instrument that can be played by operating its guidance system, or

'Sat-Nav'. The game is based on the Lauenstein and Lauenstein animated short film Balance 1989, a comment on post-war Germany, in which five figures on a floating platform must work together. When one man pulls up a box, balance is lost in more than one sense. Whilst Bell's earlier works were concerned with the function of myth, his more recent works are concerned with its absence. The game inside the car is a journey where the player must make sense of the virtual world and create balance in order to survive.

The point of this is to highlight the difficulties in interpreting such conceptual art, which while very suggestive can also be thoroughly bewildering. While this interpretation, working through the intentional-explanatory frame, maps the references and possible meanings of the work and, more crucially, maps out spaces of visitor self-recognition and agency in interpretive processes (the interpellation, the negotiation of meanings and decoding of symbols), it is also challenging to understand in itself in seeking to marshal the complex and somewhat abstract significance of the work. This is an example of one of the more challenging exhibitions held at BALTIC and in this context it is an example of the kind of differential programming which takes place. Elsewhere within the building at this time were exhibitions of Anselm Kiefer's monumental paintings (accompanied, as stated above, by conventional labels) and Dan Holdsworth's negative photographs of Icelandic mountain ranges (figs. 7.5 and 7.6), which formed more readily-understandable counterpoints to the abstruse work by Bell. When programming exhibitions at BALTIC consideration is given to each season and the relationship and balance between the different exhibitions being presented at any one time, with some exhibitions of established artists serving as counterpoints for emerging and less well-known artists and more challenging exhibitions counterpointing more accessible ones.

Notably, the text for the 'Dan Holdsworth: Blackout' exhibition works first and foremost through a predominantly technical frame:

> Dan Holdsworth uses traditional large format photography to create the raw negatives from which he works. Taking up to a year to produce, and edited using primarily analogue processes, his photographs reveal 'truths' often imperceptible to the naked eye. Rather than being elaborate deceptions, his fantastical images are articulations of what is actually caught on film. Blackout, his most recent body of work, is a sequence of images taken during the artist's many expeditions to the Sólheimajökull glacier in Iceland.

Only after this does the interpretation make good on the promise encapsulated in the description of the images as 'fantastical', in a relatively closed piece of interpretation which guides and invites a particular type of regard and experience in front of the photographs:

> Occupying a space between documentary and the make-believe, the images of Blackout transform the elemental terrain of glaciers as they melt away into a

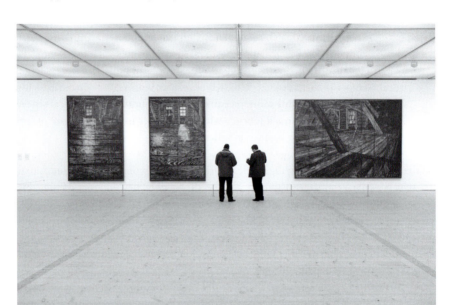

FIGURE 7.5 *Parsifal I, II and III*, 2973, Anselm Kiefer © Tate, London 2010; photographer Colin Davison; image courtesy of BALTIC Centre for Contemporary Art, Gateshead; reproduced with permission from BALTIC Centre for Contemporary Art.

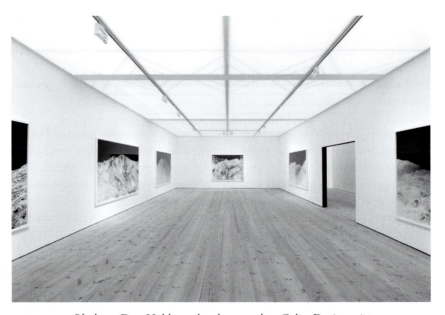

FIGURE 7.6 *Blackout*, Dan Holdsworth; photographer Colin Davison; image courtesy of the artist and BALTIC Centre for Contemporary Art, Gateshead; reproduced with permission from BALTIC Centre for Contemporary Art.

strange, futuristic landscape. The resulting photographs appear so otherworldly it is almost impossible to believe that these lunar-style landscapes actually exist. In Holdsworth's images the blue of the sky becomes the deep black of space, while the earth appears in negative, beyond plausible human time. His practice investigates the unknown, pushing the peripheries of time, space and consciousness beyond the limits of ordinary perception.

While this interpretation prompts the visitor towards a specific type of response, potentially foreclosing others, it is of course true that the text can be read before or after (possibly long after) engagement with the artworks. The poetics of the interpretation are also shored up by the artist's voice, for the take-away guide also reproduces an interview with the artist who explains the works in similar terms. What is more striking here, though, is that the artist is not interviewed by a curator but by the sound recordist Chris Watson, someone with his own experiences of 'fieldwork' in Iceland, notably recordings of the 'unearthly groaning of ice in an Icelandic glacier' in an attempt to put 'a microphone where you can't put your ears' (Watson 2010) – an intellectual and sensory project not dissimilar in some ways from Holdsworth's. This is an attempt to bind other voices into the production of gallery interpretation; it has a more complex status than the incorporation of 'other' voices as we saw at Tate Modern because it is a dialogue between non-museum professionals (although it is clearly a dialogue which has been instigated by museum professionals) and is not simply about an elicited response.

It is in the interpretive work of the Crew, however, that BALTIC's practice is at its most sophisticated. Crew members are highly integrated within the BALTIC staffing structure and within the feedback loops relating to programming (for example, they are encouraged to collate daily feedback and to attend meetings in which they can feed back visitor perspectives on exhibitions to curators). For the most part, their primary roles are to ward the galleries and discuss the works on show with visitors, as well as leading twenty-minute 'Spotlight' tours of exhibitions which have proven very popular. Notably, there are also short tours on a 'behind-the-scenes' theme, on the building (prior to its transformation BALTIC was a flour mill, and many local residents remember it as such and are interested in its history) and the quayside. This non-art interpretation is a response to visitor interests and an accommodation of the fact that BALTIC is only the most recent of the building's roles within the emotional geography of the riverscape; in this context it serves to seal the rupture between industrial past and post-industrial present, between blue-collar and leisure economies and between belonging and exclusion, combating the sense that the building has been appropriated by and for an elite cultural group insensitive to the claims and interests of those who experienced the building as a different kind of place. In some ways this might be understood as a desire to make those visitors who are less familiar with the codes of the contemporary art gallery feel at home, and represents attention to the first and second registers of interpretation identified in the model of the visit introduced in the preface to this book (Figure 0.4), namely the registers of circumstance (including visitors' histories and motivations) and environment.

Crew are also encouraged to build their expertise in the contemporary art on display, and are now able to undertake university-accredited work-based learning.[2] Crew attend staff talks with the artists whose work is to be shown in exhibitions and even, where possible, visiting relevant exhibitions in other venues nationally and internationally in anticipation of future exhibitions at BALTIC. Crew member Hazel Lynn describes the consequences of a research trip to see the exhibition of works by Jenny Holzer at the Fondation Beyeler in Basel in January 2010, a few months before the exhibition travelled to BALTIC in Spring of the same year:

> Previous to my visit to Basel, I had never done an exhibition tour. On my return, and after carrying out further research, I soon realised that I had become one of the main points of contact for this particular exhibition and this very quickly gave me the confidence to not only do visitor tours but also tours to various media representatives. The trip offered me the chance to take on the responsibility of feeding back information, making me feel a valued and trusted member of the Learning team, while also inspiring me to research into greater detail than I had ever done with any previous exhibitions. The process of seeing the exhibition on its 'journey' helped me hugely with my own interpretation of the works as well as creating my own story to tell to the visitors.

The Crew role combines in-depth knowledge and experience of contemporary art with the skills needed to communicate ideas effectively and provide an optimum level of customer service. They also have research time built in to the daily rota and work with the archivist and librarian to access research information, as well as co-ordinating peer-led walkthroughs in which they share their understandings of the art on display. Additionally, training in verbal communication skills has been built into the Crew training and development programme, involving activities such as role play in which Crew members are prompted to frame their verbal interpretation of artworks and their dialogue with people according to different audience profiles, from those with professional specialisms to those with little knowledge of art and more interest in the social dimensions of their visit to a local landmark.

Such training has helped Crew to give tours confidently but also to understand visitor behaviour and communication dynamics, equipping them to identify when to engage in conversation with visitors and when not to (not everyone wants to be thus engaged!), to encourage visitors who are less confident in discussing contemporary art and to deal with the kinds of indignation which contemporary art so often provokes. One Crew member, Linda Bulman, notes:

> It's crucial for a constructive experience, particularly in a complicated and potentially difficult area such as contemporary art that the visitor does not feel patronised or alienated but instead feels at ease, even inspired to enter a discourse in which they can enquire and contribute in a climate of stimulating positivity. The engendering of this unique and valuable relationship applies

equally if the visitor does not like the art or wishes to talk about the views, facilities, history or the weather and it can and does allow the visitor to leave BALTIC feeling valued and encouraged and much more likely to re-attend in the future.

In this context Crew do not seek to defend the value of the artworks but rather to ask questions of visitors in order to understand their responses and to equip them, where possible, with the skills to face the aesthetic and intellectual challenges set by works. Very often, this involves the sharing of personal perspectives, sharing differences of opinion, the recognition that visitors may have a lot that they want to say or comment (and that this may be very broad and diversified in the nature of its relevance to the exhibition at hand) and the notion that staff members are not positioned as specialists per se on each of the exhibitions (much of the art, after all, is very new) but as co-learners. And in this situation of co-learning, Crew and visitors alike can work through forms of questioning which 'open up different ways of looking and thinking' and show up, as Thomas puts it, the 'specific energy of contemporary art to relate or connect with people and with the contemporary world' through its reference to current concerns and its embededness in contemporary politics, society and economics. Through this co-learning approach, Crew can guide visitors, offering a framework for contextualising and approaching contemporary art. With the majority of the Crew practising artists, they are well placed to share their enthusiasm. Another Crew member, Peter Jackson, explains the precise approach to dialogic interpretation which takes place in interaction with visitors:

> I always prompt visitors with particular questions such as in specific cases: 'how would you interpret this musical arrangement of drawings by John Cage?' and 'How might you play this as music?' Or, in terms of Anselm Kiefer's work, mentioning the various feelings (anxious or serene) evoked by Man under Pyramid (1996) and asking how this makes visitors feel, knowing comfortably there is no right or wrong answer. Not everybody will want to offer their input and many are usually content to gain further insight from you. A certain 'feeling out' of the visitor is essential to know how to pitch the facts (and the jokes that keep their attention). I love to throw a joke out to break down any awkward territorial preconceptions of how one should behave in an art gallery. I want people to be comfortable and enjoy contemporary art the same way I do ... Visitors are largely responsive and thankful for knowledge and interpretations shared. I encourage visitor response with acknowledgement, clarification and debate when a visitor expresses their observations.

Many of these practices seem to relate to some of the underpinnings of contemporary theory, ranging from Bourriaud's relational aesthetics discussed in Chapter 3 to Chantal Mouffe's 'domesticated hostility' discussed in Chapter 5 and Emily Pringle's 'contemporary gallery education' model, which models the interpretational process on the very interrogative concerns of the contemporary artwork (another bind

between object and interpretation); just as the artwork (particularly the conceptual one) embodies intellectual speculation about the everyday as well as questions about itself ('Why is this art? Who is the artist? What is the context?'), the interpreting viewer should pose similar questions in relation to herself and her relationship with the world ('Who are you? What do you represent?') (Pringle 2006: 5). However, what is striking here is that this resemblance between certain theoretical models and practice is somewhat coincidental, as Thomas suggests that the model of practice is far more institutionally led and home-grown, built on strategic planning and audience research rather than on the application of scholarship. This is not to say that such theoretical understandings are not at play, for they may represent interests of individual Crew members (Jackson, quoted above, for example, cites an interest in Bourriaud's aesthetics and notions of 'open-ended' interpretation); otherwise, their influence may be felt indirectly and the very coincidence (in the literal sense) of theory and practice which can be seen to be congruent is a function of diffused cultures of discourse. This is an important issue in relation to the complex connections between theory and practice in museums and galleries, and most especially in relation to the significance for practice (which is of course itself always theoretical) of theory positioned as scholarly and/or philosophical. There is basically still a lack of direct correspondence between some kinds of theory pertaining to interpretation and much art museum and gallery practice, and this lack is compounded by the questionable distinction between cultures of and contexts for theory and practice, by the abstruse language in which some theory is articulated and by the lack of time available to art museum and gallery professionals to engage with theory. These are structural problems to which theorists and practitioners (especially art museum and gallery managers) must both respond.

As Thomas notes, the model of interpretive practice at BALTIC – at least in relation to the live interpretation – is one which recognises that 'we don't necessarily know all of the answers to everything. We use the artist's intentions, together with the learnt skills of interpretation through questioning, experience and dialogue. A particular concept of contemporary art and art gallery interpretation is at play in this model of practice: the meaning of art is not 'fixed' by the gallery context but is opened for discussion and explored over a range of interpretive media and practices; authority to speak is in question and dialogue is potentially two-way rather than simply invoked, and in a particular conceptual shift, the contemporary art exhibition becomes a field of experience, discussion and co-learning rather than one of attainment and the transmission and reception of information. The risk, of course, is that visitors may require time to become attuned to this new intellectual economy – just as they might require time to learn to play and to want to play the games encountered in exhibitions at NGCA such as 'Hints to Workmen'. In the mean time, the conventional pedagogical economy of the museum which these institutions are actively destabilising, in one way or another, may still furnish expectations for visitors that they will be taught things about the art (rather than about the wider world, or about themselves) and will learn fixed meanings and comprehend stable histories and narratives of art. In the constructive crisis of interpretation surrounding

contemporary art in museums and galleries – a binding of worries about intention, meaning, interpretive agency (whose?), authority (again, whose?), interpretive focus (what?), legitimacy, accessibility and value – curators, visitors, artists and others are being quickly repositioned to make and unmake sense of things in different ways.

At the time of writing, these positions are far from fixed and stable. This is no bad thing, and if nothing else it is a sign of productive conflict and movement. But at the same time such acceptance of the indeterminacy of the field is far from commonplace and this may continue to fuel negative and unconstructive visitor responses until contemporary art interpretation is made (by those of us who are appropriately positioned) to address itself and to represent its own cultural and contextual complexities to visitors. In the next and final chapter, we will briefly consider these and other challenges which face us today in our art interpretation practices.

8

INTERPRETIVE FUTURES

This book has attempted to provide an overview and a constructive critique of some cultures of interpretation in art museums and galleries. As stated in the preface, it has not been my intention to provide a manual of practice, and one thing which has surely emerged over the course of this book is that there are many ways of interpreting art, interpreting things as art and interpreting other things through art. None of these can have a value which is epistemologically higher than others, and the shifting nature of the concept and constitution of art, the vastness of its scope and the complexity of its classificatory ordering mean that to propose a unique model of 'good' interpretation (or something which represents 'best practice') would be inappropriate and unjust.

However, it is also true that certain principles have come to the fore over the discussions in preceding chapters, and these have been explored both as characteristic of some contemporary practice and, to some extent, as ideals towards which I believe it is worth working. In this context this book has taken a political and ethical standpoint related to personal convictions of mine (with which many may disagree). These principles – some of which can interrelate – can be briefly stated:

- It should be recognised that museum interpretation is constructive rather than merely reflective, that it plays a role within discourse and contributes to narratives of art and art history.
- There should be a consideration of the agency of artworks, and recognition of the work they do on and in the world; this need not be manifest in interpretive resources (this would be too prescriptive and would foreclose interpretive possibilities) but nor should it be obscured by circumstances of display which present art as transcendental, unworldly, non-social and non-economic.
- The status of institutional authority within interpretation, and the implicit or explicit positioning of producers and consumers, needs to be rethought at institutional levels.

- Alongside authority and the relative positioning of producers and consumers, authorship too needs to be acknowledged as a constructive problem, both in relation to artists' authorship of works and curators' interpretations; the authorless authority of the museum needs to be dismantled, for authorship is inevitable, nothing to be ashamed of and not something which should be obscured; a debate may nevertheless be had about the significance or value of authorship.
- There are multiple histories and multiple possible framings for individual artworks; in recognition of this, interpreters need to be informed and responsible when deciding how to interpret.
- The classifications, boundaries and subdivisioning of art need to be subject to scrutiny and should not be presented as natural, but rather as political and, as such, bearing exhibitionary and discursive consequences.
- The rules of any given interpretive regime should, in some way, be made available to visitors and interpreters need to identify and re-evaluate practice, behaviour and beliefs which have become naturalised. This may involve the development of metacognitive resources, helping visitors to learn how to use interpretation; it may also involve opening up to scrutiny the interpretive acts of the museum (from accession to display).
- Uncertainties and unknowns need to be acknowledged and discussed as part of interpretive programmes; this includes the problems of identifying art and identifying value in art – these are silent questions that predicate confusion among many.
- Interpretation should seek in some way to be inclusive – not inclusive of everybody, for this is unfeasible, but attentive to the needs of diverse audiences including non-specialist ones. This means knowing those audiences, and one possible extension of this (although it is no panacea to problems of exclusion and inequality) is to involve them.
- From a management and human resources viewpoint it should be recognised that the configuration of departments, the designation of roles, responsibilities and the structuring of collaborations are constructive of interpretation; this is a matter of intellectual and epistemological responsibility as much as it is a matter for research, experimentation and innovation.

Within these principles, I suggest that multiple ways of working and interpreting are possible, for the elective responsibility involved in them simply regards an attention to the political dimensions of interpretation both in the epistemological sense (in relation to discourses and constructions of art) and in the social sense (in response to visitors and indeed non-visitors).

One of the aims of this book has been to show that interpretation is not simply a matter of technique but of histories (the history of the museum itself, and of museum interpretation; the history of viewing; the historical stories told in art museums), politics (of choice, authority and inclusion/exclusion), philosophy (of knowledge) and psychology (how do we/can we relate ourselves to the world, to ourselves and

others, to the human expression we call art and to the past?). If anything, 'mere' technique is always enfolded within such matters, and my primary contention is that responsible interpretation involves an awareness of their fundamental significance for interpretive action, as well as a measure of accountability in this respect.

After this brief review of the principal contributions of this book to a kind of ethics of interpretation, I want to use this afterword to point towards a few concerns which warrant mention because either they are current but under-explored and insufficiently understood, or because I believe that they will (or should) assume special significance in the near future. These include audience-focused interpretation, the role of interpretive technologies in relation to matters of attention, and the place of interpretation within the art museum, whether as core or ancillary function, at the present time. Within the interrelation of these topics I will identify questions, pointing to areas of research yet to be thoroughly explored.

The audience focus of much new interpretive practice has been seen (albeit in different ways) in all of the case study organisations explored in Chapters 6 and 7. This is, in part, the welcome consequence of the developing exposure of visitor studies, which, in its different varieties, has brought both quantitative and qualitative understandings of the visitor experience to light, although more work is needed to understand non-visitors and the dimensions and nature of agency and structure in their lives and choices (see Bennett *et al.*: 2010).

This diffused understanding of visitor behaviour has often been coupled with interests in how people learn. For example, the influence of constructivism on museum practice is profound, even if it is sometimes understood only rudimentarily as a set of principles about recognising prior knowledge, the validity of individual responses and notions of 'scaffolded learning'. It has also often been drawn into alignment with the need to elicit more visits and attract more visitors in order either to justify public funding or raise revenue from entrance charging, for with this need comes a culture of accommodation, a culture which draws on ideas of customer care. Interest in accommodating visitors, especially new ones, is also a political or politically-driven agenda relating to ideas of inclusive practice still informed by stories of exclusion told by Pierre Bourdieu and Alain Darbel nearly half a century ago.

The visitor focus of much new interpretive practice has profound implications for the focus on objects, for the parameters of knowledge and knowing are changed and the disciplining of both objects and viewers is differently constructed: there is rarely the sense that visitors should have to work to understand interpretive resources and thus to achieve cultural competence; rather, interpretive resources now have to be made to work to be understandable to visitors. This means rethinking the language, tone and the monodirectional communication model of many interpretive resources, and in some cases it may mean rethinking the framing to which art is subject, where what most interests a curator or specialist may not be the most appealing way of seeing and knowing for many visitors. It is not surprising that the ideological work of inclusion *through* interpretation has been extended to encompass the involvement of non-professionals *in* interpretation. But the interpersonal and intergroup protocols and dynamics of this involvement of non-professionals are difficult to

characterise generically or to formulate prescriptively because of the importance of local conditions, and there is a need for a critical survey which problematises existing practice constructively. What is in focus? In some instances the focus on art objects involves a prismatic and refractive focus on visitors which is equally strong; in other instances it seems rather that the focus on people is more direct than the focus on art, so that people are both objects and speakers. Otherwise, new foci (e.g. rarely seen objects or unheard ideas) are identified by non-professional actors, but their agency too is an object of focus. Some of the most pressing questions from an epistemological perspective here are: what do practices of inclusion and involvement do to specialist knowledge, understood conventionally as disciplinary knowledge? And as corollary: what now counts as specialist knowledge, and why? Lastly, what are the limits of involvement and what are the meanings and possibilities of democracy in the art museum context?

One of the ways in which the multivocal interpretation of art has been managed has been through the harnessing of digital technologies, for example in the form of handheld audiovisual units seen, in this book, at Tate and at the MFA in Boston. These are capable of presenting different perspectives on objects to accompany conventional curatorial interpretation. Such technologies, essentially, allow for multiple framings (even musical ones) and a higher level of visitor choice in navigating an interpretive path to, through and from objects. At the same time, the conventional scopic regime of the art museum is upset by such technologies, for they embody the possibility to display ancillary objects, such as film footage and audio recordings, meaning that the object of scrutiny is no longer singular. For example, it is no longer just the painting by Jackson Pollock which occupies visitors, but also the footage of Pollock painting in his studio, or the audio track of him talking about his practice. At what point do such ancillary objects become focal ones? What then is the situation of art object in relation to art interpretation, and where does one end and the other begin? Further issues here relate to visitor attention. One of the stock presumptions of museum studies, especially as it bears on the training of museum professionals, is that increased word count in an exhibition leads to decreased attention to the 'real' objects on display, and it has always been an implicit or explicit ideal that the purpose of interpretation should be to focus attention on such objects, and should, if possible, increase the amount of time ('dwell time') which visitors spend looking at them (Bitgood 2003). While initial research seems to suggest that such digital resources do not lead to a decrease in dwell time, it is nevertheless true that they involve a new form of attention and multiple foci. How can we guarantee that the artwork remains as the principal object of focus? Or should we accept, expect and encourage the cultivation of new forms of attention, involving cross-referencing and referencing away from artworks in their physicality (where they have physicality), the introduction of new objects of focus, the destabilisation of epistemological and aesthetic hierarchies and new forms of gaze and experience? Kesner suggests that the core component of the museum visit is 'the experience of the museum (art) object' and that 'attentive viewing is a *sine qua non* of aesthetic experience' (2006: 4–5). It may be time to question and problematise some of the assumptions about fruition and epistemological value which are woven

into such statements, and Kesner's own suppositions about new forms of attention are an interesting place to start. He asks, 'Are museums faced with a definable cognitive style of the generation of new media users, whose perceptual skills have been altered and modified by the exposure to the new media and visual technologies to the extent of making art inaccessible for them?' (ibid.: 11) However, instead of suggesting that new forms of attention render art inaccessible, it may be more productive to consider whether and how they might enable new, hitherto unimagined, forms of access. What might this mean for interpretive practice?

At the same time this might be a good moment to review some of the received wisdom surrounding conventional interpretation technologies such as text panels and labels. Many art museums work to standards of brevity in the production of texts which seem geared to facilitate an experience in which imagined visitors can read everything in a given display without undue fatigue. But is this a realistic view of visitor desires? It seems more like curatorial arrogance to expect visitors to receive the interpretation encoded into a given display as it were comprehensively. If we admit that this might not be a realistic expectation, and that there may be other ideals of visitor experience which might be put forth, then our work as interpreters might be freed from a cult of brevity. For this, while it has focused useful attention on the economy and accessibility of language and phrasing, can also impoverish content and impoverish the experiences of some visitors. In McManus's 2005 research into the use of text writing guidelines at the V&A, curators reflected on the trend for succinct and accessible texts:

> In a way it's a paradigm shift in how one writes, becoming much more aware of how writing communicates. However, the downside is that I now find it [...] almost impossible to write creatively, journalistically, in more complex tone because I've trained myself to pare everything down to the bones...
>
> (McManus 2005: 19)

And:

> The fun seems to have been taken out of writing labels. The word limits are restrictive. It occasionally means that you have to leave out interesting or slightly complex facts about an object because there is no short way of saying what you want to say.
>
> (ibid.: 22)

It is not necessary or desirable to homogenise the formal composition of interpretation over institutions the world over, and even within the different displays of a single museum the varying extent and complexity of interpretive resources can make for a rich ecology of practice and experience, so long as this diversity is a product of reflection and conscious agency.

This rich ecology of interpretive practice and experience can only be sustained with directed working protocols at institutional level and, where appropriate, well

designed systems of collaboration which involve the co-operation of different kinds of expertise. This has a bearing on staff structures and models of staff interaction, as we saw in Chapter 6, but it also has particular importance at the time of writing in the midst of a global economic recession which has already begun to impinge negatively upon museum management and staffing. In this context, activities relating to interpretation and education can seem like ancillary matters, which are not essential to the museum's survival, so that personnel who are specialised in these areas (as opposed to collections management, for example) are dispensed with. This tendency needs to be countered with a new insistence on interpretation as a core function of art museums, which is as much a part of their reason for being as conservation, collecting and exhibiting. Indeed, one of the first, most basic arguments presented in this book is that all museum actions embody interpretation in some way, and if museum interpretation is conceptualised transversally in this fashion – as something which runs across all museum activity – then the need for reflective and strategic co-ordination of interpretation, and for personnel to undertake this, becomes pressing.

So, we can say that interpretation should be thought of and protected as a core function of art museums because it is already embodied in museum actions which are conventionally seen as core, and the interpretive resources available to visitors are simply part of a continuum of practice in which realities both historical and contemporary are constructed, rationalised, mapped and organised in representations. But there is another reason for casting interpretation as a core function, and this too has added relevance because of current affairs, in which rapidly shifting political and economic contexts mean that many people experience seismic changes in their everyday lives, their wealth and wellbeing, their relations with the places in which they live and their agency and mobility. This need to rethink interpretation as a core function is based on recognition of the psychological and social importance of providing people with content like art, mapped content, made of objects in some form or another made by humans past and present, enabling us to locate ourselves. This self-location is a matter of finding and refinding ourselves in time, in place, and in narratives of cultural belonging, connection and difference. In this context interpretation can be seen to enable encounters between ourselves and the world, encounters which allow us to negotiate some fundamental and most troubling (but also often submerged) ideas of selfhood such as what it means to live now and not then, to be here and not there, to like this and not that, to be us and not them, me and not you. Thus the cartography of the museum extends to a mapping of the self. Such mapping is as political and imaginative as any cartography, but it is only through interpretation that we can figure ourselves in place, in time, in (and out of) cultures and in inclinations. This is astonishing cultural technology.

NOTES

1 What is art interpretation? Why interpret art

1 For an account of the later development of Danto's thought see Carroll, N., 'Danto's New Definition of Art and the Problem of Art Theories' in *British Journal of Aesthetics*, vol. 37, no. 4, October 1997, 386–92.

2 The cultural cartography of the museum

1 The display, originally developed by the BBPR group from 1947 to 1956, is now a consecrated object of study in its own right among museum professionals, designers and architects in Italy.

3 Matters of interpretation

1 Also available remotely via the web at http://www.vam.ac.uk/vastatic/microsites/photography/stories.php).

4 Interpretive frames

1 The Vereenigde Oost-Indische Compagnie or Dutch East India Company.
2 My translations in this chapter are intended to render into English as much of the information provided in the originals as possible. They are not intended to represent 'gallery-ready' translations, and indeed where comprehensible I have sought to maintain a resemblance with the originals in relation to aspects such as the length and structure of sentences and the use of clauses. The focus of this analysis is not so much language use as it is content (insofar as the two can be separated), justifying the rather literal and hence clunky translations here, translations which I would execute very differently for gallery purposes. At the same time I have departed from the originals in instances where literal translation would not serve to convey meaning.
3 The brothers Annibale and Agostino Carracci.
4 These numbers identify specific works hung within the room.

5 Attorno all'unico dipinto posseduto dalla Pinacoteca (n. 1) di Michelangelo Merisi –
detto il Caravaggio dal nome della cittadina in provincia di Bergamo di cui era originaria
la famiglia – sono raccolte alcune tele da lui variamente influenzati, a testimonianza del
seguito largo ed immediate, anche se non sempre meditato e fedele, che ottenne la sua
pittura.

Il pittore, educatosi a Milano, si trasferì nel 1592 a Roma, dove lavorò soprattutto per una
committenza colta, in grado di apprezzare la rivoluzionaria novità della sua opera. Infatti,
come per altra via stavano facendo i Carracci (sala XXVIII), Caravaggio rifiutò l'idea
della pittura come insieme di regole da studiare sulle opera dei maestri del passato, come
pure rifiutò le norme di rappresentazione dei soggetti sacri dettate dalla Controriforma in
nome di una pittura profondamente legata alla realtà, sia fisica che psicologica, capace di
mettere allo scoperto la componente terrena di qualsiasi tema.

A partire dai primi anni del Seicento una delle sue invenzioni stilistiche, subito imitata, fu
la costruzione dell'immagine attraverso forti contrasti di luci ed ombre, che divenne una
sorta di marchio distintivo dei suoi seguaci.

In realtà, Caravaggio non ebbe una vera e propria scuola e degli allievi diretti, ma le sue
opere furono guardato con estremo interesse, tanto a Roma – in particolare fra gli artisti
'nordici' che vi lavoravano – come negli altri luoghi toccata durante la sua irrequieta
esistenza: Napoli, Malta, la Sicilia e nuovamente Napoli. Il gruppo dei 'caravaggeschi' e
perciò molto eterogeneo, e inoltre una certa differenza può essere istituita tra i pochi che
lo conobbero direttamente (nn. 2 e 4) e coloro che, più giovani, operarono dopo la sua
morte (nn. 5 e 6).

Mentre tra i primi l'influsso del Lombardo si coglie soprattutto nell'attenzione al reale,
tra i secondi il suo insegnamento fu spesso impoverito e banalizzato, ridotto all'uso di
un colorito molto contrastato e di espressioni caricate, all'insistenza su aspetti grotteschi
e truculenti che invece Caravaggio evitò, alla riduzione sistematica degli episodi sacri in
scenette pittoresche di vita quotidiana.

6 Mattia Preti (Taverna, Catanzaro, 1613 – La Valletta, Malta, 1699)
5 *San Pietro paga il Tributo*
Olio su tela, cm 143 x 193.

La tela, insieme al suo pendant (n. 7) giunse in Pinacoteca il 31 gennaio 1812 come dono
del vicerè Eugenio di Beauharnais, ma non se ne conosce la provenienza antica. L'episodio
di Cristo che fa pagare a San Pietro la tassa dovuta al gabelliere con il denaro trovato nella
bocca di un pesce che gli ha ordinato di catturare è tradotto con una gestualità eloquente,
sostenuta da una fitta trama di sguardi tra i protagonisti. Eseguito con ogni probabilità
entro gli anni Trenta del Seicento testimonia come poteva essere interpretata la pittura
di Caravaggio da un pittore assai più giovane che avesse lavorato a Roma, studiando
direttamente le opera del maestro e conoscendo i suoi imitatori.

Anche Mattia Preti, come altri artisti della sua generazione, da Caravaggio deriva, quasi
standardizzandoli, alcuni motivi esteriori, che applica poi alle sue proprie opere: in questo
caso si possono indicare il taglio ravvicinato della composizione, con le figure a tre quarti
riunite intorno al tavolo, i raggi luminosi che evidenziano i protagonisti segnandone le
rughe o i dettagli dell'abbigliamento, la scelta di riprodurre il fatto evangelico come una
contemporanea scena di osteria.

6 Case studies: institutional approaches to historical art

1 Norwood does not address the level of 'self-transcendance' which Maslow added as the
highest level of the hierarchy in 1969 (A.H. Maslow (1969), 'The farther reaches of
human nature', *Journal of Transpersonal Psychology*, 1 (1), 1–9).

2 Unlike its counterpart 'Euro-Canadian' at the AGO, this term is not used at the MFA,
and I could not find any consistently-used umbrella term which might be considered
analogous or similar. I use it here precisely to draw attention to the ways in which the

two organisations have approached the problem of identifying and naming different populations and artistic cultures who were co-located, sometimes not peaceably, on the same geographical territory, and discussing their interactions and interrelations. In so doing I recognise the political complexities of the use and non-use of ethnic identifiers in discourses of American identities.

7 Case studies: institutional approaches to contemporary art

1 At the 2001 census.
2 Thomas notes that such training has been supported by funders such as the Rootstein Hopkins Foundation and the Paul Hamlyn Foundation. The postgraduate-level Professional Practice Award is validated through nearby Northumbria University.

REFERENCES

AGO (2008) 'Campaign surpasses $276 million goal as transformed AGO opens to the world', http://www.ago.net/campaign-surpasses-276-million-goal-as-transformed-ago-opens-to-the-world, accessed January 2011.

AGO (2011) *Art Matters Blog*, http://artmatters.ca/wp/2007/05/new-ideas-the-ago-of-2008-what-do-you-think/, accessed January 2011.

Bakewell, J. (2007) 'The arts themselves are seen as part of the self-regarding picture of vanity and conceit', http://www.independent.co.uk/opinion/commentators/joan-bakewell/joan-bakewell-what-is-kylie-minogue-doing-at-the-vampa-435613.html, accessed January 2011.

BALTIC Interpretation Policy 2010–12, BALTIC Centre for Contemporary Art.

Baxandall, M. (1972) *Painting and Experience in Fifteenth-Century Italy*, Oxford: Oxford University Press.

Baxandall, M. (1991) 'Exhibiting intention: some preconditions of the visual display of culturally purposeful objects', in I. Karp and S.D. Lavine (eds) *Exhibiting Cultures: The Poetics and Politics of Museum Display*, Washington, DC: Smithsonian Books, 33–41.

Bazin, G. (1967) *The Museum Age*, Brussels: Desouer.

BBC (1999) 'Neurotic realism: come again?', http://news.bbc.co.uk/1/hi/special_report/1999/02/99/e-cyclopedia/272214.stm, accessed January 2011.

Beardsley, M.C. (1982) 'Some persistent issues in aesthetics', in M.J. Wreen and D.M. Callen (eds) *The Aesthetic Point of View*, Ithaca: Cornell University Press, 285–7.

Belting, H. (2003) *Art History After Modernism*, Chicago: University of Chicago Press.

Bennett, T., Savage, M., Silva, E., Warde, A., Gayo-Cal, M. and Wright, D. (2010) *Culture, Class, Distinction*, London: Routledge.

Bishop, C. (2004) 'Antagonism and relational aesthetics' *October Magazine*, Fall, 51–79. http://www.teamgal.com/production/1701/SS04October.pdf, accessed January 2011.

Bitgood, S. (2003) 'The role of attention in designing effective interpretive labels', *Journal of Interpretation Research*, 5 (2): 31–45.

Bourdieu, P. (1977) *Outline of a Theory of Practice*, Cambridge: Cambridge University Press.

Bourdieu, P. (1984) *Distinction: A Social Critique of the Judgement of Taste*. London: Routledge.

Bourdieu, P. (1993) *The Field of Cultural Production*, London: Polity Press.

Bourdieu, P. and Darbel, A. (1969 [1997]) *The Love of Art*, Stanford, CA: Stanford University Press.

Bourriaud, N. (1997) *Relational Aesthetics*, Paris: Les Presses Du Reel.

Cameron, F. and Kenderdine, S. (eds) (2010) *Theorizing Digital Cultural Heritage: A Critical Discourse*, Cambridge, MA: MIT Press.

Carrier, D. (2006) *Museum Skepticism: A History of the Display of Art in Public Galleries*, Durham, NC: Duke University Press.

Carroll, N, (1997) 'Danto's new definition of art and the problem of art theories', *British Journal of Aesthetics*, 37 (4): 386–92.

Carroll, N. (1999) *Philosophy of Art: A Contemporary Introduction*, London: Routledge.

Carter, M. and Geczy, A. (2006) *Reframing Art*, Sydney: University of New South Wales Press.

Conservative Party (Metacafe), *The Inner Tosser* (undated video clip) http://www.metacafe.com/watch/326093/the_inner_tosser/.

Crimp, D. (1995) *On the Museum's Ruins*, Cambridge, MA: MIT Press.

Crooke, E. (2005) 'Dealing with the past; museums and heritage in northern Ireland and Cape Town, South Africa', *International Journal of Heritage Studies*, 11 (2): 131–42.

Csikszentmihalyi, M. (2008) *Flow: The Psychology of Optimal Experience*, New York: Harper Perennial Modern Classics.

Csikszentmihalyi, M. and Robinson, R.E. (1990) *The Art of Seeing: An Interpretation of the Aesthetic Encounter*, Los Angeles, CA: The J. Paul Getty Museum and The Getty Education Institute for the Arts.

Cuno, J. (2003) 'The object of art museums', in J. Cuno (ed.) *Whose Muse? Art Museums and the Public Trust*, Princeton, NJ: Princeton University Press.

Curtis, N.G.W. (2006) 'Universal museums, museum objects and repatriation: the tangled stories of things', *Museum Management and Curatorship*, 21 (2): 117–27.

Danto, A. (1981) *The Transfiguration of the Commonplace*, Cambridge, MA: Harvard University Press.

Davies, S. (2006) *The Philosophy of Art*, London: Wiley-Blackwell.

Dickie, G. (1974) *Art and the Aesthetic*, Ithaca, NY: Cornell University Press.

Dickie, G. (1984) *The Art Circle: A Theory of Art*, New York: Haven Publications.

Doering, Z. (1999) *Strangers, Guests, or Clients? Visitor Experiences in Museums*, Washington, DC: Institutional Studies Office, Smithsonian Institution.

Dorment, R. (2009) 'Altermodern, Tate Triennial 2009, review', http://www.telegraph.co.uk/culture/culturecritics/richarddorment/4436239/Altermodern-Tate-Triennial-2009-review.html, accessed January 2011.

Duclos, R. (2004) 'The cartographies of collecting', in S.J. Knell (ed.) *Museums and the Future of Collecting*, 2nd edn, Aldershot: Ashgate, 84–101.

Du Gay, P., Hall, S., Janes, L., Mackay, H. and Negus, K. (1997) *Doing Cultural Studies: The Story of The Sony Walkman*, Thousand Oaks, CA: Sage.

Duncan, C. and Wallach, A. (1980) 'The universal survey museum', *Art History*, 3 (4): 448–69.

Eco, U. (1989) *The Open Work*, Cambridge, MA: Harvard University Press.

Elkins, J. (1995) 'Art history and images that are not art', *The Art Bulletin*, 77 (4): 553–71.

Elkins, J. (2002) *Stories of Art*, London: Routledge.

Elwick, A. (2011) Initial analysis: non-formal learning in museums and galleries, unpublished report, Newcastle upon Tyne: International Centre for Cultural and Heritage Studies.

Encyclopaedia Smithsonian: Art and Design. http://www.si.edu/Encyclopedia_SI/Art_and_Design/, accessed 3 November, 2010.

Entman, R.M. (1993) 'Framing: toward clarification of a fractured paradigm', *Journal of Communication*, 43 (4): 51–8.

Fairclough, N. (2010) *Critical Discourse Analysis: The Critical Study of Language*, London: Longman Publishers.

Falk, J.H. (2006) 'The impact of visit *motivation* on learning: using *identity* as a construct to understand the visitor experience', *Curator*, 49 (2): 151–66.

Falk, J.H. (2009) *Identity and the Museum Visitor Experience*, Walnut Creek, CA: Left Coast Press.

Falk, J.H. and Dierking, L.D. (2002) *Lessons Without Limit: How Free-choice Learning is Transforming Education*, Walnut Creek, CA: Altamira Press.

Feeney, M. (2010) 'He put the writing on the wall', http://www.boston.com/ae/theater_arts/articles/2010/11/14/5000_labels_for_5000_artworks_that_was_benjamin_weisss_job/, accessed January 2011.

Fohrman, D. (2007) 'Do visitors *question*?', in K. McLean and W. Pollock (eds) *Visitor Voices in Museum Exhibitions,* Washington DC: Association of Science-Technology Centers Inc.

Foucault, M. (1984) 'Nietzsche, genealogy, history', in P. Rabinow (ed.) *The Foucault Reader,* New York: Pantheon, 76–100.

Fox, I. (2007) 'Kylie overwhelmed by V&A show', http://www.guardian.co.uk/music/2007/feb/07/kylieminogue, accessed January 2011.

Freeland, C. (2002) *But is it Art?: An Introduction to Art Theory,* Oxford: Oxford University Press.

Gitlin, T. (1980) *The Whole World Is Watching: Mass Media in the Making and Unmaking of the New Left,* Berkeley, CA, Los Angeles, CA and London: University of California Press.

Goffman, E. (1974) *Frame Analysis: An Essay on The Organization of Experience,* London: Harper and Row.

Goulding, A., Newman, A. and Whitehead, C. (2012) 'The consumption of contemporary visual art: identity formation in late adulthood', *Cultural Trends,* 81, in press.

Government Office for the North East Analysis and Performance Team (2007) *Local Authority Area Profile: Gateshead,* version 9, http://www.gos.gov.uk/nestore/docs/ourregion/laps/gateshead.pdf, accessed February 2011.

Graham, B. and Cook, S. (2010) *Rethinking Curating: Art after New Media,* Cambridge, MA: MIT Press.

Grenfell, M. and Hardy, C. (2007) *Art Rules: Pierre Bourdieu and the Visual Arts,* London: Berg Publishers.

Hargreaves McIntyre, M. (2010) 'Audience insight – the whole story, annualised findings of the BALTIC visitor survey – June 2009 to May 2010.'

Harley, J.B. (2002) *The New Nature of Maps: Essays in the History of Cartography,* in P. Laxton (ed.) Baltimore, MD and London: The Johns Hopkins University Press.

Hartley, L.P. (1953) *The Go-Between,* London: Hamish Hamilton.

Hetherington, K. (1997) 'Museum topology and the will to connect', *Journal of Material Culture,* 2 (2): 99–218.

Hirschi, K.D., and Screven, C.G. (1988) 'Effects of questions on visitor reading behavior', *ILVS Review,* 1 (1): 50–61.

Hooper-Greenhill, E. (2000) *Museums and the Interpretation of Visual Culture,* London: Routledge.

Hooper-Greenhill, E. (2007) *Museums and Education: Purpose, Pedagogy, Performance,* London and New York: Routledge.

Housen, A. (2010) 'Aesthetic development', *Visual Thinking Strategy,* http://www.vtshome.org/pages/art-aesthetic-development, accessed January 2011.

Housen, A. (2010) 'Research', *Visual Thinking Strategy,* http://www.vtshome.org/pages/research, accessed January 2011.

Housen, A. and Yenawine, P. (2001) 'Basic VTS at a glance', *Visual Thinking Strategy,* http://www.vtshome.org/system/resources/0000/0018/basic_vts_at_a_glance.pdf, accessed January 2011.

Iser, W. (1978) *The Act of Reading: A Theory of Aesthetic Response,* Baltimore, MD: Johns Hopkins University Press.

Kesner, L. (2006) 'The role of cognitive competence in the art museum experience', *Museum Management and Curatorship,* 20, 1–16.

Klonk, C. (2009) *Spaces of Experience: Art Gallery Interiors from 1800 to 2000,* New Haven, CT and London: Yale University Press.

Koke, J. (2010) Personal communication.

Koltko-Rivera, M.E. (2006) 'Rediscovering the later version of Maslow's hierarchy of needs: self-transcendence and opportunities for theory, research, and unification', *Review of General Psychology,* 10 (4): 302–17.

Landi, A. (2008) 'I expect to be surprised every day', *ARTnews*, 107 (10).

Leinhardt, G. and Knutson, K. (2004) *Listening in on Museum Conversations*, Walnut Creek CA: Altamira Press.

Lewis, B. (2009) 'New age of the "ism", in Altermodern', http://www.thisislondon.co.uk/arts/review-23636018-new-age-of-the-ism-in-altermodern.do, accessed January 2011.

Litwak, J.M. (1996) 'Visitors learn more from labels that ask questions', in *Current Trends in Audience Research,* American Association of Museums Committee on Audience Research and Evaluation, 10, 40–50.

McClellan, A. (1999) *Inventing the Louvre: Art, Politics and the Origins of the Modern Museum in Eighteenth-Century Paris*, Berkeley, CA: University of California Press.

McClellan, A. (2008) *The Art Museum from Boullée to Bilbao*, Berkeley, CA: University of California Press.

McClellan, A. (ed.) (2003) *Art and its Publics: Museum Studies at the New Millennium*, Oxford: Blackwell.

McEvilley, T. (1999) 'Introduction', in B. O'Doherty, *Inside the White Cube: The Ideology of the Gallery Space*, Berkeley, CA: University of California Press, 9–12.

McManus, P. (2005) Curators and visitors: the impact of the V&A Text Guidelines in 2004, unpublished report, Victoria and Albert Museum.

McManus, P.M. (2009) 'Book review by E. Hooper-Greenhill, 'Museums and Education: Purpose, Pedagogy, Performance', *Museum and Society*, 7 (3): 207–8.

Malraux, A. (1967) *Museum Without Walls*, Garden City, NY: Doubleday and Co.

'Manchester Gallery' *Manchester Art Gallery*, http://www.manchestergalleries.org/whats-on/permanent-galleries/cis-manchester-gallery/, accessed January 2011.

Maquet, J. (1986) *The Aesthetic Experience: An Anthropologist Looks at the Visual Arts*, New Haven, CT and London: Yale University Press.

Marincola, P. (ed.) (2007) *What Makes a Great Exhibition?,* London: Reaktion Books.

Maslow, A.H. (1943) 'A theory of human motivation', *Psychological Review,* 50, 370–96.

Merrill, L. (1992; reprint 1993) *A Pot of Paint: Aesthetics on Trial in Whistler v. Ruskin*, Washington, DC: Smithsonian Institution Press.

Meszaros, C. (2007) 'Interpretation in the reign of the "whatever"', *MUSE: Journal of the Canadian Museums Association,* 25 (1): 16–29.

Mouffe, C. (2002) *Politics and Passions: The Stakes of Democracy*, London: Centre for the Study of Democracy, University of Westminster.

Museum of Fine Arts (2010) 'Director's Message', http://www.mfa.org/annual-report-2010/director.html, accessed December 2010.

Museums, Libraries and Archives Council (2008) 'Generic Learning Outcomes', http://www.inspiringlearningforall.gov.uk/toolstemplates/genericlearning/, accessed January 2011.

Newhouse, V. (2005) *Art and the Power of Placement*, New York: Monacelli Press.

Newman, A. and Whitehead, C. (2006) *Fivearts Cities: An Evaluative Report on The Impact on Over 50s Participating in Activities Related to British Art Show 6.* Gateshead, UK: BALTIC Centre for Contemporary Art.

'Northern Spirit', Laing Art Gallery, Newcastle, http://www.twmuseums.org.uk/laing/news/northern-spirit/, accessed January 2011.

Norwood, G. (1999) 'Maslow's hierarchy of needs. The Truth Vectors (Part I)', http://www.deepermind.com/20maslow.htm, accessed May 2002.

Norwood, G. (2009) 'Maslow's hierarchy of needs', *Deepermind*, http://www.deepermind.com/20maslow.htm, accessed March 2011.

O'Brian, J. and White, P. (2007) *Beyond Wilderness: The Group of Seven, Canadian Identity, and Contemporary Art*, Montreal and Kingston: McGill-Queen's University Press.

Obrist, H.U. (2008) *A Brief History of Curating*, Zurich: JRP Ringer.

O'Doherty, B. (1999) *Inside the White Cube: The Ideology of the Gallery Space*, Berkeley, CA: University of California Press.

O'Neill, P. (2007) 'The curatorial turn: from practice to discourse', in J. Rugg and M. Sedgwick (eds) *Issues in Contemporary Curating*, Bristol: Intellect, 13–28.

O'Neill, P. and Wilson, M. (2010) *Curating and the Educational Turn*, Amsterdam: de Appel.

Parry, R. (2007) *Recoding the Museum: Digital Heritage and the Technologies of Change*, London: Routledge.

Parry, R. (ed.) (2009) *Museums in a Digital Age*, London: Routledge.

Pekarik, A.J., Doering, Z.D. and Karns, D.A. (1999) 'Exploring satisfying experiences in museums', *Curator: The Museum Journal*, 42 (2): 152–73.

Preziosi, D. (2003) *Brain of the Earth's Body: Art Museums and the Phantasms of Modernity*, Minneapolis, MN: University of Minnesota Press.

Pringle, E. (2006) *Learning in the Gallery: Context, Process, Outcomes*, London: Engage.

Rand, J. (1990) *Fish Stories that Hook Readers: Interpretive Graphics at the Monterey Bay Aquarium*, Technical Report 90–20, Jacksonville, AL: Center for Social Design.

Ravelli, L. (2005) *Museum Texts: Communication Frameworks*, London: Routledge.

Reith, C. (2010) 'The death of the curator and the rise of interpretive democracy: dissolving hierarchies and undermining the authoritative voice in the contemporary art gallery', unpublished MA dissertation, International Centre for Cultural and Heritage Studies, University of Newcastle-upon-Tyne.

Rice, D. and Yenawine, P. (2002) 'A conversation on object-centered learning in art museums', *Curator: The Museum Journal*, 45 (4): 289–99.

Ritchhart, R. (2007) 'Cultivating a culture of thinking in museums', *Journal of Museum Education*, http://www.pz.harvard.edu/vt/VisibleThinking_html_files/06_AdditionalResources/CultivatingACultureofThinking.pdf, accessed January 2011.

Robert, J.Y. (1999) 'The institutional theory of art', in M. Kelly (ed.) *The Encyclopedia of Aesthetics*, Oxford: Oxford University Press.

Rugg, J. and Sedgwick, M. (2007) *Issues in Curating Contemporary Art and Performance*, Bristol and Chicago, IL: Intellect Books.

Rugoff, R. (2006) 'You talking to me? On curating group shows that give you a chance to join the group', in P. Marincola (ed.) *What Makes a Great Exhibition?*, London: Reaktion Books, 44–52.

Schaffner, I. (2006) 'Wall text', in P. Marincola (ed.) *What Makes a Great Exhibition?*, London: Reaktion Books, 154–67.

Serota, N. (2000) *Experience or Interpretation: The Dilemma of Museums of Modern Art*, London: Thames and Hudson.

Serrell, B. (1996) *Exhibit Labels: An Interpretive Approach*, London: Sage.

Shiner, L. (2001) *The Invention of Art*, Chicago, IL: University of Chicago Press.

Simon, N. (2010) 'The Participatory Museum', http://www.participatorymuseum.org/, accessed January 2011.

Smith, T. (2009) *What Is Contemporary Art*, Chicago, IL: University of Chicago Press.

Snow, D.A., Rochford Jr, E.B., Worden, S.K., Benford, R.D. (1986) 'Frame alignment processes, micromobilization, and movement participation', *American Sociological Review*, 51, 464–81.

Solima, L. (2000) *Il Pubblico dei Musei. Indagine sulla comunicazione nei musei statali italiani*, Rome: Gangemi.

Storr, R. (2006) 'Show and tell', in P. Marincola (ed.) *What Makes a Great Exhibition?*, London: Reaktion Books, 14–31.

Sunderland City Council (undated) 'Chapter 2 – planning for people', *Unitary Development Plan; Includes Adopted Alteration No. 2.*, http://www.cartogold.co.uk/sunderland/text/02_plan_people.htm, accessed February 2011.

Sunstein, C. and Thaler, R. (2008) *Nudge: Improving Decisions about Health, Wealth and Happiness*, New Haven, CT: Yale University Press.

Swartz, D. (1998) *Culture and Power: the Sociology of Pierre Bourdieu*, Chicago, IL: University of Chicago Press.

Tallon, L. and Walker, K. (2007) (eds) *Digital Technologies and the Museum Experience: Handheld Guides and Other Media*, Lanham, MD: Altamira Press.

Tate (2009) 'Altermodern Manifesto: postmodernism is dead', http://www.tate.org.uk/britain/exhibitions/altermodern/manifesto.shtm, accessed January 2011.

Tate (2011) 'Collection displays', http://www.tate.org.uk/servlet/CollectionDisplays?venueid=2, accessed January 2011.

Tate Modern (2010) 'About Tate Modern', http://www.tate.org.uk/modern/about.htm, accessed January 2011.

Teeman, T. (2007) 'Kylie at V&A', http://entertainment.timesonline.co.uk/tol/arts_and_entertainment/visual_arts/article1341366.ece, accessed January 2011.

The Times (2006) 'Hang on ... this all looks very different', http://entertainment.timesonline.co.uk/tol/arts_and_entertainment/article712255.ece, accessed January 2011.

Thompson Klein, J. (1993) 'Blurring, cracking, and crossing: permeation and the fracturing of discipline', in E. Messer-Davidow, D. Sylvan and D. Shumway (eds) *Knowledges: Historical and Critical Studies of Disciplinarity*, Charlottesville, VA: University Press of Virginia, 185–211.

Thomson, P. (2008) 'Field', in M. Greenfell (ed.) *Pierre Bourdieu: Key Concepts*, Durham, NC: Acumen.

Upchurch, A. (2004) 'John Maynard Keynes, the Bloomsbury Group and the origins of the Arts Council Movement', *International Journal of Cultural Policy*, 10 (2): 203–17.

Victoria and Albert Museum, 'Day of record', http://www.vam.ac.uk/collections/contemporary/day_record/index.html, accessed January 2011.

Warburton, N. (2002) *The Art Question*, London: Routledge.

Waterman, A.S. (1992) 'Identity as an aspect of optimal psychological functioning', in G.R. Adams, T. Gullota and R. Montemayor (eds) *Advances in Adolescent Development* Vol. 4, *Identity Formation During Adolescence*, Newbury Park, CA: Sage.

Watson, C. (2010) www.chriswatson.net, accessed January 2011.

Weibel, P. (2007) 'Beyond the White Cube', in P. Weibel and A. Buddensieg (eds) *Contemporary Art and the Museum*, Ostfildern: Katje Kantz Verlag.

Weiss, B. (2011) Personal communication.

Welch, E. (1997) *Art and Society in Italy, 1350–1500*, Oxford: Oxford University Press.

Welch, E. (2000) *Art in Renaissance Italy*, Oxford: Oxford University Press.

Whitehead, C. (2005) 'Visiting with suspicion: recent perspectives on art and art museums', in G. Corsane (ed.) *Heritage, Museums and Galleries: An Introductory Reader*, London: Routledge, 89–101.

Whitehead, C. (2009) *Museums and the Construction of Disciplines: Art and Archaeology in Nineteenth-century Britain*, London: Duckworth Academic.

Whitehead, C. (2010) 'National art museum practice as political cartography in nineteenth-century Britain', in S. Knell, P. Aronsson, A.B. Amundsen, A. Barnes, S. Burch, J. Carter, V. Gosselin, S. Hughes, A.M. Kirwan (eds) *National Museums: New Studies from Around the World*, London: Routledge.

Whitehead C. (2011) 'Towards Some Cartographic Understandings of Art Interpretation in Museums', in J. Fritsch (ed.) *Museum and Gallery Interpretation and Material Culture*. London: Routledge.

Wilson, G. (2004) 'Multimedia tour programme at Tate Modern', *Museums and the Web 2004*, http://www.archimuse.com/mw2004/papers/wilson/wilson.html, accessed January 2011.

Wolf, E. (2006) 'On the seventieth Anniversary of Cubism and Abstract Art: Alfred H. Barr, Jr's legacy', http://www.artandeducation.net/papers/view/4, accessed January 2011.

Yanal, R.J. (1998) 'The institutional theory of art' in M. Kelly (ed.) *The Encyclopedia of Aesthetics*, Oxford: Oxford University Press, 508–512.

INDEX